GW00578236

MY OTHER FAMILY

MY OTHER FAMILY

An Artist–Wife in Singapore

PATRICIA MORLEY

The Radcliffe Press
London · New York

Published in 1994 by
The Radcliffe Press
45 Bloomsbury Square
London WC1A 2HY

175 Fifth Avenue
New York
NY 10010

In the United States of America
and Canada distributed by
St Martin's Press
175 Fifth Avenue
New York
NY 10010

A full CIP record for this book is available from the British Library

Library of Congress Catalog card number: 94–60181
A full CIP record is available from the Library of Congress

ISBN 1–85043–823–4

Copy-edited and laser-set by Selro Publishing Services, Oxford
Printed and bound in Great Britain by WBC Ltd, Bridgend, Mid Glamorgan

TO MY HUSBAND

Contents

List of Illustrations

All illustrations are reproduced
from original drawings by Patricia Morley

Characters in order of their appearance. The original portraits were mostly done in charcoal, some with pastel additions.

Acknowledgements

First, and above all, I am grateful to John, my husband, for his constant encouragement and unfailing help. Next, to Irene Thomas, for reading the manuscript and commenting on it. I greatly appreciate the time and trouble she has taken on my behalf.

Thirdly, to Lester Crook, for his generous introduction, and sympathetic interest in all matters concerning the publication of this book.

Last, and certainly not least, I shall be forever grateful to all those members of my 'other family' in Singapore, whose joys and sorrows I was privileged to share, and who made the years 1946–48 spent in that great city the most memorable of my life.

Foreword

This is an extraordinary, moving, multi-faceted and unique book.
At the heart of the book there is a striking contradiction, at least
for readers inexperienced in the often strange ways of Em-
pire — now in its decline. Here was a middle-class young English-
woman married to an officer in the Colonial Service, transplanted to an
exotic region, and thrown into a new and colourful world which seemed
to be full of problems — ethnic, personal, and in the community at
large. This community was still suffering from the effects of the Second
World War and the brutal Japanese occupation, and its former stability
had been shattered. Here, perhaps, the wisest course would have been
to follow the role of the traditional colonial memsahib in the twilight of
Empire — bringing up her young family, entering into her husband's
busy life with its multitude of official responsibilities, which left limited
time for family matters. Of course she would be surrounded by servants
who would, no doubt, ease domestic life but not usually provide friend-
ship, or even interest. Why not withdraw into the colonial cocoon and
stick it out with the other expatriates until the next posting, and the next
step in her husband's career?

But Patricia Morley — encouraged and supported by John — was
different. She came from an intellectual and artistic background, and
was trained at the Regent Street Polytechnic and the Slade School of
Art in London, specializing in portraiture. Her art rapidly became the
catalyst by which she progressively entered into an intense and close
personal relationship with the Malays — the servants and their families
and friends who soon became her 'other family'. This is why the book
is unique: the splendid portraits do not serve just to illustrate the text,
nor does the text merely surround and explain the portraits; both are
part of an almost organic whole.

Foreword

As a result of her art Patricia Morley gradually became part of the world of her sitters and of the Malay community with all its complexity and tension — which often built to traumatic climaxes. A particular problem — with contemporary resonance — centred around the relationships between men and women and the often bitter resentment at traditional male domination. She shares the lives of her 'other family' — in sickness and health, their joys, tragedies, fears, hopes; and gently understands and tempers the conflict. A network of deep and affectionate relationships grows up transcending seemingly impassable race, cultural and class barriers.

The book is much more than a charming account of relationships even when illustrated by superb portraits. It is certainly this and more — a vignette of late-imperial history. But it is also an important work of social anthropology couched in intimate and detailed personal experience. It is a picture of another side of Empire — and a most attractive one.

<div style="text-align: right">Lester Crook</div>

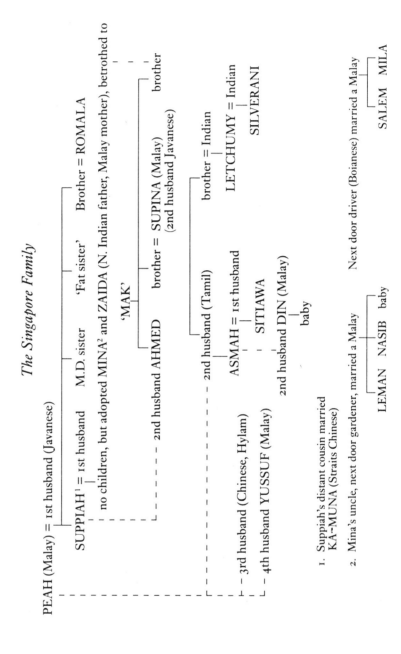

The Singapore Family

1
Introducing Mina

A rrival in Singapore was a thrilling and wonderful experience. After a long voyage travelling single-handed with Margaret at four years' old and Tania at only three months, after the dragging years of war and post-war austerity in England, clothing coupons, food rations, standing in long queues for something which had sold out when one's own turn came, Margaret by my side, cold and irritable, fidgeting in the wind and rain, the baby alone at home because there was no one to leave her with — after all this and the long separations from my husband, everything seemed so new and so exciting. I enjoyed the glorious feeling of being warm, the luxury of having someone else do the cooking, the lovely decorative dark women to help with the children, clean the house and wash and iron, and a home which seemed such a mansion after my tiny flat with no garden in London. How fascinated I was by the little half doors with nothing above or below them to obstruct the circulation of air. It was hot, there was no question about that, but gorgeously hot when I remembered the east winds at home and the snow, which was not much fun when there had been hardly enough coal to keep a fire going in one room.

Upstairs we seemed to live almost out of doors, with a veranda on three sides of a sitting room which looked out onto the tops of green trees where coloured birds fluttered from branch to branch. A large garden rolled away below. It was filled with gardenias, which cost half a crown each in Piccadilly; there were hibiscus hedges bearing soft pink blooms with frilly edges like women's petticoats; and a patch of scarlet cannas at the edge of the lawn came into view as one turned the corner in the car and drew up under the porch.

It was there that I saw Mina for the first time, standing on the steps in the shadow. The amber pupils of her great languid eyes shyly rested on

mine for a moment, and then turned down. She was like a beautiful polished carving in dark wood I had seen in a museum, but could not remember where. She wore an olive-coloured jacket, which was faded and torn. I greeted her. With a shy nod she returned my greeting and took the baby from me. The brilliant coloured sarong wound about her waist fell to her ankles in graceful folds as she walked, showing her feet, splayed and angular.

What a sarong! Afterwards I got to know it well. Although it was only made of cotton, it had turquoise blue bands running horizontally with green bands flowing down. Where they crossed, the little squares shone like porcelain tiles and as she moved they danced up and down.

I shall never forget our first tea of water biscuits with butter and raspberry jam — butter so heavily rationed at home, raspberry jam a luxury and biscuits almost unobtainable — and the most delicious fruit cake I had tasted for years. Tea was served in a beautiful china teapot, hand-painted in harmonious colours with little butterflies on a blue-green background. It gave me wonderful pleasure every time I looked at it. My husband had bought it at a Chinese shop before I arrived, together with the hand-made plates scattered upon the table, whose asymmetrical curves dipped pleasantly in unexpected places. They were not expensive but very artistic, each varying with the hand that had made it.

At that time, besides Mina, we had a Chinese couple. He did the cooking while she kept the house clean, spotlessly clean, and washed and ironed for the family. It was she who came in·with the tea, wearing a white high-necked jacket so stiff with starch that I wondered how she managed to turn her head, and wide black trousers which flapped about her legs as she walked barefoot across the room.

Margaret was soon down in the garden, climbing the frangipani trees, heavy with white fragrant blossom, rich little flowers, like Catherine wheels, succulent and highly scented. The small Chinese daughter followed after, her straight black fringe bobbing up and down as she wriggled along a horizontal branch, her legs dangling in the air, ready to spring dangerously near her little brothers playing in the grass below her.

That night I put on a long dress for dinner for the first time in years. My husband and I dined alone in our own home, which we had not done before. In all the years of war tinned pineapple had lingered as a

luxurious memory. Now fresh pineapple was served as a matter of course, followed by roast chicken and a delicious light, cold sweet, like a pale mountain of snow. I asked the Chinese cook to make it again, but it never afterwards tasted quite the same as on that first evening. Through all the open doors the stars in the night sky glittered, and the moon cast odd shadows on the lawn where the day's flowers were strewn. Catching the fragrance of frangipani I thought of Margaret, who had been kept on a rein for so long, and I knew with satisfaction that here she could have her freedom at last.

But this peace was not for long. Soon afterwards the Chinese left us. Still unaccustomed to the idea that other helpers were to be found, I saw myself back at the sink I had so gladly abandoned and, mindful of the new sweet leisure I had been enjoying lately, dreaded that I might be trapped again. Then Mina came to my rescue. She came eagerly, feeling perhaps how much more pleasant it would be to work with her own people than with someone I might find independently. Could she go and get two friends to work with her? The idea had not occurred to me and I gladly let her go, with a faint hope beginning to kindle. Too agitated to concentrate on any serious work I walked about upstairs putting things away, straightening cushions or doing other little jobs that did not need much attention. Finally I sat down to sew.

When Mina returned with her friends, the purple shadows of the hibiscus hedge were already creeping across the road. The warm rays of the declining sun caught the white jackets of Mina's two companions as they moved, so that they glittered and shimmered like mother of pearl. I did not need to see her face to know Mina's graceful gait, the rhythm of which I had already memorized for its sheer beauty. The taller woman beside her walked with an air of self-confidence lacking in the other, who hung back with her head slightly bowed. I stood on the top veranda watching their leisurely movements, then sat down again and took up my sewing as they approached the house.

A moment later they were under the porch. I could hear their soft voices and laughter down below. Soon Mina appeared to ask if they might come up. She was so excited at the prospect of working with her friends, instead of enduring her previous loneliness in the house with a couple who did not speak her language and whose food was so different that she had to eat by herself, that she was gone again almost before I had time to answer her. Waiting for them I listened. The nervous chat-

tering had ceased now. I could hear only their bare feet ascending the wooden stairs. How long a few moments can seem when one is waiting. I was new to all this. Would they never come up? Then all at once I heard Mina: 'This is Suppiah, she speaks English,' she said in her soft Malay. Raising my eyes I caught the little bob of her head, so characteristic of her when she wanted to be polite, coupled with a small reserved smile which just showed the one gold tooth of which she was so proud.

I saw in front of me a woman of between 30 and 40 years of age, with a clear direct gaze, or rather as direct as was possible with a growth on one lid which almost entirely hid her right eye. I noticed that her black hair brushed from her dark forehead was not straight like that of all the other Malay women I had seen, but crisp and wavy. The broad sensitive lips, more like an African's, had that same sense of sorrow lingering about them as the deep lines engraved from either side of her broad nostrils to her mouth. In spite of her disfigurement she was not unhandsome. There was a decisiveness and vigour in her voice and general demeanour to which I at once responded. All this, and much more, I became conscious of while we were exchanging courtesies. References? That there should be none dating from the period before the Japanese occupation of Malaya was understandable. Possession of even the most harmless notes of this nature had been dangerous, and if found they would have made the owner an object of suspicion, if not worse. What about the nine or ten months since the liberation then? She showed me a large scar on one foot, only recently healed, which might well have made her unable to work for some time. During the occupation she had worked for a Japanese doctor, but even so, I gathered, had not escaped entirely the want and privations of that period. However, I did not wish to talk of these matters just then and brought the conversation round to the subject that immediately concerned me. She could wash and iron and clean, and Supina could wash and iron too, she said, turning round towards her and dragging her forward. For a moment I had almost forgotten about the other one. Now she stood there, head bowed, playing with her fingers. I asked her one of two questions. She couldn't speak English. Could she cook? For answer she dropped her head a little lower and shyly wriggled her hips. She could clean? Yes. They both said they could clean, but I also wanted a cook. Could Suppiah cook? 'Only a little bit, my husband can,' she said. But hardly

were the words out of her mouth than she regretted them. 'Better take Supina on. Better women together,' she urged. But I liked the idea of having a married couple, it seemed more stable, more permanent. Perhaps they would grow fond of us, and faithful, and remain with us for years and years, and neither they nor we want to change. So my mind ran on and I returned to Suppiah's first suggestion, but all to no purpose, for she would not hear of it, making various excuses why the arrangement would not work until finally it was decided that I would try Supina and teach her to cook myself, and leave the house and laundry to Suppiah.

So, for some weeks I went to the kitchen regularly to teach Supina. Spoon in one hand, Malay dictionary in the other, I tried to demonstrate, while the patient Supina giggled and looked on and tried, and giggled, and tried again until dishes moderately palatable appeared upon our table. There were times when Supina would go off into peals of hysterical laughter for no apparent reason. Suppiah caught me looking at her, perhaps with a puzzled expression on my face, for she answered the question I had not asked: 'She is little bit funny today,' she explained, sniffing and nodding her head contemptuously. But while Suppiah dismissed what she did not understand with a wave of her brown hand, I puzzled about Supina long after the cooking lesson was over. She had a strange face, half man, half woman. There was something passionate about the curve of the broad nostrils, something in the lines of the mouth I did not understand. But she had a friendly eye and with it a sense of humour always in readiness. In spite of her occasional lapses into silliness she always tried very hard, and worked consistently. Eventually she became so loyal and cheerful that we almost forgot that she might have other sides to her character. She did a lot more for me than the cooking for which she was paid. She would pose as my model for hours on end in the most cramped and uncomfortable positions. She would rather have melted than move before I had given her leave to rest.

She lived in the room adjoining the kitchen. It was a bare room with one·window and door and a board in a corner for her to sleep on, which was supported by wooden posts about three feet from the floor. If she had any household possessions she did not keep them there, for I never saw anything more to make her comfortable than one round pillow. Sometimes her washing hung over a length of cord just below the

ceiling of her little room, trim white and pink jackets and pretty coloured sarongs, for Supina had good taste. She would iron them herself later when everyone else had finished their jobs for the day.

Suppiah slept at home and visited daily. It was our aim to have her sleeping on the premises, but it was some time before this was achieved. Lodgings in the overcrowded town were hard to obtain, and Suppiah had been fortunate to get a little house at a reasonable rent. She was naturally reluctant to abandon it, even to one of her relations, without first making certain that her work with us would be for long enough to make it worth her while to sublet it. Except when out of humour, she worked rapidly; by early afternoon she had got through twice as much as Mina did dawdling around all day. She used to arrive before eight while we sat at breakfast. On most days I would see her husband, Ahmad, dragging up the hill behind her. More often than not the men walked in front of their women folk, but Ahmad always followed Suppiah, peering inquisitively at us through the hedge. As Suppiah left the road and turned into our garden her spirit seemed to rise within her with a newborn happiness, for she liked working; she had been idle too long in her little house nursing that bad foot of hers. I enjoyed watching her working, for her movements were so leisurely and graceful. She changed from one charming attitude to another, sweeping the dust into tidy little heaps and all the time reminding me of some fine statue that had come to life.

One day she paused in the middle of her sweeping. Outside a happy bird sang in the bright blue sky. Suppiah's face was grave and her eyes were very far away. 'I don't want that husband,' she burst out suddenly and, as she spoke, half turned her head away. For a moment I hesitated, still linked with the bird's song, then broke the link and asked her, 'Why did you marry him?' 'My mother give him to me,' she replied, turning her sad eyes to mine again: 'My mother make me marry him — before, I married 14 years. I very happy — Japanese come — he die.' Her sentence closed softly like the last sound of a train disappearing into the distance. I dared not look at her eyes.

'Who is that quiet little man who is hanging round the kitchen today?' I asked, feeling the need to change the subject. 'That is Supina's husband. She not happy.' 'Does he live here?' I asked. 'He work other place,' she replied. 'He come here one time each two weeks.' 'I see,' I said. But I did not see. As I walked away to find Mina

6

my mind ran on regarding these two unhappy women whose lives for the moment touched ours, yet I knew I could do nothing for them.

At the bottom of the stairs I came across Mina's slippers, bright blue and cracked where the shiny paint had chipped off showing brown veins of leather underneath. Often there were several pairs there in the mornings. They were all of the some simple pattern: two straps across the toes stitched to the sole. I knew them all — Mina's down on one side, Suppiah's brown and neat, tidily placed where nobody could trip over them, Supina's black and polished, never in the same place for two days running.

Actually Mina was not in the house, but in the garden, where she had gone without bothering to put her shoes on again. There I found her dreaming in one of her beautiful poses: all her weight resting on one foot, pushing her hip out into a smooth round curve. The heel of her other foot was placed on the arch of the first one, her toes pointing outwards like a dancer resting. She stood staring into the distance. Then suddenly her daydream lifted; she was aroused by the noise of children in the road. Going to the edge of the garden where she could watch their play, she plucked a red Ixora flower from the bush growing there and pushed it behind the low knot of hair she had coiled in the nape of her neck. The Malay name for this flower is *pechah periok* or 'broken vessel,' perhaps because its crown of petals resembled a broken shard. Somehow the name seemed disturbingly apt. Mina was an orphan and had been married very young in Java. Although she was only fifteen when we found her and gave her her first job, her husband had already left her and she had made her way to Malaya with an uncle and his family.

I stood there bewitched by the beauty of her pose. 'Mina,' I called, feeling my voice had already betrayed my eagerness. 'Tania is asleep. I want you upstairs.'

She was a bewitching model of whom I never grew tired. I often used to draw her in the mornings when the baby was asleep, sometimes with her heavy hair let loose, hanging in black coils below her waist. Today she had it neatly parted and brushed back behind her small ears. I could see the large gilt earrings swinging slightly as she swayed backwards and forwards. She hated sitting and never sat well. Sometimes she nearly fell asleep while I worked hard on a piece of drapery or hair which was not affected by her mood. Or else she sulked, and her lower

lip pouting lost its enigmatic expression. Moods, yes, passed over her carven face, but despite her sad childhood orphaned of father and mother and the hunger and poverty she had known in recent years since the collapse of her marriage, there was no suffering in Mina's young face, not one line to reveal her story.

After some while I put down my pencil, told Mina she could go and, wandering about the room, fell to thinking about Suppiah again. It must have been the long sorrow in her heart that had engraved so deeply those lines from nose to mouth that I had observed when Mina brought her to our house. The first choice by her parents had been a lucky one. Bereft of her beloved, Suppiah, against her will, had married again. Now that she had plainly told me that she did not want this second husband her parents had found for her I was interested to know more.

2

Suppiah and Ahmad

Next day I saw Suppiah's husband, hanging behind her as usual, carrying a bunch of bright red dahlias, warm and glowing, in vivid contrast to his jet black hair. He wore it too long and his nervous fingers were constantly running through it, pushing it back from his round high forehead, where it would fall again a moment later. As I was on my way to the kitchen to give Supina her daily cooking lesson, he intercepted me and engaged me in polite conversation, in clear but halting English. How charming my children were. Wasn't I young. It was nice for Suppiah to work here. He gave me the bouquet saying: 'Tomorrow I bring you a much better one. I have a Chinese friend with a big, big garden.' I already knew that he 'did' for a bachelor in the barracks nearby and apparently had almost limitless leisure in which to visit our house, but I was mildly surprised that he should have prosperous Chinese acquaintances to supply him with flowers. He turned round and, glancing scornfully at Supina's back inside the kitchen, continued quickly, 'I want to work here too.' I thanked him profusely for the bouquet, regretted very much I had all the help I required (and more than I could afford I might have added), but promised to do what I could. Perhaps I might hear of one of my friends needing help nearby.

After the confidence given me by Suppiah I must consult her first, I thought, before finding him a job anywhere near our house. She had felt the need to get away, for part of the day at any rate, from an atmosphere that oppressed her, and now, like a bird with clipped wings hopping about an open cage, she had come to me. Perhaps she knew she could never be entirely free, for, having told her of my conversation with her husband, I found her resigned. 'My bad fate,' she said, raising her hands and letting them fall heavily to her sides. She was teaching

9

Mina how to bath the baby. Mina, lazy about everything, stood sullenly by, supposedly looking on, but actually occupied with some far-off thoughts of her own. Suppiah had known Mina ever since she came to Malaya and had fed her in bad times when she was nearly starving. All the effort came from Suppiah, vivacious, observant and loving every minute of her time with Tania. 'Like this,' Suppiah said, brushing the wisp of hair and tying it with a fine ribbon from my sewing box. Not only had Suppiah initiative but she knew when and where to take a liberty. Looking at Tania's amused and pleased little face, it was impossible to scold her for stealing my best ribbon. Mina looked on wearily, her eyes staring into the distance, her mind far away. Perhaps she yearned for a baby of her own. She was always at her best with children.

Tania was still looking thin and pale from a recent illness and Mina had been brought into the house temporarily to sleep in my room. She slept in her clothes on a couch at the bottom of my bed, her black hair let loose, hanging like a mantle round her face. When she rose in the half-lit room her eyes had a lamp-like quality. Her patience was endless. We took our watch in turns, hour by hour, rocking Tania in our arms, for she was continually restless and seemed soothed only by movement and a lullaby. Mina could croon rhythmically and with a sweet simplicity. Like Ravel's *Bolero*, there was a barbaric attraction in the monotony of her chanting, and this appealed to the child's restless little mind, which seemed to want nothing more than the feeling of journeying on. Mina crooned tirelessly until it was my turn to take over. I found it an effort to chant monotonously on and on. My throat was dry and the mosquitoes biting my feet deprived me of any inclination to sing. When at last my watch was up I listened to Mina's steady breathing and saw how heavily she slept, but could not resist tapping her on the shoulder to wake her. She jumped up willingly, never complaining or grumbling, or suggesting with a word or even a gesture how tired she was. This I remembered now as I watched her weary eye wander towards the window.

But at this moment I heard Margaret's voice downstairs calling, 'Mummy! May we have something to eat?' So, leaving Mina to gossip with Suppiah, I went downstairs to find bread and cheese for Margaret and her clan who were playing in the garden. Salem, her favourite companion, was turning somersaults. His father was the driver next

door, a Boianese whose upright carriage gave one the impression he was tall. When he smiled, showing a row of exquisite white teeth, his eyes remained dreamy. There was a great deal of sorrow in his face, which may have come from the Japanese occupation. As I heard their individual stories, I came more and more to realize how much ordinary men and women had suffered during that period. Salem's mother looked over the hibiscus hedge and smiled proudly at her son, whose black hair stuck out in all directions as he went over and over. Although she was smiling there was no vivacity about her face. Dark rings under her brown eyes gave her an appearance of ill health. She was a pure Malay with a large dome-like forehead. The Malay style of hairdressing, brushing the hair straight back and tying it in a bun at the nape of the neck made her high forehead look even higher, and gave her face a rather quaint appearance. She carried herself with a poise and elegance unusual even among the graceful Malays, and wore beautiful transparent jackets covered in different-coloured flowers, which caught the light as her curves rose and were lost in shadow as they fell again. This constant coming and going, this rhythm of light and shade, were things I never grew tired of watching, here in this land of abundant sunshine and white and coloured costumes and dappled shadows. But I never really got to know Salem's mother. She was reserved and seldom came over our side of the hedge. Watching her standing among the red hibiscus flowers, shining like lighted paper lanterns through the green hedge, I knew her only as someone who was beautiful and dainty and rather remote.

Besides Salem, she had a daughter called Mila, who lived with her grandmother in a house more conveniently situated to her school. When Mila visited her parents she always came to see me, asking pertinent questions about women's clothes and hairdressing. She was unusually grown-up for her age, even allowing for the fact that Malay children mature much more rapidly than Europeans. She had great charm and a most attractive enthusiasm for life. When she came, she ran across the garden, a row of bangles jingling on her arm, smiling, as lovely as an open flower. Her straight black hair, cut to her shoulders, trailed in long untidy strands behind her.

Salem's mother glided beyond the hedge and disappeared round the corner that led to her room. I distributed the bread and cheese between Margaret and Salem and some other children who lived near Salem in

one of the rooms of the block that faced our neighbour's house. This family consisted of father and mother and three small boys. The father was the gardener next door, a tired wizened little man who melted into the background as he worked, as far from the house as he could. Poverty had aged him before his time. He did not thank Allah for his three children whose mouths continually needed feeding and whose bodies required a little clothing now and again when the rains fell, or they grew big enough for school. He wore a pair of ancient khaki shorts and shirt, both green with age, and an old felt hat of the some colour, onto the brim of which dropped the grass cuttings as his arm swung round and round. Bringing his arm down too rapidly he lost the natural impetus of his stroke, and the grass flew in all directions leaving the earth bare and patchy. I often wondered what his wife saw in him. Probably this was another marriage arranged by parental authority. Enchanting as a picture, when she tilted her head I was reminded of a portrait of a gypsy by Augustus John, black hair flying from warm cheeks, wild and wispy. She did not try to grapple with life, but took it as it came, bleak and bare, careless of present comfort or future security. With a lazy nonchalance that seemed almost enviable she slopped along the road noisily in her wooden shoes as she took her son Leman to school, the other small boy Nasib hanging onto the folds of her sarong, while the third boy, a baby, bounced up and down in the hammock of cloth she slung across her back. All the Malay women carried their babies this way. It was a very practical method as it left their arms free to work and eased the weight of the child, who soon feels heavy in one's arms.

Leman and Nasib were old enough to join in a game with Margaret, though Nasib was only three. His idea of a somersault was rolling sideways over the grass, but as long as he could join the others he was happy. Nasib had a sweet, attractive, dreamy little face and pursed his lips in a most engaging manner before he smiled, as though he were too shy to smile directly. His straight black fringe slid round his forehead almost level with the top of his large round bewildered eyes, eyes that looked out always in wonder, frightened eyes, lost and appealing. I should have liked to have made friends with him, but he always ran away. In our family only Margaret gained his confidence. He would go to her of his own accord. Being young, she had a natural sympathy with these people, born of simple friendliness. No barriers in her child world

barred friendship anywhere; no false conventions prohibited the giving of an overflowing love.

Leman was less interesting than Nasib though nearer Margaret's age. He had neither Salem's good manners nor his gaiety of heart, but he had a most charming way of protecting his two little brothers. Just now he and the other children bent over their bread and cheese like Beatrix Potter's mice, nibbling rapidly as though frightened of being caught. Leman and Nasib soon finished and ran back to their room.

At that time I was teaching Margaret myself. Salem came upstairs to join in her lessons. What he lacked in knowledge of English, he made up in attentiveness; and when he was attentive it was an inducement to Margaret to take pains, so I was glad to have him. However short the lesson it was too long for Margaret, who wanted to be out in the garden again as soon as possible and was impatient when Salem hung behind asking questions, eager to learn more. He had been her playmate for some time now. A concrete slide between the house and the kitchen gave them a common bond long before there was a common language. Margaret, rather fond of her own way, cried when she did not get it. Salem mimicked her so accurately that her pouting lips burst into a smile, however hard she tried to keep it back, and, brushing away her tears and yellow hair falling in her eyes, she started off down the slide cheerful and happy again, with Salem close behind her crying 'Pip! Pip!' like an English boy playing trains.

Then, tired of sliding, they climbed trees. Scorning the safe frangipani, they preferred now a tree that overhung a steep high bank, and had the additional attraction of edible fruit. I hated to see them trying to reach the top boughs, bending and shaking beyond the bank, and never felt really at ease until they were on the ground again, with enough fruit bulging in their pockets to make another excursion up the tree unnecessary. All the Malays were very fond of this sour yellow-green little fruit. Margaret ate hers with them, loving every minute she was in the company of this wonderful race, who climbed trees when adults, told ghost stories, ate with their fingers and sat on the floor. 'Mummy, why don't we?' was a question she often asked and sometimes it was hard to think of a reason for why we didn't. I loved watching the Malay women climbing this tree regardless of the yards of material clinging round their legs. Mina was often to be found there giggling like a schoolgirl caught at some prank. I thought with amusement how

strange women with a family at home would have thought it to see their nursemaid up a tree.

Margaret threw a couple of the hard little fruits to Suppiah and Supina, sitting in the grass below her. They sat there gnawing and talking. Something had come out in connection with Supina the other day. I understood now the link which bound them as friends despite the disputes which often arose between them. Before her present marriage Supina had been married to a younger brother of Ahmad, Suppiah's husband, but quarrelled so violently with him that he became frightened and divorced her. So together they sat giving vent to their feelings in cruel and vivid criticisms, while they talked of the two brothers, whose lives had been passed in strife and discord with their wives.

When they arose the sun had already gone down. Supina returned to the kitchen to prepare for the coming meal. By this time she could do most of it herself; I only had to give her directions. I found she was not altogether reliable as she was subject to attacks of what she called her head going round and round, and was sometimes doubled up, as though in spasmodic pain.

Finding her in this state one morning I told her to go to her room, saying that I would do the cooking. But that afternoon I happened to catch sight of her, dressed in her best, a colourful pink jacket, a black and white sarong, with darkened eyes and reddened lips, tripping down the road on the way to town. 'If you are too ill to work, you are too ill to go out,' I called, going angrily towards her. She stopped suddenly like a scared animal and as we faced each other I met her eyes, eyes which at that moment were glowing with fire and hatred. She turned round and walked slowly back to her room. I thought of all the stories of running amok I had heard from people who had lived for many years in the country and knew the ways of its people.

Later that evening when I was standing on the veranda and looking out across the trees I saw a tall Malay approaching, a sturdy fellow with a shock of hair. Anyone who climbed our hill must have business with either us or our neighbours, for there were no other houses there. So I asked my husband to watch where he went and it was to Supina's room.

But Supina's indiscretions, if any there were, must soon come to an end, I thought, or else be more carefully concealed, for the back of our house was filling up. Only yesterday I had met my neighbour over the hibiscus hedge which separated the two gardens. After talking of this

14

and that she mentioned that her cook was leaving. I thought at once of my conversation with Ahmad and said: 'I think I can help you. Would you be prepared to take a Malay?' Most Europeans had Chinese cooks whose cooking was, one had to admit, very much better. But she replied enthusiastically, and it was arranged that Ahmad should call next door. He made an excellent impression, as indeed he could when it suited him, and was taken on immediately. This turned the scale in the matter of where Suppiah should live, miserably resigned as she was to this second marriage. I did not see them arrive though I was vaguely aware of a host of friends and relatives at the back, helping them move in. Needless to say, I was heartily pleased with the new arrangement, and felt that we had at last recovered the stability in our domestic life which had been broken by the departure of the Chinese.

3
Zeida and Others

A dancer, conscious of her body, takes up an attitude to express a particular emotion. The girl I saw picking up the pegs that had fallen from the washing, glittering like swans' wings on a dark river, moved in my garden harmoniously, with as much expression as a dancer, but unconscious of it. To an observant eye, a body, like a face, can be a useful guide to character. The rhythm in the lines of this bending figure, enhanced by its Malay costume, attracted me. But where did she come from? Who had asked her to hang out my washing? She straightened up and began to move towards the kitchen, but seeing me she slipped behind a wooden post. I smiled; it was much too narrow. A little reassured, she smiled back. Now I had an opportunity to observe some details. She was not well dressed. Her jacket was far too tight and stretched uncomfortably around her. Her sarong was torn and shabby. But her face was beautiful, with the loveliness that lies in expression and not in features. Her skin was dark, making all the more effective the contrast with her eyes; they shone as bright as stars and were framed by lashes that rolled back like the petals of a flower. She was without question very lovely. I heard Suppiah's voice beside me, saying, 'That is Zeida, my adopted daughter. I have no children of my own.' Suppiah had come through the kitchen, treading softly across the red-tiled floor and, until she spoke, I had not known she was there.

She had surprised me in this manner before. The Malays and Javanese moved without noise or haste. An occasional clash of china as plates came together, or the beating of a fork on the bottom of a bowl were my only clues to Supina's activities. The rest was silence. It was pleasant living quietly in this atmosphere of peace.

Suppiah told me that she had adopted Zeida before she married Ahmad, and had naturally taken her to their new home. Her father was

16

from northern India and her mother was a Malay. Suppiah delighted in her, and even Ahmad was proud of her, though it would have been quite improper for him to have admitted it after becoming her relative. The qualities of an unmarried girl must, by custom, speak for themselves. But the fact remained for all to see, she was a model daughter.

Suppiah, who had trained her well, had every reason to be proud. Zeida was always the first to leave their room, lighting the charcoal while the moon still hung lingering in the sky. The meal was cooked and ready before Ahmad or Suppiah had begun to stir.

On hot afternoons, when they often slept or lounged in the shadow of the trees, she squatted outside their doorway washing up the dishes from the midday meal. Sometimes she sang, dipping the dishes into a bucket of rainwater, running her supple hands round their rims. After making quite certain that they were clean, she placed them carefully on the concrete slab against the wall where they glistened in the sun. I had the feeling that she did her work well for the simple pleasure of it and without thought of reward or for the future. She did not know that from an upper window I stood watching her, admiring her natural integrity. Soon she was working in our house too. 'I like to train her a little,' Suppiah said. But I did not approve. I felt too much had already been placed on Zeida's willing shoulders. Young and strong as she was, there were limits to what she could do, even with the best intentions. But it was difficult to intervene. I could not complain without implying that Suppiah should do more herself. She worked very well when in the mood and would have been quick to resent my interference. So I did not interfere and Zeida moved about the house doing whatever work Suppiah allotted to her. I too was to blame for upsetting the routine when I asked one of them to pose as my model instead of cleaning the house. Then I became responsible for the cobwebs that collected. But I always got Suppiah's permission before asking Zeida to sit, so that she would not be blamed for any work left undone. Zeida posed very well, being naturally reflective, but in spite of this I never felt I quite did her justice. Drawing portraits brings constant surprises. The most unexpected people make good models. Others who bewitch one with their charm in the flesh, might appear on paper with a forehead too low, or a nose too broad, or some other feature that attracts too much attention to itself. In Zeida's face the balance of features seemed almost perfect, and yet I never quite succeeded in capturing her beauty in any of the

17

many drawings I made of her.

In this way, I relieved Zeida of some of the work put upon her. Margaret too delighted in her as a playmate. Sometimes I asked Suppiah if Zeida could be spared to join her. Being sweet and imaginative and kind-hearted, Zeida entered wholeheartedly into the spirit of these games, just like a child herself. She was, after all, only fifteen. They played at hairdressers, Zeida plaiting Margaret's fair hair in all sorts of styles with different coloured ribbons. Or together they lay on their tummies with bits of puzzle scattered about the floor. Zeida of course always did most of it, being older and more poised than excitable Margaret.

Sometimes they sang before Margaret went to bed. The sun, beginning to set, shone with a warm glow over everything. Ahmad, his work finished next door, brought out his guitar and strummed an accompaniment. Mina also joined in. Margaret tried her hardest to imitate these two girls, whose singing, though harsh and shrill, was so happy. The first time I heard them I was surprised and disappointed, for their speech was attractive and soft and flowed with a certain melody. But my husband and I listened attentively, for if their song was not beautiful, their gaiety was so infectious that we could not tear ourselves away.

Mina and Zeida were close friends. I often saw them squatting together over the baby's washing. Mina alone was responsible for this, but she was always willing to accept help when she could get it. Suppiah and Zeida both spoilt her in this respect. There was something so likeable about Mina, that even when she slacked one of the others nearly always did her work for her. I watched them rubbing the clothes on the cement slab that connected the home and kitchen. The kitchen was built apart from the house, a practical arrangement in a hot country where doors are often replaced by shutters, which would not keep out the smell of cooking. Zeida did most of the washing while Mina chattered merrily. She loved talking to her friends, but was more reserved with me than any of the others. Mina and Zeida made an attractive pair — pretty figures beside zinc buckets full of water, which reflected the colours of the various garments as they dipped them in and out. Beyond them, the garden stretched away, green and dewy in the early morning. Gauguin would have enjoyed such a scene, making from it a pattern of colour contrasts and tone. As their brown hands rubbed the linen against the hard grey slabs, I knew it would not last very long that

18

way and showed Mina how to wash it in the hand basin upstairs. She followed my instructions once or twice, but as soon as my back was turned she was downstairs again, squatting outside the kitchen, chattering to her friends.

It was no good. I began by thinking I could get them to change their ways but had to admit defeat. They would smile pleasantly, but after a few days, unless I went to a great deal of trouble to keep them to it, they would slip back into their own comfortable ways of doing things, more or less adequately but not entirely satisfactorily. Besides which, I could never be sure that, like Mina with the washing, they were not doing it 'my way' when I was looking and 'their way' behind my back. She knew all the tricks. She lied when she thought she could get away with it. And not only Mina: few of them told the whole truth. They did not seem to take lying as seriously as we did. They played it like a game. If I found out, I won. If I did not, well, they were one up. I grew never to believe what they said until I had confirmed its truth. If there was anything I particularly wanted to know, I never asked a direct question; I waited, went round it, observed, and in the end it usually slipped out.

During the washing sessions I used to observe the various styles of hairdressing Mina and Zeida favoured. Abandoning the orthodox style, which so admirably suited the Malay head, they tried endless variations of Western styles they had seen at the cinema or in the pages of a magazine. Sometimes East and West did not meet at all happily, as in an ugly arrangement of two little plaits dangling in mid-air with knots at the end and cheap coloured slides on either side. They tried everything from rolls on top of the head to a roll so low down on the neck that it had to be held in a fish net. Mina had beautiful hair, shining and silky, as soft as the fur of a cat. I hoped one day she would go back to her own custom of wearing a large bun attractively coiled at the back of her head. While they followed traditional lines their taste was unerring; in borrowing alien ideas they were less successful, appearing to lose the ability to discriminate between what looked good and what was vulgar. I was horrified one day, when Ahmad proudly produced a photograph of his brother's wedding, to see the bride and bridegroom in cheap European clothes. I had once been to a Malay wedding and had been charmed by the bridal costumes; now I could hardly bring myself to say something polite about the photograph Ahmad dangled before my eyes.

My mind went back to that other wedding, the details of which I still clearly remembered, for it had been a vivid experience. When we arrived, on time, the ceremony had not begun; the door of the bride's house was still closed. Children were peeping through the cracks to get a glimpse of her as she prepared for the arrival of her groom. How fast her heart beat as the attendants nervously arranged her hair! It was not surprising that she was in such a state of agitation. She had not yet seen the man to whom she would that day, irrevocably, so far as she was concerned, be wedded. The marriage had, by custom, been arranged between the bridegroom and her parents, and the bride had been brought up to accept her parents' choice without question.

An old woman with smiling eyes placed the heavy jewelled head-dress on the bride's head. Perhaps she was thinking of her own wedding so many years ago. Her fate had been a lucky one, for she had grown to love her husband and had been happy. As she put the last touches to the bride's appearance, she nodded her old head approvingly. It was draped in a fine black net; like everyone else she had put on her party clothes that day.

From the far end of the lane came the sounds of beating drums and tambourines. Louder and louder the music grew as the bridegroom advanced. He was magnificently dressed in a scarlet velvet coat and apple green breeches. Gold bands and flowing crimson silk hung decoratively, like necklaces, down to his waist and below it. His gold and silver turban, ornamented with multicoloured jewels, glittered as he walked, eyes cast down, carrying a little bunch of purple flowers. I wondered if all this splendour was real, or only imitation, for they were not Raja Malays taking part but simple people, like Ahmad and his brother. If all the finery was genuine, it must have been hired for the occasion. At any rate, from a distance, it looked extremely effective and created the right impression.

The guests had gathered into a large crowd. All heads turned towards the bridegroom, full of subdued excitement now that the ceremony had really begun.

The bridegroom advanced to the closed gate several yards from the bride's door. He and his companions took part in a mock battle, the people of the house pretending to resist his entry into the bride's apartment, as was the custom of the ceremony. When he reached the threshold an old woman good humouredly waved her fist at him. There

were roars of laughter as this last line of defence was overcome and the doors of the room were opened for the bridegroom to join his bride.

They sat side by side, eyes down, no look, no smile, no word of recognition to each other, or greeting to the curious crowd. Like two statues of bygone days they sat motionless amongst the scent of numerous flowers and the rustling of flowing draperies and the admiration of their friends.

Zeida's wedding was still far off. One day she would have to face it, but in the meanwhile her youthful fancies could roam at will. In her own corner of Ahmad's and Suppiah's room she had pinned or pasted up every kind of film star or bathing beauty she could find in the illustrated magazines that occasionally appeared in our house. One day, to my surprise, among these pin-up girls I came across a photograph of my father-in-law and mother-in-law with their family. It seemed familiar and, on looking at it more closely, I saw that it was the family group Margaret had been looking at only the day before. I supposed it had accidentally found its way into the wastepaper basket, from which Suppiah had retrieved it and added it to Zeida's collection, though none of the members of the group were people she knew. That did not matter: they were all members of my husband's clan and it was as natural for her to take an interest in them as to expect us to be interested in the affairs of her relations. And what a lovely family they were! As they came to visit her in turn I got to know them all.

4

Peah and her Family

Peah, Suppiah's mother, was an unusual character. I often wondered how someone with her experience of the world could have insisted on this second marriage for her daughter. I had been told that after a first marriage a woman is free, by custom, to marry whom she pleases. Suppiah had a powerful personality, but when I met her mother I was not entirely surprised that she found it impossible to resist her wishes. Peah liked Ahmad and, having selected him for a son-in-law, managed to persuade her daughter to marry him. Suppiah obeyed her mother's wish to enter this second marriage, but failed to find any happiness in it.

Peah herself had been married four times. Her first husband, a Javanese, was Suppiah's father. Peah was a Malay and Suppiah was born in Singapore. The marriage did not last very long. After her divorce she married a Tamil from southern India. She then left Singapore to visit his relations in Madras, where she remained, living with them, for over a year. Asmah was born on her return. Of all the family, as I became acquainted with them, Asmah was my favourite.

On her visits to Suppiah, Peah would sometimes bring a young Indian woman with her. She was the daughter of her second husband's brother and her name was Letchumy. She was a lovely tall woman with large dark eyes and jet black hair that fell a long way below her waist. Where the light fell on it, it turned pale blue. Once or twice Letchumy stayed the night. She was nineteen and married to an Indian cook who worked in the barracks nearby. They had a baby girl who was just learning to walk. The child fell sick one evening and I was called in to give advice. Finally, after much argument, it was decided that the child should go to hospital. We all went, Letchumy, the baby Selverani, and I. When we left the hospital I had some trouble tearing Letchumy away.

She cried ceaselessly all the way home. The next day her father and mother turned up. When they heard where I had taken the baby a fearful family row in fluent Tamil ensued. I almost regretted my efforts to help these people who believed that hospitals were places where people were only taken to die.

Fortunately they were not all like this. The younger generation was begining to learn the value of trained doctors and nurses, while the older generation still clung to its traditional remedies. Ahmad himself was a great advocate of education and progress, but I think that in his heart he still preferred his mother's and his own mixtures to medicine from the hospital. Suppiah, on the other hand, was more ready to accept change and, had she been given the opportunity earlier in life, would have picked up a great deal more about hygiene and European methods.

Peah's third husband was a Chinese from Hainan. It was rather unusual for Malays to intermarry with the Chinese. She married him soon after she lost her Indian husband, whose baby was yet unborn. Asmah told me that he was incurably deaf and perhaps that was why they separated. It was always Asmah who gave me these little confidences. Suppiah told me very little gossip about her own family, although she was always ready to talk about other people's.

Peah's present husband was a Malay called Yussuf, a dear old man of some 70 years. But he did not look it. A philosophical mind and easy going outlook on life had preserved in him a certain youthfulness, so that even now his face was not very lined. On special occasions he still wore the very old style of headdress, which had given way to the black velvet cap, and very effective it looked. It was made of hand woven or printed cloth, often in very beautiful colours, twisted into a rather fascinating shape — not exactly a turban and not exactly a toque.

Another interesting headdress seen in Singapore was worn by the Cantonese 'coolie' women, as they used to be called. It was fashioned from bright red cloth, folded and standing out from the head just as Holbein's 'Unknown Woman' might have worn it, or a sister of an order of nuns. It was cleverly put together, being pinned in only one place, and must have been primed with a great deal of starch to keep its shape. Part of it fitted to the head and part of it stood away at an angle, like a sail stands away from the mast in a stiff breeze. It was said to have been first worn by the mistress of a famous poet in a certain district of China. If she had been pretty, she must have been irresistible

in it, for it was without question a most attractive fashion. Eventually it became worn by all the women in the province in which she had lived. When some of them emigrated to Malaya, they brought this delightful headdress with them. A Chinese peasant woman working on a building site or bending in a field, with her brown weather-beaten skin under a scarlet cloth, dressed in a high-necked coat of Prussian blue and a pair of cotton trousers of the same colour, was an invitation to any artist. But these simple people were difficult to get as models. Primitive, hard-working and thrifty as they were, they could hardly be bribed to pose for a photograph, let alone to sit as models.

Peah had an old-fashioned respect for Europeans and was quick to borrow our ideas when they suited her. Altogether she was a fascinating and attractive person, and very loveable. I personally found it almost impossible not to forgive her for everything, except perhaps for having forced Suppiah's marriage on her, for I was also very fond of Suppiah.

Suppiah had a mentally defective sister who once or twice came to visit us. I was never at ease with her. She had a film over her eyes and smiled vacantly. She had a rather repellent, uncertain personality; I felt she might do anything from kissing to killing, as her mood inclined. I was always glad when she went away, but I could not explain all this to Suppiah.

One of Peah's sons had died during the Japanese occupation. His widow, Romala, often came to see Suppiah, for she was lonely and fond of her sister-in-law. Sometimes she did the cooking to relieve Zeida and, like Letchumy, she often stayed the night. It was lucky that all the relatives and in-laws did not come at the same time, as the one room in which Ahmad and Suppiah slept was not very large and, with Zeida permanently residing there, was already quite crowded. However, they thought nothing of putting up the odd guest or two in their one and only room. Where there was floor space, however small, there was hospitality. Romala was a good-natured girl and always willing to help Suppiah with her sewing. Suppiah sewed very well but the obstruction on one eye was a great handicap to her.

Suppiah had another sister, who became a source of delight to us all. She was always known as the fat sister. It was Suppiah who first gave her that name and we never knew her by any other. 'She is a pretty girl,' I said aside to Suppiah. 'Too fat,' she replied out loud and, turning round to look at her, passed some very personal remarks. But the fat

sister took no offence; they were used to giving and receiving personal criticisms. In this as in many other ways they were like children, who say to each other, 'Go away' and 'I hate you,' and five minutes later have forgotten all about it and are playing together as if nothing had happened. Fat she undoubtedly was — it was a flabby unhealthy fatness — but she had beautiful dark friendly eyes and her skin was lighter and clearer than Suppiah's. I can still see her sweet smile breaking out rather wistfully, trying to hide the fact that she was not entirely happy. She had become resigned without growing bitter, and had a kind and good face. Like Zeida and Mina, she enjoyed changing hair styles and sometimes wore a heavy plait across the top of her head which, with her resigned smile, gave her an angelic appearance, in spite of her size. She had lost one baby (it was stillborn) and was proceeding with another when I first saw her. She had beautiful hands, but bit her nails like all the Malay women in our household. I cannot remember a pair of Malay hands without dumpy nails. The hands themselves, especially those of the young girls, were graceful and supple and one instantly associated their beautiful brown curves with the art of dancing, which is so highly developed among Asian peoples. The fat sister made us paper flowers, which she gave as gifts at Christmas and on the children's birthdays. Of their kind they were perfect. Watching her deftly twist the petals so that the paper became flowers before our eyes made me think how well she might have learnt another craft if she had had the opportunity.

Her husband was very tall for a Malay. He was also extremely good-looking and, like most Malays, had perfect manners. Before the war he had been in the navy. I had no idea what he was doing now, but he seemed to have plenty of spare time and we frequently met the pair of them with the others at the back of our house.

We had got into the habit of visiting Suppiah's room in the evenings, when they all congregated there. Leaving our shoes at the open door before entering, according to their custom, we joined the family circle on the floor. At first it was not very pleasant, as the window was shut and we were obliged to sit in a stuffy atmosphere. When we pointed out the virtue of fresh air Suppiah, who was by nature very touchy, defended herself, making excuses, explaining that they were afraid of thieves and that the room was overlooked by anyone walking along the path at the back. This was true, but she must have given the matter further

thought, for one evening we found the window wide open. She had made a curtain from a bit of cloth I had thrown away two of three days earlier. The warm night air was much more agreeable than the breath of eight or ten Malays, so we sat enjoying ourselves as we had not done before. I wondered if they thought it an improvement. After that the window remained open even when we were not expected. Suppiah prided herself on her modern outlook.

During these evening visits the younger unmarried members of the family remained outside with their friends until they were invited to come in. One evening when we had settled down, during a lull in the conversation we heard stifled laughter outside, which we recognized as coming from Mina and Zeida. We were always attracted by the gaiety of these two young girls and we asked if they might be allowed to join us. They were not far away and must have heard what we said as our suggestion caused them even greater mirth. Finally Mina was dragged in by Zeida, Mina protesting and giggling in an old discarded pair of my husband's khaki trousers. She was full of fun and a little bold, even among her own people. Malays generally seemed so modest, but we could never tell what went on behind the closed door once we had said goodnight and retired. I expect other personalities emerged which never revealed themselves to me in the ordinary intercourse of the day.

Suppiah's room was the first of a line of four, two of which faced our neighbour's house. One of these was occupied by Salem and his mother and father, and the other by the gardener and his wife and three children, to whom the reader has already been introduced. Abbas (our gardener, who was unmarried) was next to Suppiah, Ahmad and Zeida, in the second of the two rooms that faced our way. Suppiah's room was undoubtedly the best, for it was well above ground level and the pathway outside formed a vantage point, where she would sit, often with Tania in her lap. Zeida, preparing rice nearby, handed Tania a grain or two to throw to the baby chickens chirping and hopping round her small feet. Bending forward, her little hands closed round one of them. She picked it up, laughed triumphantly, looked at it and let it go. Suppiah purred like a mother cat watching her kittens, keeping an eye on all that was going on — my excursions to the kitchen, the comings and goings next door and the fish vendor coming up the drive. To make things more convenient for her he kept his account chalked up on the wall outside her door, so that while others might have to bestir

themselves, she could sit still to do her marketing.

There was a small recess inside the door, where pots and pans were kept and the cooking was done, then go up one step and through another door into their room, which was scantily furnished. In one corner, pushed against the wall, was their bed. It consisted of a large mattress made up with an old but clean sheet and piled high with cushions. Some of these were elaborately decorated with frills and lace, worn but cherished relics of Suppiah's former home. I wondered where Zeida slept. Apart from the mattress there was only a little mat. I supose that this, with a pillow, was for her.

At our evening meetings we discussed the small affairs of the day. They talked without restraint about everything. Their conversation was never vulgar, but covered topics that would have been regarded as improper for discussion in English society. Although everything was said naively and naturally, I sometimes wondered if Margaret might be picking up biological facts a little too early. I was therefore glad to be able to keep an eye on her for most of the time. Although Suppiah was outwardly placid she was crude. I could perceive a depth of passion beneath the surface, which I hoped would never be revealed to the children.

Sometimes the conversation turned to marriage, not unnaturally in view of Zeida's age and eligibility. Ahmad would pretend that a marriage was to be arranged between Zeida and Abbas, our uncouth Javanese gardener. Immensely pleased with himself, he sniggered at the suggestion. He and Suppiah derived great pleasure from this cruel joke, a sadistic pleasure for Suppiah, a jealous one for Ahmad. It was a horrid subject and one I did my best to discourage. Actually I knew that such a match was never in question; they despised Abbas, not only for his uncouthness but also for some difference in social status, which was important to them but which I never understood. When they despised someone they were cruel and sarcastic and laughed scornfully at that person's expense.

But marriage was a dangerous topic, for Suppiah was liable to lead the conversation round to her first husband, whose faded photograph would then be produced. We knew this was a danger sign and grew uncomfortable. Ah! Her first husband had been a real man! She would speak disparagingly of Ahmad, openly before all of us, himself included, and within the hearing of Mina and Zeida outside the door.

27

Ahmad hung his head in shame. On such occasions I felt nothing but pity for him, whereas at other times he wearied and sickened me with his vain boasting. He was, he would say, a musician, a barber, a doctor among his own kin, a fortune-teller and an interpreter of dreams. I had heard his music, halting strains from a couple of strings, and all his other attainments were of much the same standard. He only boasted of them to win some praise, however spurious, to help him recover the self-confidence Suppiah had so ruthlessly shattered in one of her diatribes against him. Had she loved him, he would have found peace and there would have been no need for lies and boasting. But it seemed that this could not be, for Suppiah would harden her heart and mock him by bringing the photograph out of her pocket once again. This would go on until we, shuffling uncomfortably, broke up the party and went to bed.

5

Ramadan

R amadan drew near. This was the month of fasting; not a calen-
dar month but a lunar one, beginning with the appearance of
one new moon and ending with the arrival of the next. Fasting,
I was told, was one of the principal articles of the Muslim faith. I
looked forward to it with great interest. Fasting, I thought, might trans-
cend self discipline and lead to a spiritual experience, to something
beyond the bounds of ordinary knowledge. I did not know. I knew that
real knowledge could only be attained through personal experience, but
nevertheless thought that if I watched these people carefully I might at
least be able to see if they were reaching beyond their usual selves. The
month of fasting was also a time for additional devotional exercises,
which should be interesting. But in our household I was extremely
disappointed, for concerning these nothing was said. On the contrary,
the talk was mainly of the presents that would be given and received at
the end of the month when the new moon appeared. I think this was a
polite way of letting me, a newcomer to the country, know what was
expected of me. There was, however, some talk about the fast itself. No
meal would be eaten between dawn and dusk, nor one drop of water
swallowed till the sun went down.

Progress in the house was slow. The absence of meals in the daytime
meant that inroads had to be made into the night. The meal after sunset
was of course nothing unusual, and indeed during Ramadan it was
taken earlier than was customary, almost before it became dark. What
really upset their routine was the early rising, while there was still no
light in the sky, not even the palest glimmer of the approaching dawn.
The lost sleep had to be made up somehow and of course it was made
up during the day. Our own meals arrived late and were ill-prepared,
the children's clothes lay crumpled on the ironing board and dust

settled in every corner. I could not blame them for that. During this month East and West were incompatible because we lived by the clock and these people, at least during Ramadan, lived by the movements of the sun and moon. But I do not think any of them fully appreciated the meaning of Ramadan. Only Zeida, given the opportunity, might have fitted herself to receive rather more than the others. The compromise between fasting and working was inevitably a failure. Both were done half-heartedly and badly. Mina walked about, moody and sleepy, carrying Tania. She spat as she reached the end of the veranda, for the prohibition against eating or drinking was held to include even the swallowing of saliva.

Slowly the days dragged on, sleep haunting the house. Idle figures sat beside their work looking at it in a sort of dazed stupor; the Javanese gardener by his tools, Mina by her unfinished washing, Supina stretched upon a cushion when she had finished cooking. Suppiah, who was independent and more daring than any of them when it came to taking a liberty, blatantly reclined upon the floor without bothering to do even a small part of her work. Only Zeida, always full of good intentions, made her way between Ahmad and Suppiah, following their instructions, which they gave carelessly, without regard for her health, or to what she had done previously. Her gait was not effortless now, nor did she move with her usual rhythm, for she had been up long before the others and had worked all day. Her pace slackened even while her will drove her tired body. By the afternoon the sun beat down upon the ground, relentless and unbearable, while the Malays lay in the shade like boulders.

Later in the day, I went into the garden to pick up some of the yellow flowers I had seen there earlier, lying in the grass, when it had been too hot to gather them. Now that the sun had lost its harsh severity, the flowers still lay, turned up, like large buttercups. They would do for the dinner table, I thought. Going to fetch a bowl, I happened to pass Zeida crouching in the doorway that led to the small ironing room. She had buried her head between her knees to stifle her sobbing. Her shiny black hair slid over her arms, giving her in her despair the appearance of one of William Blake's figures. This was the first time I had heard Zeida cry. Suppiah stood over her, scolding and punching her in the back. 'What has she done?' I asked. 'She very naughty girl. I give her ironing. She burn your ironing board.' Oh, Suppiah, I thought, but I did

not dare say it, you are scolding her because you have been lazy at Zeida's expense. She has brought it home to you and you don't like it. You hate yourself for your own indulgence and, hating yourself, you take it out on this girl whom you love. I glanced at the ugly black hole smouldering in the ironing board. 'Come,' I said, 'we all make mistakes.' Taking her by the arms I drew her to her feet again, out beyond the little room and away from Suppiah's bad temper. Ramadan or no Ramadan, Suppiah can finish her own ironing today I thought. This single incident bound Zeida's great heart to mine irrevocably. So began a sympathy between us which, through space and time, will never be forgotten.

As the month wore on tempers, to my surprise, gradually improved. I supposed they must have become accustomed to the routine. One morning, contrary to my usual practice, I had to go into town soon after breakfast. I ought to explain that we lived some way out in a pleasant residential area. The large gardens attached to the houses backed on to a road that twisted pleasantly and, like a country lane, was canopied by trees arching overhead. We were fortunate to live up there, three or four miles out of the centre of the town, which was always noisy and stuffy.

Before setting out, I called for Suppiah to give her some instructions. As I could not find her I asked Margaret if she knew where she was. 'She's having a meal with the others,' Margaret replied naively. I managed to conceal my surprise and also — with difficulty — resisted the temptation to knock at the closed door where they were having their repast. However, they soon knew that I knew all about it and, before the end of the month, I was calling round at the back during their breakfast time as though there were no such thing as Ramadan. I do not think any of them survived the full month, but could never be sure about Abbas, who, besides being our gardener, used to go off on his bicycle each evening to teach in a mosque, so had a reputation to keep up. He was a very solitary person, but I could never make out whether this was by choice or by force of circumstance. Abbas cooked for himself and could keep his eating, if indeed he was doing so, secret more easily.

While I was in the town I thought I had better see about presents for their feast day at the end of the month. So I made my way to Arab Street where all the sarongs were sold. It was a fascinating place. There seemed to be endless shops with hundreds of bales of cloth, all textures and colours, arranged to attract, but succeeding only in confusing the

eye of the passer-by. I walked the length of the street, down one side and up the other, where if I had not been looking I would have stumbled as I went over the numerous babies sprawling across the pathway. Sometimes, as my eye caught a delightful colour, I only just avoided the deep drain running between the path and the road. Here and there the pavement ended abruptly with one or two concrete steps. Then there was nothing but road to walk on with bicycles and endless rickshaws, cars and trishaws to avoid. At the further end of the street the shops gave way to stalls, some of them going back some distance, and covered with awnings or thatch. It was here that the lovely Javanese sarongs were to be found. These fabrics, Javanese or Balinese, of a type called batik were all imported. Before the war, supplies were easy to obtain but now when I went, there were only a few lengths to be had, so the dealer asked a high price. I had to bargain with determination to get one eventually for a reasonable figure. I selected one for Suppiah with autumn tints predominating, russet brown and gold on a pale oatmeal coloured background.

Having bought the Javanese sarong, I left the stall and returned to one of the shops that sold nothing but locally made ones. These were hand woven in towns and kampongs far up the east coast and had a lovely colour and texture. I picked one for Zeida with gold and crimson threads running through it on a blue background. The dealer assured me it would not tarnish, but I noticed later, when Zeida made use of it, that it did not stand up for long against the bright sun, which took its colour and left it patchy. Supina, I thought, would be just as happy with one of the cotton sarongs manufactured in Manchester with a machine-made pattern. Mina could have the blue material sitting in my trunk at home. It was a fine piece of French watered silk which I had originally brought from England to have made into an evening jacket. But when I arrived I found one never needed anything over a dress even in the evenings.

When I returned Supina was saying her prayers. The door of her little room was bolted, but the wooden shutter, which closed the window frame in place of glass, was not quite fast. Suppiah dug her fingers into it and pulled it open. 'Look,' she said, with a little note of pride, 'Malay prayers.' Had I not known I would never have guessed who this figure was, clad in white from head to foot and looking like a being from another world. Only a small hole for her face broke the white draperies

in which she was covered. Her eyes were lowered, so she did not see me, and I only stayed to look for a moment, feeling that I might be intruding. 'Do all the Malay women dress like this for prayers?' I asked. 'Yes,' Suppiah said, 'we say prayers early morning, middle day, afternoon, evening and night.' 'What do the men wear?' I asked. She said that they had to wear the black velvet cap. This was commonly worn out of doors by every type of Malay from raja to peasant. Ahmad wore one too when he dressed up and wanted to appear impressive and smart.

On another occasion I saw Romala in her prayer costume. I felt a little ashamed of myself for asking her to sit for me like this, but to my surprise she consented most willingly. So also did an old lady, a friend of hers, who came to visit her a few days later. These people did not sit for me for money. They sat through kindness and out of the generosity of their hearts.

Preparations were beginning for the great feast day. In the evening Suppiah, sitting cross-legged on the floor of her small room, worked hard on the jacket she was making for Zeida. She sat under the lamp straining her one good eye. She cut well and fashioned her jackets to suit Zeida's curves. Mina, with typical extravagance, went off to a Chinese tailor and had something unusual created. Suppiah would have made her one too, for she loved Mina. But Mina was independent and chose something more modern and daring. I watched her toying with a bit of red paper, trying to make herself an artificial flower. In the end, I thought, the fat sister would make it and Mina would wear it carelessly, forgetful of the labour and confirmed in her own laziness. Supina made a new jacket too, but was spending more and more time in her own room in the evenings and did not join the others. Mina often left Suppiah's and Ahmad's room to join Supina and, together, with the door shut, they talked. I do not know what they spoke about, for neither I nor Suppiah were ever invited to join them.

Towards the end of the month there was much discussion about when the new moon would rise. On the first day when it was due, it would appear for only a few moments; if there was any rain that evening, or even if there were clouds, it might not be seen, and that would mean a prolongation of the fast and postponement of the feast for another 24 hours. How awkward, I thought, if our own holidays, August Bank Holiday for instance, were dependent on an uncertain phenomenon, so

that one did not know for sure until the evening before whether it was going to take place the next day or not. Ahmad looked at the sky, nodding his head prophetically. Mina frowned a little anxiously. She, I felt certain, had made plans of her own. Supina looked excited. Only Suppiah took little interest in the birth of this new moon whose advent was so eagerly awaited by hundreds of thousands of Muslims all over the world. My mind then turned to the deeper meaning of the end of the fast. For those who had kept it, and purified themselves and prayed, surely the new moon would come as a symbol of their own rebirth. But I knew it would be useless to discuss this point with Ahmad, who had probably little acquaintance with either prayer or purification. And Zeida would still be too young to understand.

In the end, fortunately, all went well. The new moon shone weakly in the west for a few minutes, and died. I did not see it, nor did they, but someone did somewhere, and it did not take long for the news to get around. All sighed with relief and gladness. I asked them what their plans were for the next day. The festival was to be very devout, I was told. Ahmad would go to the mosque and all the others would visit their ancestral graves.

At dawn I suddenly remembered the blue silk lying in my trunk. I had forgotten all about it. I crept out of bed and, finding it, threw it over my couch. Then I waited, listening for the approach of Mina's bare feet on the boards outside. 'Blessings on this day, Mina,' I called out as I heard the soft patter of her feet approaching. She came to the door smiling and bobbed her head, her eyes shining. 'There is my gift to you, Mina,' I said, turning my eyes towards the silk. She looked at it, her face betraying her surprise, her shyness and delight. It was un- doubtedly a very beautiful piece of material. If Mina had seen anything like it before she certainly had never been able to purchase it. As she stood there a great crimson rose crept into her skin. Then suddenly she seized the silk, crumpled it to her and fled from the room.

We got our own breakfast as previously arranged, but not because anyone had gone early to the mosque. They were all busy dressing up, Ahmad no less conscientiously than the rest. A little later they appeared like a gorgeous fancy dress parade, stopping to be admired before they went out for the day. Mina wore a white, transparent bodice over the new blue silk. It was drawn tight across her hips and fell in pleated folds in front, draped like a sarong, but carried a little higher than usual

so that an interested eye could observe her shapely ankle. Before me she looked demure but I thought this adventurous dress was not for nothing. Over one shoulder lay a small mauve scarf, which was fastened at her waist on the other side. In her marvellous hair a red flower nestled seductively, made, I supposed, by the fat sister. For Zeida, Suppiah, in spite of her bad eye, had finished the bodice of emerald green with a pattern of black and gold that suited her well, together with a sarong of the same material. But Zeida was unaware of the impression she made. With her charming smile she walked unselfconsciously towards Mina, more beautiful than any of them. Then Ahmad appeared. Now here was genuine vanity, not a proud pretence. And indeed he did look good. His head, held high, was surmounted with a black velvet cap shining softly in the sun. It was the same cap he would have worn to go to the mosque. Over a high-necked silk shirt and trousers of lilac colour he wore his sarong wrapped round his waist, woven in green and purple checks. I could not help but wonder how he had managed to save enough money to pay for it. As he walked he could not restrain a little proud self-conscious smile, aware of the effect he produced. 'Like a raja,' said Suppiah. It was not often that she paid him a compliment, but she recognized that we were impressed by his appearance. Supina looked effective in black and white with little gilt ornaments around her neck and arms, and in her eyes a naughty little twinkle, not for the mosque I thought. Suppiah, who was the only one not to have made an effort to rise to the occasion, wore a simple costume of sober brown. This was no great day for her, or if it was, it was a day of memories and dreams.

However, whatever Suppiah's personal feelings, she saw no need to forego her holiday on their account. After they had gone, my husband and I decided to take the children with us in the car so that we could watch all the cheerful Malays parading in the streets on their 'Great Day'. It was a long established custom among both European and Chinese car owners that, if possible, they would arrange to do without their cars on this day so that their drivers could borrow them to visit their friends or see the sights. Nearly all the drivers were Malays, or people of similar stock from the Dutch islands, and of the Muslim faith.

Our first visit was to the house of a headmaster of a small Malay school situated some way out, and on our way there we passed group after group of Malays, in cars, on bicycles or on foot, making their way

towards the town. The men wore velvet caps and sarongs wound around their waists, like short skirts, showing their trousers below, which matched their shirts above. It was a very elegant costume, though Malays have told me it was somewhat hot to wear. The colours were chosen with an instinctive sense of harmony. One wore a blue satin shirt and trousers, and over it a crimson sarong crossed with silver threads. I saw another in a turquoise suit with a green and black striped sarong, and a third in pink with a sarong woven of mauve and green. Caps were usually black, but today their best were on show — wine, light brown, purple and royal blue. They glistened in the sunlight with that lovely soft sheen that velvet always shows.

We turned off the main road and drove a few hundred yards up a track. Here was the school, with the master's house adjoining, and tumbling down the steps were his children, also wearing their best clothes, for later in the day they would be going out to visit their relatives. One could see they were from one family, for when they smiled, all their eyes puckered alike in little half-moons. Father had left for the mosque, they said, as we handed them our gift of boiled sweets, and just then their mother came out of the house and greeted us. She had dressed all her children before making herself ready, and had still not given the final brush to her hair when we surprised her. She was wearing her finest jacket, with long sleeves, well cut to fit her still youthful figure and worn outside her sarong. When she went out she would probably place a small scarf decoratively over her head or on her shoulder to add an extra touch of colour. In former days the women's heads were always covered but these were modern times and fashions were changing. Mostly only old women still covered their heads, remaining true to their generation, much like our mothers, who do not wear two-piece bathing suits but leave that to their more daring daughters.

She was a little confused to see us there, but the two families were already in conversation and she quickly asked us to come inside. We could not do this, we said, as we particularly wanted to be back in town in time for the prayers in the mosque, and it was half past eight already. 'Wait, wait then,' she cried, and turning ran up the steps into the bungalow, from which she emerged later with a paper bundle. As we drove off Margaret and Tania eagerly untied the parcel and to their delight found pink biscuits in the shape of starfish, white ones fashioned like leaves, and small brown cakes like cowrie shells.

We passed a little wayside mosque built of wood and dark inside, where prayers had already begun. We stopped the car for a minute and turned off the engine, but all we could hear, and that only faintly, was the voice of the imam, rising and falling within. The worshippers could be dimly seen, turned to the west with their backs to us, standing there motionless. Outside a Malay leisurely pulled his bicycle onto its stand, looked through the open doorway and hitched and unhitched again his sarong as though he intended to go in but could not bring himself to leave the bright sunlight. Further down the road a family group was engaged in clearing the weeds from a grave surrounded by rubber trees, and a Chinese food seller stopped to rest himself from the weariness of the load he carried. He rubbed his shoulder where the pole had rested and stared curiously towards the mosque. Then he lifted his pole onto the other shoulder and started off again down the road half ambling, half trotting. His movement seemed to break a spell and we too continued on our way.

But we need not have hurried. The moving stream of caps and sarongs was still flowing towards and not away from the big mosque in the town. I was curious to see whether any women were entering it. I had been told that it was permissible for Malay women to go into the mosque provided they wore prayer costumes to hide their bodies and covered the whole of their faces except for their eyes. I did not see any go in, though when we arrived opposite the main entrance I became so interested in looking at the beggars who lined the pathway that I forgot to pay particular attention to those who went along it.

Certainly none of the faithful who went to the mosque that day were allowed to forget their pious duty to give alms to the poor. Rather it was to be feared that their resources would be exhausted long before they reached the end of the line of suppliants. Those who sat nearest the door were the ones I could see best, and they appeared to be in the most advantageous position. An old man with a long tobacco-stained beard sat cross-legged, watching a pile of rice in front of him increase as hand after hand poured out the fine white grains for which he waited. Next to him a man waved a stump of an arm, smiling his thanks as he deftly handled the paper notes that were thrust into the other. On the other side was a boy without legs, and next to him one who stared at the sun with sightless eyes. There were dozens more, but suddenly I was attracted by a movement in the interior of the mosque, where the devout had

been patiently waiting. Prayers had begun and the many hundreds taking part, roughly arranged in parallel lines, all standing, raised their hands level with their heads, then bowed down as a field of corn is bowed by the passing wind. The startled pigeons flew aloft out from the grey shadows of the mosque into the sunlight, while below the prostrations continued.

6

Ahmad Moves In

The housing shortage was one of the main problems in Singapore after the liberation of the city, for Asians and Europeans alike. Most Europeans had to share their houses, often with people they did not know. We also were obliged to take in a lodger, a bachelor, to live with us, and this necessitated extra help. About the same time our friends next door moved up-country, so Ahmad became free. We were lucky with our bachelor, who fitted in admirably and agreed, at our suggestion, to take him on. Ahmad was delighted and so, though for a different reason, were we. I think Ahmad imagined he would usurp Supina's position as cook. I know this was his aim as he was very jealous of Supina. I had no intention of allowing this to happen and made it quite clear that he would work as a steward in the house, mainly looking after the bachelor. Nevertheless, I felt Ahmad's presence in the house cemented Suppiah's position, because I knew that wherever he went, he would want Suppiah to accompany him, whether she wished it or not. Suppiah, perhaps because of the long tradition of her race or because of her mother's strong influence, or perhaps because she was too tired to battle with life or no longer had any real desire to, would give in and go with him. But the fierce fire that burnt within her would flare up one day, I felt sure, before it burnt itself out.

Working next door and living in one of our quarters, Ahmad was of course already a familiar figure about the house and had won the confidence of the children. He was indeed genuinely fond of them. Frequently he brought Margaret and Tania little surprise toys, or a piece of chocolate. He was immensely fond of Tania because she responded readily to his efforts to amuse her, gurgling at him from the playpen at the back of the house. She gave him something he longed for and never got in his own home. 'I want to adopt Chinese baby,' Ahmad often said

to me, 'we have none.' One day Suppiah heard these remarks in passing and she shouted at him in Malay. I saw her face, full of resentment and temper. She was tied enough to him without adding another chain, she retorted.

This was typical of the way in which Suppiah snubbed him in our presence and, in the privacy of their room, far worse things must have been said. Perhaps not only said; Suppiah had boasted of using a stick when sufficiently roused. With my children she was forgiving and sweet, and even chided me when I scolded them, but with Ahmad she was hard and cruel. He remained hurt for days after one of their quarrels. The house seemed to be overhung with clouds and I wondered uncomfortably when they would disperse.

With a little encouragement from Suppiah, Ahmad might have gone far. Naturally deft and good with his hands, he would, with training, have made an excellent mechanic. One of his tricks was to repair seemingly useless electric light bulbs. Whenever a bulb 'went', it was always handed to Ahmad to see what he could do with it before it was thrown away. 'This will be too difficult even for you,' I would say, 'but you may like to look at it.' Ahmad would then take it and examine it with rapt concentration, like a learned botanist confronted with some rare specimen; he might even shake his head slightly, to indicate that this really was more than he could be expected to deal with. Then, having observed where the filaments had become detached, he turned the bulb over and very gently shook them together again. All that remained after that was to place the bulb in its socket and turn the switch when, hey presto! the light worked again. We applauded and Ahmad smiled with pride, pointing his lips as dancers point their toes.

Another favourite was my old German sewing machine. Something in its mechanism was always going wrong. Ahmad, having a constant desire to please, and also anxious to prove what he could do, spent hours trying to put it right. As for his other duties, Zeida could see to them, he said. Then, when he had finally succeeded, he stood triumphant while I tested it, thankful that he had finished at last. I praised him for his cleverness, and his trampled self-confidence momentarily reasserted itself, a gleam coming back into his melancholy, uncertain eyes. Having no one else in whom to confide, and longing for sympathy and encourgement, he stored up little stories of his achievements to narrate to my husband and me, waiting pathetically for the words of

praise to follow. I, unwilling to bring about a situation in which I might lose Suppiah, and indirectly Zeida, bore with him; but while I flattered him with my tongue my feelings revolted and, although I felt sorry for him, I wished he would find a means of satisfying his self-esteem without recourse to me.

An opportunity soon came for him to display his talents to advantage. Up till now my husband had done the shopping on the way to his office. This was a very inconvenient arrangement for us all. It did not improve the vegetables to be kept in the car for a whole morning and with fish and meat it was impossible. But it was difficult to know how the shopping could be arranged otherwise. We lived a long way from the market, too far to walk, and taxis were expensive. It would obviously have been better to have made use of transport that had to pass the market anyway. But Supina, who might have gone down with my husband and come back in a trishaw, could neither read nor write, and her brain was not equal to the task of remembering until she got home what everything had cost her. Ahmad took a keen interest in all that arrived at midday. My husband had paid too much, he said, eyeing the wilting cabbage, and the bananas were over ripe. We could buy better, he was sure. So it was decided that he should do the buying. He was taken down to the market by my husband, introduced to the stall from which he used to buy the vegetables and left to carry out the shopping and find his own way home.

Here Europeans (English and Dutch) and Asians (Chinese, Malays, Indians, Jews, Arabs and a few Persians and others) — customers, traders and dealers — all mingled in the market. Here I eagerly watched my models come and go. The procession passed — in bright colours and in black, with heads held high and heads bowed; children holding onto their mothers' hands; fine black hair in a long plait against a bright blue jacket; a young Chinese girl; a figure with a long grey beard walking as if in meditation and dressed in white from turban to sandals; an orange tie against a grey shirt; an old Indian woman with grey hair and a very old sari which scarcely covered her lean body; an English lady with white curls; a Chinese coolie; and, among many others, Ahmad.

Speaking a fair Chinese and looking somewhat like one too, his eyes slanting upwards and being about the same colour as most of them there, he was a match for any Chinese seller in the market. Quickly his eyes ran from stall to stall, pricing this one's oranges and that one's

apples; the cauliflower was less expensive there and the potatoes had dropped in price. Eggs could be got from a friend more cheaply, but the price of fish today was reasonable. He did not take long to make up his mind that my husband had been overcharged at the stall where he had always dealt and, if Ahmad was to be believed, he had made them sorry for it. However tired we were, we always enjoyed listening to Ahmad's accounts of his battles in the market. He was by nature dramatic and acted rather than told the stories of these encounters with great vigour and intensity. They always began in the same way, with Ahmad walking up to a stallholder and addressing him in Chinese. The stallholder, completely baffled, would ask Ahmad what manner of a man he was, looking so like a Malay but speaking such perfect Chinese. 'No matter,' Ahmad would say, and then the battle of wits would begin; it would take various turns but we know it would end in the defeat of the adversary and in Ahmad returning home with a bargain.

He saved us a lot of money in this way at a time when we had little to spare and we were always grateful to him for it, even though he must have made a bit on the side somewhere. After a time he dropped the rickshaw and took to using a taxi. Had he waited until he had gained our confidence and could afford to put a little more of our money into his pocket without suspicion? Or was there another reason? Sometimes when he returned he looked pale and ill. I could well believe that his encounters with the shop people and stallholders were a drain on his nervous energy, for I had seen him at work trying to get a good bargain, and the drama he subsequently re-enacted at home was not at all exaggerated.

One day he came home flustered and excited; a thief had picked his pocket. He had felt a hand slide down into his trousers and had caught and held it. He had fought the man, blackened his eyes and knocked him down. It was unfortunate that, in the general confusion, the thief and our money had gone. He grew warm and excited as he enlarged on the story. The tale was not altogether convincing, but there was nothing we could do other than make up the market money and warn him to be more careful next time. It was a pity that Ahmad was not always as responsive to our states of mind as we were to his, for the money had no sooner reached his pocket than he was asking for an advance on his own pay. It was near the end of the month and he needed it for his little brother's wedding party, which was due to take place shortly. My face

must have told him that he had chosen a bad time to ask for a loan, for he switched rapidly to another subject. Where was Supina? Why had she not come forward to help him carry the things through to the kitchen? She was the cook, wasn't she? — a fact Ahmad always resented — so why couldn't she do her job properly? 'Ah, but I know,' he said, looking round and drawing closer to me. 'I know very much. Supina naughty woman. Supina go out at night. Supina not come home until five o'clock in the morning. Supina like man very much. You see man, very tall, wait outside house in evening.' I did remember seeing a very tall man with a shock of hair, not merely waiting outside the house, but going to Supina's room. But Ahmad was not waiting for a reply, he was in the mood to reveal more scandal. 'Supina take Mina too,' he continued. 'She teach Mina many bad things. Mina too young. Mina know too much now.' I might have heard more, but at that moment he caught sight of Suppiah coming towards us from the garden and hastened to carry his loads into the kitchen himself. I went off in search of Mina and, finding all the children's clothes unironed, I rated her for her slovenliness without saying anything about the unrest that Ahmad's half-finished story had created in my mind. I also had the switches changed, so that the iron could be used only in a little room upstairs where her work could be properly supervised.

7
Mina's Illness

Although I knew that Ahmad's tales about Supina and Mina were told through jealousy, I also knew that they might well have been true. Early one morning not long afterwards, I was surprised to find myself woken from a deep sleep by Suppiah gently shaking me. Before I had time to sit up, I heard her saying breathlessly, 'Mina is sick, Mina is sick.' She was wringing her hands and begging me not to waste any time. I tumbled out of bed, walked into my slippers, put on a wrap and followed her downstairs.

Going across the garden, I was conscious that the day had hardly begun. The lawn, spread with sparkles, had that soft misty appearance of early dawn. Everything was only just waking up. I hurried a little towards the bank, climbed it with difficulty in my Chinese slippers and entered Suppiah's room, to which Mina had been carried some time earlier and where she now lay unconscious. Her eyes were open, but, as though in a trance, she appeared to see nothing. Her hair, wet from the dripping perspiration that fever brings, trailed across the floor. I dropped a little water between her parched lips and laid a pillow underneath her head.

At that time we did not have a private doctor, so I rang one whom I knew by reputation only, but he had already gone out and I could only leave a message. Lunch time came and went, but still no doctor arrived. The afternoon was stifling and tense with a gathering storm, which made me more uneasy than ever. When, later on, Mina's temperature rose to 105°, I rang again and spoke to the doctor personally. He would come as soon as he could, he said, but it might not be till later in the evening. Now the storm broke with violence and driving rain, a fresh cause for anxiety as he would have difficulty finding our house, which was tucked away round several corners. But as the daylight faded the

rain diminished and finally stopped. Soon after dark we heard a car approaching. I stood waiting as the doctor got out and, eyeing his immaculate dress, warned him to be careful. He made no comment, but followed me as I led the way across the garden, where it was difficult to walk without falling and there was no light to guide us up the slippery bank to Suppiah's room.

When we entered we were met by a pungent smell of cooking. Zeida had only just finished preparing the evening meal in the small space which served as a kitchen and through which we had to pass to get to Mina's room. I wondered whether the doctor disliked the smell as much as I did, but if so, he concealed it with perfect composure.

I shall always remember those suede shoes, looking so incongruous in the little room, and the kind voice of the doctor kneeling on the floor beside Mina. I shall remember with gratitude the immense amount of care and trouble he took to look after her.

On the morning of the third day of Mina's illness it was decided that she should go to hospital. The rain continued to fall, monotonous and heavy. There was no colour in the landscape to drive away one's depression. In the garden, the flowers of the buttercup tree lay on the earth, beaten to death and faded brown, a travesty of the yellow beauty they displayed on pleasant days when, fresh in the springing grass, they lay as though waiting for admiration. It was fortunate that Mina was too ill to realize what had been settled over her head. She, like most of the others, regarded doctors and hospitals with suspicion — they were utterly foreign to her customs and understanding. But Suppiah, who was looking after Mina and who admired these free Europeans whose marriage laws were so much more generous than her own, was quite ready that Mina should be sent there.

So Suppiah, my husband and I together stooped to lift Mina's lifeless body from the ground. When she was well, a single person could have picked up her young, responsive body, but now three of us had trouble moving her. Going down the slippery bank was difficult after the rain and we moved step by step with caution, stopping at times to shift our burden. At last she was safely in the car, where she lay stretched out on the back seat, knowing no-one. Suppiah and I crowded in front with my husband and, as we drove along, I caught sight of the look of anxiety on her face. At the hospital we found many people waiting to be admitted and had to wait our turn. Worried though I was about Mina, I

found my gaze wandering and my eyes taking in details of the scene around me.

Near us, a small Chinese girl sat on a low wall swinging her legs. Her black silky bobbed hair shook as she tugged at small stones and threw them triumphantly to the ground, pausing after a minute to admire the scarlet shoes she waggled on her feet. She had hardly a look to spare for her mother who, sitting on the steps beside her, beat her head against her knees, weeping copiously. A young man on the other side, putting his arm about her shoulder, tried to comfort her. But she would not let him and, pushing him away, she went back to beating her head against her knees with a fresh outburst of weeping and wailing. A middle-aged Indian woman with a diamond in her nose drew her sari round her and held it close to her face, as if in pain. Her husband, standing by, tried to coax her, but she too turned away and would not accept the comfort he wanted to offer her. A Chinese girl in a floral cotton jacket and a pair of trousers passed, sitting primly in a trishaw. The trishaw driver pedalled along like a man in a dream, regardless of the oncoming cars. His shirt was grey with age, his battered hat sat on his head at a rakish angle and his sand-coloured socks slipped to his ankles as his feet went round and round. An ambulance drove up and stopped opposite our car. A corpse-like figure was carried out on a stretcher, motionless under a blanket and, as it passed, I saw the wasted skin stretched across the temples. Hunger and privation, battle, despair and pain all had a place round that hospital entrance, waiting for admission.

Now it was our turn at last and we moved inside, where we found many others waiting, a few Indians but mostly Chinese. A Tamil woman dressed in an orange coloured sari and an oatmeal coloured blouse squatted on the ground. Her baby lay beside her on the floor, deposited there like a basket that had become too heavy. We were near a ward and one or two of the patients who were well enough to walk came and stared at me with great curiosity. Dark little girls in white hospital gowns wandered about the corridors, strange figures, like those in Stanley Spencer's pictures. Wherever I turned my eyes I saw beauty — beauty in a pose, beauty in colour, beauty in the great contrast of tones; black hair and white gowns, light and shining eyes in dark faces, glittering teeth and heads tilted at graceful angles; beauty in expression and sometimes even in pain.

46

After recording all Mina's particulars in an office, we saw her put on a stretcher. As she lay there staring at nothing, I realized that she was not merely my ayah, but someone to whom I had become deeply attached. The long wait made Suppiah anxious. She kept pulling at her fingers, making her bones crack. I recognized the sound of it without even looking at her; many Malays did the same when they were nervous. We went into the room in which Mina was to be examined by a lady doctor, a slim Chinese, keen-eyed and quick-witted, whose small hands ran lightly and rapidly over Mina's little body. After her examination, Mina was admitted to a ward. Suppiah and I followed the trolley as it was wheeled down corridors and past open doors, where bored, curious or melancholy eyes turned in our direction. Finally we reached the large ward to which Mina had been admitted. As she was wheeled in I quickly cast my eyes around. It was nearly full, but all the beds were occupied by Chinese. Mina was going to feel strange and lonely. On one side of her a Chinese woman lay stretched out and still. Her skin had that dreadful, yellow appearance of the very ill and in her eyes suffering stood out, stark and cruelly triumphant. On the other side a woman crouched, her head madly turning from side to side in restless desperation. Though Mina was not conscious of our leaving, Suppiah could hardly drag herself away and followed me past the long row of beds, silent and dazed.

Mina was in hospital for some time. She was difficult to feed, they told me, as she would not touch milk in any form. I did not go to see her until she was a lot better, but sent Suppiah with whom she would feel more at home. These visits disorganized my household very considerably, for not only was I short of Mina, but the long hours Suppiah took off going backwards and forwards to the hospital meant her work got badly done or left. When I myself first went to see Mina she was already sitting up, in the lovely attitude which was so characteristic of her. I had seen it dozens of times at home; one leg bent under her to sit on like a cushion, the other drawn close to her chin; one arm hugging her knee, the other dangling loosely, untidy and graceful like Mina herself. Her wide eyes seemed even larger and the lines of her high cheek bones more pronounced, for the long fever had taken its toll. She was a bit sullen, like a child who had just been woken and resented it. I had seen Mina in moods before. At such times she had little regard for other people; she was casual and stubborn and made not the slightest effort to

control herself. In her eyes I saw only peevishness and no trace of gratitude for the loving care that had been lavished upon her. By nature she had no gratitude; she had never needed it, for her charm seemed to cast a spell on those who came into contact with her, so that she could do without the manners that are required of other people. I took her coffee in a flask, and eggs and pomolo, which tastes like grapefruit. Peeling the thick, green-gold skin, I quartered the segments for her. These she ate greedily, belching afterwards, and cracked the hard-boiled egg in her fingers, disregarding the shell falling untidily all round her.

Now that she could sit up and take an interest in what was going on I visited her daily. Suppiah had soon wearied of the long journey down to the hospital and was glad to be left at home to keep an eye on the children. I think Mina enjoyed these visits more than I realized, for one day, when something kept me and I arrived late, she was already feeling lonely and crying. After this I made a point of always being punctual, but every time I went out of the ward her eyes looked at mine like an animal pleading not to be left behind.

At last, after many visits, I was told one day that Mina might be discharged on the morrow. All was made ready for her at home; a clean pillow on the floor and a new mat to lie upon. The car, whose frequent trips to the hospital had been a heavy expense, made the journey for the last time. But Mina would not know and, had it entered her head, she would have thought little of it. All the Malays in our household seemed to think that we had boundless wealth.

I took Suppiah with me when I went to fetch Mina. The doctor happened to be going round the ward, not the little Chinese lady who had admitted Mina, but a European. She was very interested in the growth on Suppiah's eye and urged her to come to hospital to have it removed. 'It would be a simple operation,' she said. 'You would only need to stay in hospital a few days.' Afterwards I asked Suppiah what she thought of this. She was very willing but Ahmad was half-hearted, even hostile. It was not merely prejudice against European doctors and medicine, but he was afraid that if the growth were removed her attractiveness to men would increase, and her dependence on him would be lessened. It was incredible how his imagination ran on, for Suppiah was middle-aged and lined and her hair was even going slightly grey. Ahmad was unbelievably jealous, Suppiah told me. When he took her

to the cinema in one of the large amusement parks he jostled her from stall to stall so that she had no chance of looking at anything, for he was jealous even of the dealers. She enjoyed watching the Malays dancing in the *ronggeng*, but Ahmad would not hear of it. 'She might find other man,' he said to me one day. I could well imagine that if Suppiah had found a man anywhere, it might have been at a Malay *ronggeng*. I had watched it myself and had been fascinated by its apparent decorum and underlying seductiveness. The partners stand opposite each other, man and woman, and dance as a pair but without touching for, as he advances, she retires. She comes forward and he steps back, or they both retire in opposite directions, the woman following her partner's steps through one variation to another as the music or his mood inspires him. All parts of their bodies move to the languid but quivering rhythm, with the emphasis now on the hips, now on the hands, now on the head, while the feet beat a constant accompaniment. One movement merges into the next as one part of the body takes over from another, drawing attention to its grace and calling for admiration. The women performers were professionals, but those who thronged to watch caught something of the spirit of the dance, its excitement of the emotions, its liberation from repression, its gaiety of spirit. And through it all the bright colours of the women's dresses, the jackets cut to display their curves, their sarongs tight across their hips, shaking and quivering; bright scarves waving, every kind of colour — jade and purple, yellow, gold, orange and black; men with dark eyes and powdered faces, slim men and fat men, beautiful bodies, ugly ones. I was not surprised that Ahmad hurried Suppiah past the *ronggeng* to the safety of the cinema, where he could sit jealously guarding her in the dark, with perhaps Zeida on the other side.

8
Visit to Mersing

Although Mina was better for two or three days after her discharge from hospital, she had a relapse and was again confined to her room. Her illness had never been diagnosed, as the doctor who first saw her was baffled and, in hospital, the nurse could only tell me that it was a fever of unknown origin. I thought of Ahmad's words, 'Supina teach Mina. Mina know too much.' I said nothing, but felt uneasy in my mind about this child who had no mother or father, nor husband now, to care for her and guard her from the perils that surrounded her.

By an unfortunate coincidence Zeida also fell ill, through sheer physical exhaustion, not only from the work, which increased as time went on, but from the constant presence of discord between her foster parents. She began to look thin and hollow-eyed, till finally she had to give in. I nursed her, with Mina, in one room. 'She must have milk to drink,' I replied, when Ahmad asked me what she needed. 'Milk Zeida has,' said Ahmad, 'but Mina won't drink it. Only rice. She eat a lot of rice. Rice very dear.' 'But you all have your rations,' I said. 'Rations?' Ahmad replied, 'Mina has no ration. Every week we give Mina rice. We pay all Mina's food. Suppiah sorry for her. Suppiah spoil her. I very angry with Suppiah.' 'But where is Mina's ration card?' I asked. Ahmad shook his head with a gesture of despair. He didn't know. Mina hadn't got a ration card.

After this typically inconclusive conversation, I walked away, determined to look into the matter before I heard any more of Ahmad's complaints. The price of rationed rice was controlled, but rice on the black market was prohibitively expensive. The ration varied in amount but was small enough at the best of times. No other food satisfied the Malays, or the Chinese either. When the ration was lowered, the black-

market price of rice immediately rose and there was great discontent. In fact the threat of strikes, even strikes themselves, could be attributed to the lack of rice. It was the staple food to which the entire Asian population (Malay, Chinese and Indian) was accustomed. They would never willingly accept a substitute for their beloved rice diet. Indeed, there was no really acceptable one available, but they could have done much more than they did to supplement their rice with other foods if they had been less conservative and if they had not become so heartily sick of the tapioca and sweet potatoes, which were all they got to eat during the Japanese occupation (and were lucky to get that). One of the principal concerns of the military (and now civil) administration after the end of the war was the procurement of sufficient rice to feed the population, but it was not easy, for much of the land had gone out of cultivation during the war and transport shipping was scarce.

On questioning Mina I learnt for the first time that the gardener next door was her uncle and that the coveted rice card was in his possession, for Mina had been listed as one of his children. Suppiah told me that when the job of gardener fell vacant next door, Mina had gone to her uncle, from whom she had previously run away, to make up her quarrel and to persuade him to apply for the post. At the time he had a wife and three children dependent on him and no work. Mina was fond of children and especially fond of her three little cousins. Subsequently, she must have quarrelled with her uncle again, but she was always kind to Leman, Nasib and the baby. Sometimes, sitting with Tania, she took the third boy on her knee and, with one arm round Nasib, spoke to him protectively as though he had been her own child.

As Mina's uncle had not voluntarily surrendered her rice card, my interview with him on the subject was hardly likely to be pleasant. Squelching through the mud left by the recent rains I made my way to his room in anything but a cheerful frame of mind. I knocked on the door. It was opened by his wife — a lovely woman, I thought once again, out of temper though I was. She had glad eyes despite life's bleak inhospitality, but the gaiety in them soon died when I told her why I had called. Instead of giving me the card I asked for, she spoke wildly, an angry mother on the defensive, wandering away from the subject, aware that I knew her three children were all sharing Mina's rice ration. She spoke harshly about Mina, of her ungratefulness as a child and of how they had clothed her and fed her before she ran away.

She had not repaid them, not even a few cents, for her keep in her early childhood, when they had taken her in and cared for her as one of their own after her mother and father died. Besides, she added, I could not have the rice card for Mina's name was included on the family card. I demanded to see it. After much ill feeling, anger and resentment on her part, insistence on mine, she went to find it, taking as long about it as she could. At last she returned and would, had her manners permitted it, have thrown it at me, but she was after all a Malay and Malays are by nature well mannered. Going away with the rice card in my hand, after assuring her that it would be returned as soon as Mina's name had been struck off, I realized that for the first time in this country I was actively hated by one of the Malays whose friendship I enjoyed so much. For some time I could not forget the fire that flashed from that mother's eyes when I took the card from her — and all for Mina.

I never spoke to her again. Now, when I think of it, I am indeed sorry that it was necessary to deprive that poor family of an extra ration of rice. Some months later the mother was drowned after the heavy rains. She was caught by a current while wading along one of the badly flooded streets and carried into the canal. She was on her way to fetch Leman from school at the time.

There was another reason for securing Mina's rice card. We were shortly due to go on local leave, and whether Mina was well enough to go with us or whether she had to stay behind, she would certainly require her ration of rice, for in either case she would not have Suppiah to rely on over that period.

The usual way of spending local leave was to go to one or other of the hill stations where, I was told, the air was cool and bracing. But our Malays shivered at the thought of it. Even the cool rainy days, which we occasionally got during January and February down near the sea, were too much for them. What seemed so extraordinary was that they refused to put on anything extra. In the coldest weather the womenfolk in our household still wore nothing but a little brassiere and a scanty transparent jacket to cover their nakedness. I had given Ahmad a knitted pullover of my husband's, but he never put it on. For reasons of vanity possibly; it was too big and perhaps he thought the colour did not suit him. Ahmad had odd ideas about his appearance. When he first came to work for us he took a great fancy to a pair of pale blue pyjama trousers, which he wore without any top until I said how much I liked

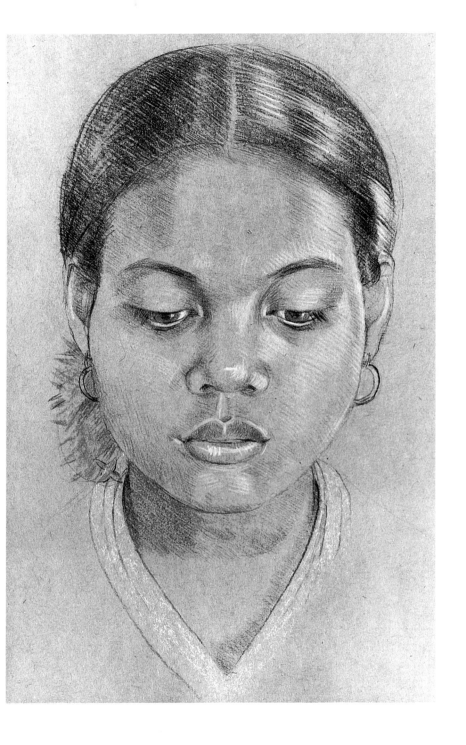

1. Mina.

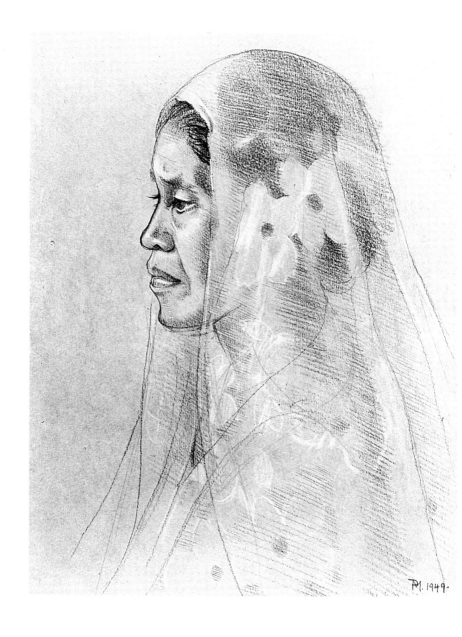

2. Suppiah.

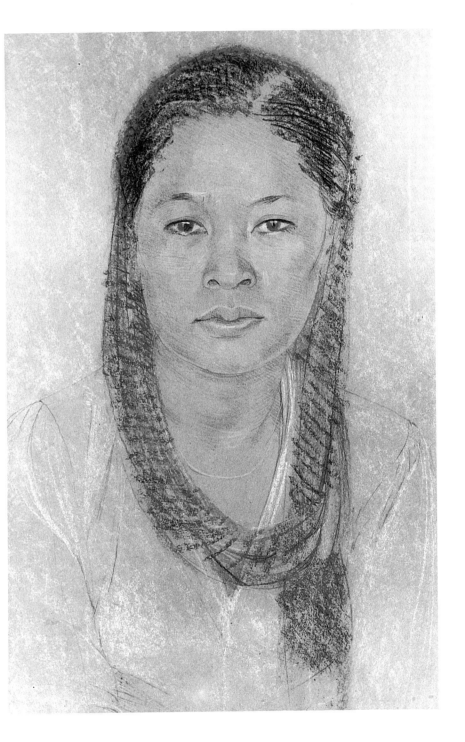

3. Supina.

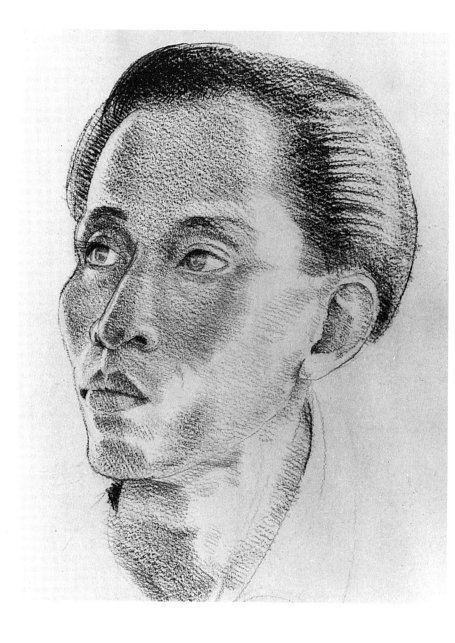

4. Ahmad.

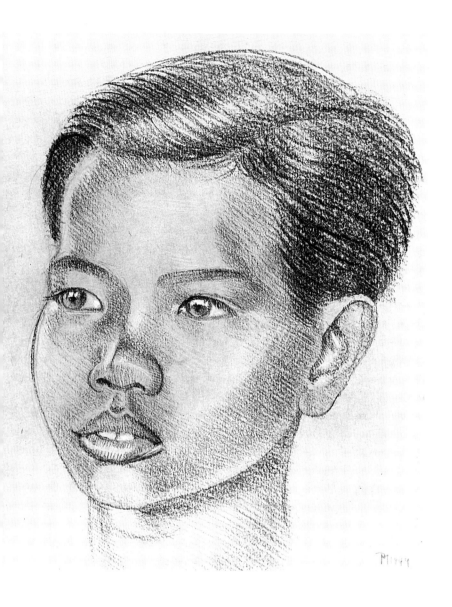

5. Salem.

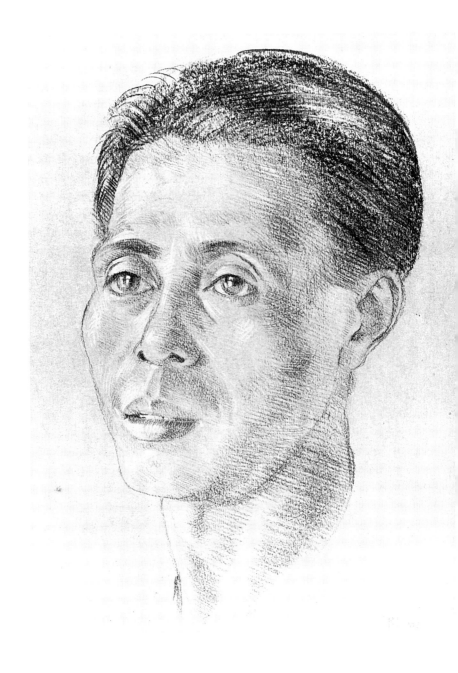

6. Salem's father.

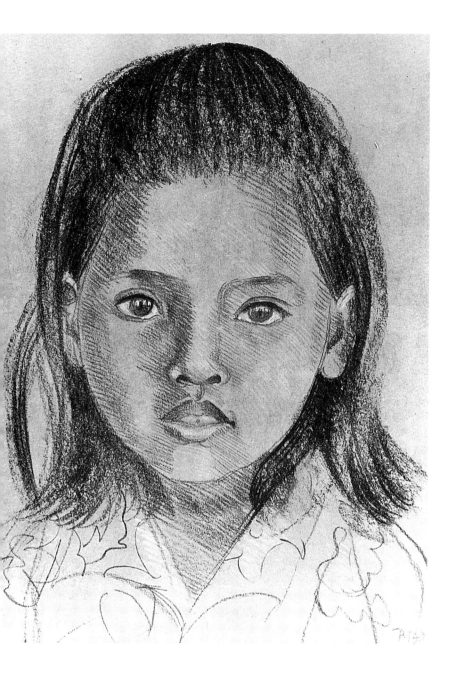

7. Salem's sister, Mila.

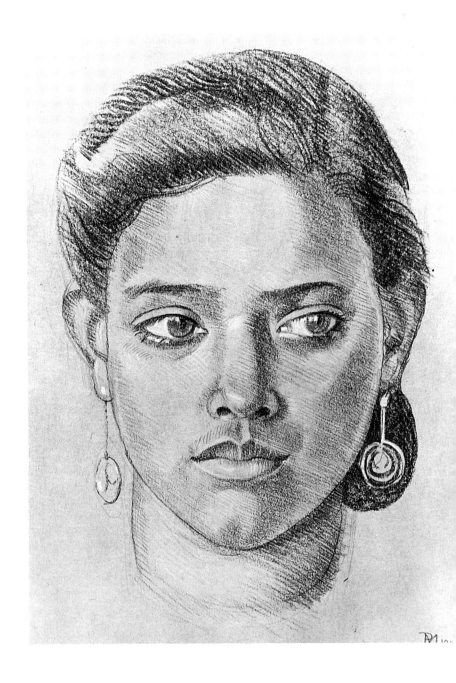

8. Zeida.

the appearance of Malay men wearing sarongs. It had the desired effect: the pyjama legs were more suitably reserved for the bedroom and the sarong came into daily use, until this in its turn was discarded for a European shirt and white trousers.

Because of all this we decided to go to the nearest point on the east coast. It would be warm enough for them, but was visited by fresh winds at this time of the year, we had heard, and should give us the change we needed. How I longed for a wind again. I missed the wind more than anything else when I first settled in the tropics. There was little change and no seasons to speak of in my new home. There was rain or sunshine, a dull or bright day, but it was always hot and the nights were always warm. It is true that the nights were very beautiful when the sky was brightly illumined by a myriad of stars and a full moon. The garden took on all sorts of strange forms in cold tones, with white flowers coming unexpectedly out of the darkness and shadows walking across moonlit paths, and a strong scent of flowers. But there was nothing to compare with winter in its cold white beauty, or with the sweet, fresh rejuvenation of the spring, or even with the lazy charm of a hot summer day which, unlike the monotonous heat of the tropics, one knows will not last. But the greatest contrast of all was with autumn, for in this land the trees are never bare with the seasons, but leaves succeed each other unnoticed in perpetual succession of life and death. They know nothing of the dramatic hour which awaits our English foliage, as green changes to crimson, gold and brown and, when it falls, leaves the forest branches stark and comfortless against grey skies. Weary of this monotony I longed for the fresh winds we heard we should get in the little village on the east coast where we were going for the next two weeks.

It was less than a hundred miles away by road, a journey that could be arranged easily and would not tire the children. Mina, we decided, would be insufficiently recovered from her illness to come with us, as previously intended, and Supina would have to stay behind to cook for our friend and lodger. There were no difficulties about Suppiah coming — except those she made herself. I stood listening to her making all manner of excuses for not accompanying us, the last of them being that she could not eat Chinese food and that we were going to a resthouse run by Chinese. This final difficulty was only overcome when we agreed, at some inconvenience, to bring Ahmad too, to cook for her.

We had already been warned that there was no extra sleeping accommodation. So far as Suppiah was concerned this did not matter, as she was, for the first time, going to be sleeping with the children. This was probably one of her objections to coming with us, although she did not admit it. Suppiah would not want to risk interrupting her sleep if she could avoid it. Ahmad then, if he came, must fend for himself, I told him, forgetting what a marvellous opportunity for dramatic self-advertisement this gave him. He would sleep anywhere, on the veranda, in the garden — never mind the snakes or the rain or even the tigers. He would guard and protect us all.

So this was all arranged, but what was to be done with Mina and Zeida? I was now a bit doubtful about leaving these two young girls with Supina, lest there be something in what Ahmad had told me. It was his suggestion that they should stay with his mother; they could go there the day before our departure, he said, and he would collect them when we returned. Mina was still convalescing and had not left the garden since she had returned from hospital.

Next day we all crowded into a truck, packed together tightly with a variety of luggage, including, amongst countless other things, a large cot and a camp bed for Ahmad. He was quite oblivious of everything other than that he had to sit in front with the driver while I sat near Suppiah (with Tania) at the back, and this he resented. So we set out with Ahmad already in a black mood; but I was too happy at the prospect of our holiday to care. Even then there was to be one more display of temperament, which was as touching as it was unexpected. As I started to close the door of the truck Supina, who was standing on the steps to see us off, suddenly dashed forward, seized my hand and kissed it, while large tears rolled down her cheeks. I then remembered that when we were discussing who should accompany us she had volunteered to come. But I had not realized that she really wanted to and was not merely saying she would out of a polite willingness to help.

I enjoyed every minute of the journey through the outskirts of the town, watching the endless variety of figures coming and going. Many of the impressions still stand out clearly in my mind. The first is of a group of Chinese women walking together, all carrying black umbrellas to protect their uncovered heads from the sun and wearing bright blue jackets over black shiny trousers. One of them wore a jade green cotton coat instead — such a pleasant note of colour to contrast with the blue.

Soon after leaving the town we passed through a village and Suppiah pointed out where she had lived with her first husband, giving a loud and glowing account of her life there for Ahmad's benefit. I saw the back of his head fall forward and, sorry as I was for him, I wished he had been left behind. Forgetting him and looking again at the landscape, I saw more Chinese women walking in single file, all dressed alike, strange figures like witches from some fantastic ballet. Their costumes were astonishing; if you had met them in Europe you would not have believed your eyes, but here they were a common sight. To protect themselves from the sun each of them wore a hand-woven hat with a very wide flat brim and a high pointed crown. The hat rested, not on the head itself, but on a scarlet cloth worn as a hood and tied under the chin. The rest of their outfit was all black — jackets with long pointed sleeves that covered their hands, and long cotton trousers. There were about eight of them, all carrying what looked from the distance like flat wicker trays, large and shallow, curiously all tucked under the same arm — dancers in a ballet, stepping to a tune.

Further on the journey I met more of these peasant women working on the land. They had discarded their witches' hats so that I could see the cotton handkerchiefs worn over their heads, varying in colour from a deep red to a pale pink and even mauve. They were preparing the ground site for a house, moving to and fro, figures in black with coloured heads bowed to their work.

After this we passed yet a third group of Chinese peasant women in black, this time wearing brilliant orange scarves over their heads and under their chins. They were hard at work cutting into the hillside, and did not look up as our truck passed. What a rich and lovely colour scheme they made in their orange and black uniforms and weather-beaten brown skins against the red earth and long sweeping acres of emerald green grass over the hill beyond them.

Now the landscape changed again. There were few people on the road, which twisted interminably past rubber estates and on into the jungle. For miles there was nothing to be seen but giant trees standing out from the depth of the forest on either side, grey bark and ghostly lights against olive backgrounds, with this narrow, red, earth road stretching between. Every now and then we crossed a bridge of loose planks, which rattled as we drove over them, a sudden and unpleasant noise which awoke and frightened the children.

55

I was quite exhausted with impressions by the time our journey came to an end. I think Ahmad had been too absorbed in his own mood to notice anything outside himself. Now he found fault with nearly everything, including the wind, which softly and freshly blew salt from the sea, which the resthouse, perched on a hill, overlooked. Round the garden the slender casuarina trees, their foliage delicate and feathery, swayed and rustled in the breeze. We could take full advantage of the wind, for our bedroom was built with windows on three sides looking out towards the sea. Suppiah, who had charge of Margaret and Tania, slept in the room adjoining ours, while Ahmad found a passage nearby where he put up his bed and soon made himself comfortable. Suppiah, living so intimately with the children, developed a stronger affection for them, which they returned. Although she gave Ahmad a bad time, I think she enjoyed every minute of our holiday. She had a gift for making friends, which she was quick to exercise when, as now, she had the opportunity. That Ahmad disliked her doing so possibly made her enjoy it all the more. She was soon sitting in the kitchen talking and laughing with the Chinese cook, a big jovial fellow and excellent at his work, while Ahmad remained sullen in the garden. She and he had constant rows. Ahmad refused to eat and became more and more unhappy, while Suppiah devoured with relish the curries that he prepared for her. She seemed to benefit as much from the change as we did. At home I had never seen her eat for pleasure. Here, the less inclined Ahmad was for food, the more she enjoyed hers. She put on weight and, not sharing the usual Malay dislike of the sun, at the end of a couple of weeks looked more like an African than ever. She was splendid with Tania. My husband and I used to go out walking and leave her in charge of the children without the slightest anxiety.

On one of these excursions we took a boat out to one of the small islands lying off the coast. We were extremely lucky with the weather and the brilliance of the sun and the blueness of the sky lent enchantment to the island. The sand was white and as fine as salt and the sea richer in colour than emerald or jade; the long trunks of the palm trees were silver where the sun caught them and the palm fronds golden and shining, shading a little pool at the foot of a ravine, a pool that reflected a blue as brilliant as the sky itself. Now when I think of it, remote and beautiful, it seems like a paradise I had known long ago in some other existence.

When we returned Ahmad and Suppiah were not on speaking terms. While we were out my husband used to think of things to tell Ahmad that might force a smile out of him and make him forget his misery. We told him how the Malays could not get the engine of the boat to start on our return from the island and how we had sat out at sea for over an hour wishing Ahmad had been with us, for his deft hands and mechanical instinct would soon have put it right again. He responded with a slight gesture of his head but he was too despondent to be roused even by this appeal to his self-esteem.

On sale at the resthouse were hand-woven bags, little baskets, mats and small purses made by the local Malays from a palm used for thatching. The finished article resembled raffia work, usually on a natural coloured background with a few threads of purple, green or bright pink woven in to bring out the pattern. We bought some smart little bags for Mina and Zeida and something larger and more suitable for Supina.

Ahmad also decided to buy presents for his relatives and friends at home, borrowing the money from us. When it was time for us to set out on the return journey, our truck looked like a harvest festival, loaded with the huge quantities of fruit and vegetables Ahmad had bought early in the morning before starting. He had collected bananas, coconuts and durian (a large thorny fruit greatly loved by the Malays, but having such a pungent odour that few Europeans can bear it) and other fruits of the most bulky variety, all of which could be bought in Singapore, though not of course so cheaply. These were the presents to be distributed among his numerous and expectant relatives.

All the way home Ahmad sat nursing his arm and complaining of the strain it had undergone bringing all this stuff up the long hill from the market to the resthouse. I was glad to see that Suppiah's ill-temper seemed for the time being to have exhausted itself. She refrained from her bickering, the children slept and we had a peaceful journey home. When we arrived Supina was on the steps waiting for us, and Mina, looking very well, bustled about under her directions opening doors and windows. I was a little surprised to see her, but with Tania ready for bed my mind darted rapidly to questions of aired sheets and pillows and, going upstairs, I forgot all about her.

'Everything is all right,' said our kind friend when he returned to lunch, so we settled down again to the usual routine. But unfortunately

he did not know what had been going on behind the scenes. Ahmad went off to fetch Zeida and some special ointment for his arm, which was still troubling him. He explained that this lotion was made up by himself and would do it good. While Ahmad was gone, I went into the garden to see what Abbas had been doing during our absence. Not much, I feared, as he was not only a bad gardener but lazy, and likely to have taken the opportunity to slack while it lasted. My favourite tree had got a blight on it. Its large white flowers, like double peonies, still blossomed boldly among its withered leaves. While I stood there wondering if anything could be done about it, Salem's father came over to speak to me. He enquired whether our holiday had been a pleasant one. It had, I said, and how about things at home? For himself, very well, he replied, but as a friend he owed it to me to tell me that things in my house were not as they should have been while I was away. He apologized for saying so much and was reluctant to say more. But I insisted and he told me what he had seen. Supina had been visited nightly by her tall dark friend and had often gone out with him. This part of his story did not surprise me, but I was shocked and angered by what followed. Mina had returned to her room at the back of our house the day after we left. She had been careful not to show herself to our lodger, who went to and returned from his office at regular hours. She had also often accompanied Supina on her nightly excursions.

I returned to the house with all these things heavy in my heart. Not long afterwards, Ahmad returned with Zeida. I must question him, I thought, but the time was hardly appropriate as Margaret ran out to greet him. She was very fond of both Ahmad and Suppiah, whose quarrels with one another did not appear to affect her. 'Bapa,' she called out, which is the Malay for father. She called Suppiah 'Mak' or mother, and Zeida 'Kakak' or elder sister. Margaret could by now speak Malay and English with equal fluency. Tania also when she began to talk chose Malay as her first language and we had left the country before she started to speak any other. These children were not speaking classical Malay, be it understood, but copied the language of the common people and endeared their hearts to them for that reason. Soon Margaret caught the simple country songs that Zeida sang about the house.

> Here comes the rain,
> Off run the flocks,

You Tamil man,
Get into your box.

This Malay song was one we came to know especially well, for it was repeated whenever rain threatened or came, and the singers delighted in substituting each other's name for that of the 'Tamil man'.

Ahmad returned home from carrying the presents to his relations looking dreadfully ill. His arm, white from shoulder to wrist, swung uselessly by his side like a pendulum. He was grateful when Margaret asked him about it, because Suppiah was much too busy giving Tania a walking lesson to bother to look up and greet him. Judging from the intensity of the pride and delight on her face, these first steps mattered more to her at that moment, I thought, than anything else in the world. Tania was pushing the little rattan chair on wheels and venturing to let go, now with one hand, now with both, responding to the praise and encouragement Suppiah gave her.

When Zeida had gone to find Mina, and Margaret had joined them, I took Ahmad aside and questioned him about Mina. It was as Salem's father had told me. She had refused to stay with Ahmad's mother for more than one night after we had left. Zeida had remained but Mina had disappeared. Ahmad's mother had a great sense of discipline and would, I dare say, have made things uncomfortable for Mina in her own house. But I could still hardly believe that Mina could have defied convention, not to mention my express wish and that of her guardians, to act in such a way. Ahmad and Suppiah were very angry with her and that night my husband lectured her. But it was really very little use being angry now, I thought.

9

Ahmad's Secret Revealed

T he eggs from the market became worse and worse, until finally, when we could tolerate their odour and taste no longer, I suggested to Ahmad that we might keep a few hens. At that time our neighbour's hens were frequenting our garden, appearing to find its attractions superior to their own, so we did not stand to lose anything by the experiment. Ahmad, as I might have expected, had more than a passing knowledge of poultry farming and he discussed with me learnedly the rival advantages of plain and hill stock, and the desirability of buying our own cock and breeding. He then set out for the market, from which he returned with four very nice looking hens which, for a while, did all that was expected of them. He quickly knocked together a hen coop from packing cases and immured the newly arrived birds in it for the several days it took until they came to regard it as their home and returned to it of their own accord at nightfall. The coop was then moved indoors into an empty room adjoining Supina's, which could be locked, for it was never safe to leave anything outside after dark.

In imagining that the procurement of hens and the provision of the necessary inducements for them to lay would ensure to me a sufficient supply of eggs, I fell into the same error as many other European housewives newly arrived in the tropics. For some while all went deceptively well. The hens produced an ample supply of eggs, so that when one of them gave up in order to concentrate on rearing a family, I was happy to think that she could do so without our going short of the fresh eggs we had begun to enjoy. I was puzzled to see that two birds were sitting, while the same number as before appeared to be scratching about outside. Ahmad enlightened me. Suppiah had also invested in a hen, a broody hen, and the two of them were sitting together. I felt he ought to have added the words 'to see which will do best' and my

unspoken thought was that my hen and her brood, which Ahmad was supposed to be looking after for me, would stand little chance in competing with Suppiah's. So it turned out, for the other brood was three times as numerous as mine and survived with fewer casualties the perils of chickenhood in the tropics — the hawk that swooped swiftly and unnoticed through the boughs of the rain trees and the smooth-sided storm-water drains that became miniature cataracts after a sudden shower. As with the chickens, so with the eggs; our hens soon lost their initial enthusiasm, or so Ahmad said, though if I insisted on having a fresh egg, he would always be able to produce one. 'The hen has just laid,' he used to say naively, which amused me as he feared that I might think he was appropriating my eggs under cover of Suppiah's posses-sion of a hen and thought he could deceive me. It was certainly a remarkable hen if it really produced eggs at that rate, while mine had gone off laying altogether. Suppiah's pullets also seemed to do better. There were, as time went on, plenty of them about, making the back of the house disgusting with their droppings. They even strayed into the kitchen and left their messes there. I was not only tired of the experi-ment I had encouraged, but disgusted by these chickens. I might have had better results if I had been able to give them more attention, but since our return from local leave I had not felt well enough to do so.

Cats were another minor vexation and provided us with many oppor-tunities for cursing the casual outlook of our Malay household, which was as much a part of their nature as their friendliness and humour which so delighted us on other occasions. Unlike the hens 'Tempor' was introduced into our house without any prompting on our part. She soon cleared it of rats and mice and then, like the hens, settled down to the business of rearing families in earnest. She had four of five of them in the time we knew her.

Her families, as they grew up, were distributed among Suppiah's relations, who took them away after our children had gone to bed. It would have been considered unlucky to drown them and, I must say, although I did not wish to keep them, I did not like the idea either. However, no sooner was one lot disposed of than we suffered all the noisy preliminaries of another.

We tried times without number to engender in Suppiah and Ahmad a sense of responsibility towards Tempor but their efforts never lasted for more than a few days. I had deliberately avoided acquiring an animal of

any sort, because with two children already, and a third to prepare for and my drawing to work at, I had as much to do as I could manage. So although Ahmad locked up the house at night, my husband always went round afterwards testing the doors and windows. We never felt that we could rely on Ahmad absolutely. He was by nature casual and temperamental and his relationship with Suppiah aggravated this condition. Most nights Ahmad collected Tempor before he had finished locking up, but often when we went round later we were aware of her presence in the house and could not retire to bed until she had been picked up and dropped through one of the back windows.

Sometimes Tempor got onto the roof of the covered way connecting the house with the kitchen and found herself unable to move backwards or forwards. The jump to the ground was just too much for her, but if a chair were placed somewhat precariously on the slab by the kitchen sink, and someone tall stood on it, she could usually be enticed within reach and be lifted down. Well do I remember my husband so standing one evening when we had gone out to have a talk with Supina while she was washing up. Supina had, since our return, kept rather more to herself than before, because although Suppiah had forgiven Mina, she had not forgotten Supina's behaviour while we were away. My husband and I felt sorry for Supina for, in spite of her shortcomings, she was a delightful person to have in the house. Whatever her temper with other people, with us she was always cheerful and, although constantly being out late at night must have been a drain on her physique, she was always a very hard worker. On this particular occasion I had taken a cloth and was drying the dishes as Supina washed and put them on the draining board. We were really all enjoying ourselves, laughing and teasing her and making little jokes. Then Tempor started mewing up above. Supina disappeared indoors to put away a pile of plates and my husband tried to coax the cat to come down. But tonight she was very obstinate and stood there crying and not moving while my husband stretched in vain to reach her. We did not get her down though, for suddenly we heard terrified shrieks from Supina. My husband jumped off his chair, I dropped a handful of spoons and we both raced down the steps into the house.

Ahmad was lying full length on the floor, rigid and unconscious, his fists tightly clenched, his eyes shut and at first I thought he was dead. He had fallen diagonally across the confined space at the foot of the

stairs on the hard concrete floor, so that it was only possible to get into the pantry by stepping over his body. He must have just finished locking up because the key of the dining-room door was in the drawer where he always left it. Supina ran out into the garden, hysterically calling Suppiah. My husband went to ring the doctor while I stood looking at Ahmad not knowing what to do. Then Suppiah ran in, followed by Supina and Mina and Zeida. She took one look at Ahmad and said '*Hantu*', which is the Malay word for a ghost or spirit. She was quite sure Ahmad was possessed by an evil spirit. She bent over him, calling 'Mat! Mat!' but nothing roused him. My husband returned, having failed to get the doctor. We all lifted Ahmad and carried him to the nearest room at the back, which was Mina's. He was a great weight in this condition and very awkward to lift. There, Suppiah showed an affection for Ahmad which amazed us and, had she been conscious of it, would probably have amazed herself. She started whispering terms of affection in his ear, calling herself by some pet name I had not heard before. This demonstration of unexpected affection was poignant and touching, even tragic I thought. Ahmad, who so eagerly drank in any chance word of kindness or praise that fell from his wife's lips, was deaf to this astonishing exhibition which we had never witnessed before and about which, poor man, he would never know.

Ahmad was alive but still had not recovered consciousness. My husband thought he had better try another doctor. While he was gone Suppiah and Supina started rubbing Ahmad's arms and legs and pum-melling him all over. Mina and Zeida remained in the background, squatting close to each other and staring at the spectacle, silent and terrified.

Then my husband returned. This time he had succeeded in getting in touch with a doctor. The doctor said it might be a fit, and if so Ahmad would be coming round in a few minutes. But, he added, if this is the first one, he is, at thirty five, a bit old to be starting epilepsy. It may be something else.

My husband came back with this news and about the same time Ahmad began to revive. The colour, or more correctly the appearance of life, returned slowly to his face. His limbs relaxed and he opened his eyes. 'Oh! My head! My head!' he complained. 'The spirit is going,' Suppiah said in Malay. Mina and Zeida ran forward now that Ahmad had 'come to life,' more curious than frightened. Supina, with simple

faith, muttered some words about devils and jinn. Ahmad was fully conscious now but suffering from an acute headache and the one light in the room worried his bloodshot eyes. We helped them all lift him up and take him back to his own room and then, when there was no more to be done, went off to bed ourselves.

But it was a long time before I could get to sleep. To get rid of Ahmad and Suppiah at this particular time was the last thing I wanted. I had the future to think of. When, at a later date, I should be going into hospital, I wanted to leave the children in Suppiah's care, because she had proved herself to be reliable; she knew their routine and loved them. I was doubtful about leaving my children with a comparative stranger, which anyone taking her place would inevitably be.

I could not get to sleep while the problem turned over and over in my mind. On the other hand, I did not want to have an epileptic about the house, if Ahmad really had epilepsy. If they stayed, I thought, I must make it quite definite that Ahmad must on no account ever be allowed to pick up Tania — poor fellow, he so enjoyed carrying her round the garden, talking to her, delighting in the happy noises she made in response. Epileptics often fall without warning. I thought of the large concrete drop and the hard drains outside the kitchen, shuddered and turned over. That must be made quite clear, I said to myself, and he must not carry hot water, must not carry ... must not ... hot water. ...

I must have dropped off to sleep at that point. When I awoke it was already morning — a long way past dawn. The sun shone in a scintillating blue sky; the yellow flowers were wide open again and everything was hot and still. I hurried into my clothes, thinking of Ahmad, and went to his room. The patient still had a very bad headache; his eyes remained horribly bloodshot and he was desperately depressed. 'I've sent for his mother,' said Suppiah.

I looked forward to her arrival, as perhaps she would tell me something of her son's past history. But she only shook her head and denied all knowledge of epilepsy. She was a fat little thing, like an old barrel, with unhealthy, flabby cheeks and a wart on her nose. We called her 'Mak' but that was not her real name. Unlike Suppiah's own mother, I never got to know her. So it was expecting too much, I suppose, to hope that she would tell me the truth, or at least what I suspected to be the truth, about Ahmad.

As soon as Ahmad was sufficiently recovered I sent him to the hospital with a note asking for him to be examined. The results were not very satisfactory. Unless I could in some way trace that he had had fits before there was nothing about him to suggest this condition. I believe it is impossible to diagnose epilepsy unless the symptoms during a fit are seen or accurately described. We, unfortunately, had only seen him after the fit (if it was a fit) had taken place. He might have been in a dead faint, having fallen for other reasons. It did indeed appear from Suppiah's behaviour that she had never seen him like this before. But he may possibly have had fits in his sleep, or even when she was not there and, not wishing her to know, concealed the fact.

Gradually the effects wore off and Ahmad resumed his usual duties, with the whites of his bloodshot eyes recovering their pale beige sallow appearance. It seemed as though he was normal again and I did not know what to think of the incident. But it was some time before I dismissed it from my mind and it occasionally returned to me afterwards to renew my former horror. Ahmad would suddenly look peculiar and I was fearful lest he should fall onto the open charcoal stove in their room, or in our house against some projecting angle, or down the stairs. The nightmare returned again and again that he was falling onto Tania, crushing her beneath his weight. I longed for the days to pass more quickly. For, until my baby was born, I felt at the mercy of Suppiah and Ahmad.

10

Painting at Changi

I t was pleasant to be able to leave the town behind occasionally for a day's sketching out of doors. Landscape painting is no easier than portraiture and I seldom obtained results that satisfied me. But to get in touch with the landscape and for a time to be aware of nothing else was a change and therefore a rest. When drawing portraits, one is constantly interacting with other personalities, which is very exhausting. Landscape on the other hand is impersonal, for although scenery has its moods, one does not have to make personal contact with it in the same way as one does with people who sit for their portraits.

Another advantage of drawing or painting a landscape is that it stays still for several hours at a time, provided of course one chooses a peaceful day. So it is not necessary to work at quite the same pressure. When the subject is a person, it is as well to draw the main construction of the portrait before the sitter requires a rest, for, on resuming the pose, the model is likely to take up a slightly different attitude. In all but the most simple positions it is often impossible to get the same pose again. Therefore, in order to carry out one's first idea, it is necessary to make sure that the construction or 'ground plan' is all there before allowing any movement. Only then can the model be allowed to relax slightly.

I found the landscape in Malaya especially difficult to paint. Palm trees, which are so graceful in reality, are seldom attractive on paper. The long grass which grows monotonously over vast areas when the trees have been cleared away makes a difficult foreground, because there is little form to seize hold of. Distant hills usually form part of great ranges of mountains, the whole of which one cannot see without turning one's head to right or left. To paint only the part that lies within the fixed focus of the eyes (and one cannot draw or paint from more than one angle of vision) seems to me to destroy the beauty which lies

in their expanse. Sky and clouds are often gorgeously dramatic, especially at sunset, but it is difficult to capture their beauty and the results are too often merely sentimental.

So I collected the materials I would need and went downstairs, without any great expectations but determined to enjoy myself. Supina had packed up a nice picnic basket and smiled rather wistfully as she put it in the car. She would have liked to accompany us. Ahmad and Suppiah saw us go with the greatest goodwill, for on picnic days they could work — or not — at their own convenience. Mina came with us. She was moody today, sitting silently in the back of the car, staring out of the window with Tania and Margaret beside her. I could see by her eyes that she was not looking at anything and certainly was not listening to Margaret's chatter. Margaret might as well have talked to the cushions as talk to Mina. But this did not seem to put her out and she went on as children do from one question to another without minding whether she got a reply or not. In this way we left the city behind and passed through outlying villages, the houses continuing almost without a break except for patches of wasteland, or of (aesthetically) uninteresting rubber trees.

Suddenly we emerged on the coast and the villas gave way to the sea, which at this point came almost up to the road. Tall palm trees bent over the water, and here and there long rows of fishing stakes jutted out into the sea like fragile fences with little houses on the end. I always enjoyed driving along the coast and looked round to see if Mina was enjoying it too. But she appeared to be taking no notice. I did not attempt to wake her from her, no doubt, much more interesting adolescent thoughts, but returned to my own enjoyment of the view. The road left the coast and passed through a few more miles of undulating country until the sea came into view once more, just as we reached our destination.

I had been there before soon after I first arrived, when the two Chinese were still with us. That was a long time ago now. We had stayed in the government bungalow, with its atmosphere of enchantment and peace, which was almost impossible to find on the crowded island where we lived. Now that I visited it again I thought it was lovelier than ever. Looking out to sea there was a superb view across the Johor Strait to the hills beyond. At sunset they were spread with powdered gold and here and there a building glittered like a jewel. From the

veranda, which ran the whole length of the house, one could watch a vast expanse of landscape and enjoy the changing colour of the sea as the day pursued its course from dawn to sunset. Boats passed to and fro, mostly fishing craft but also pleasure yachts, one with a colourful sail which, caught in the evening glow, seemed transformed beyond reality as it sped to the west — an abstract shape which carried the mind away from temporal things.

I had sat on that veranda most days watching and painting this attractive landscape. Directly below the house was a garden, which had been properly laid out in former days but had been neglected during the Japanese occupation. One could still see traces of its former perfection. A double row of fan palms lined a circular path round the edge of the garden where one could walk unobserved from the house, as in some shrubbery in an old English garden. We wandered there amidst flowers that saved their perfume for the evening, wafting their scent through the cool air as the light began to fade and the outline of plants and trees became dim and mysterious.

Flowering bushes grew everywhere in this garden and there were all kinds of bougainvillaea — purple, magenta, mauve, deep red and flame. At the foot of the veranda steps stood two stone elephants. Age had coloured them an ochre-green, like moss on old walls. Perhaps they had been brought from Siam, from a sacred monastery or convent, to house the guardian spirit of this lovely dwelling. At night we saw their sombre forms as we sat on the veranda steps and we passed them each time we descended the terraced path bordered with flowers and scarlet-stemmed palms which led to the very edge of the seashore.

Today we parked the car farther off, for someone was in residence, and traced our way towards the sea by a little path that ran below a grove of coconut palms. We came round a bend in the shore to a creek, where there was deeper water in which a group of Malay women stood up to their waists carrying tins in their hands and fishing for something — but there was no one to tell me what it was and I had no way of finding out without wading waist high up to them myself. They were fully clad, but all their clothes were wet and clinging tightly to their forms. These I began to regard with professional interest, until I remembered that today, for a change, I was supposed to be sketching landscapes, and leaving faces and bodies severely alone.

Mina had strolled away with Tania. Margaret and my husband were

already in the sea. Finding some shade and taking up my pencil, I began to draw and forgot at once where I was or how long I stayed there. I continued working, lost in the scene before me, until quite suddenly I found I had finished.

On looking at my drawing I decided that I had better stick to portraits. But I did not have to persuade a landscape to pose, I thought regretfully, remembering how difficult it often was to procure models. Some needed encouragement, others responded to flattery. A few reflective ones needed nothing more than their own thoughts to keep them still and they, as a rule, made the best models because their minds went into restful regions and I could work undisturbed, without the double effort of making a portrait and entertaining the sitter at the same time. Children were very difficult and, whether they were Asian or European, I usually needed another person in the room with them to keep them amused and entertained. When there was no chance of a second sitting I had to persuade the model to sit for a little too long and try to ignore the signs of discomfort, such as fidgeting on the chair, cracking the fingers or moving the head. Then there was the occasional model who, having sat once, became difficult about sitting for a second time. This could be quite upsetting if the portrait had started well and required only a short sitting to be finished.

Looking again at my landscape, I thought that it was not really very satisfactory in pencil. Yet there is a certain quality in a pencil drawing that cannot be obtained by working in any other medium. The range of tone from dark to light is so extensive that one can go from pitch black to a silvery grey so light as to be barely visible. Perhaps charcoal would have been more satisfactory, but I had never tried landscapes in charcoal. I wondered about its possibilities. I had experimented with both these mediums on an Asian head and had found that on toned paper charcoal was more satisfactory.

As a rule one disregards colour in setting out to 'draw' as opposed to 'paint' and concentrates the mind entirely on form. But a landscape loses a lot without colour. Perhaps a suggestion of colour would help, as it sometimes improves a portrait drawing. My beautiful brown paper, so close to the bronze skin of the Malay, seemed to strike a happy balance between the two extremes of too much colour and none at all. What sort of paper would suit the landscape? A 'middle-tone' paper brings out the highlights, which on white paper are, to a certain extent,

inevitably sacrificed. The skin of a Malay is like a mirror reflecting lights. So is the sea, which reflects the sky. But in the one case I had found the right technique, in the other I was still searching for it and had got nowhere.

It might be expected that since portrait artists aim to delineate characters, they would succeed best with the characters they know best, but, strangely enough, often the reverse is true. Many of my most successful portraits have been of casual strangers; examining them later, I often found that I had expressed more of their character than I was conscious of while at work.

I looked at the sea again, and then at my sketch. No offence meant and none taken, I thought. How different it was with portraiture, in which one constantly risks offending people. It was true that my Malay sitters were not easily offended. However, I fear the reason for this was not that they were any less vain than other races, but that being, for the most part, simple people unused to seeing themselves in photographs or drawings, they did not know what to expect. They had only the barest critical knowledge, the comment 'not pretty' or 'too old' being sufficient to express it. More sophisticated people, on the other hand, are vain about their relatives, vainer about their children and vainest of all about themselves. Woe betide the artist who draws the character or features he sees, rather than those his sitter expects him to see.

So my thoughts roamed on until I heard Margaret's voice beside me. 'We've been right along the beach, Mummy. You have been sitting here a long time.' I picked up my sketching materials, the picnic basket and a pail of tiddlers Margaret had collected, and we all went home.

11
Artist and Model

Ahmad's fall was only the first of several crises which occurred during the next few months. Mina became so lazy I began to wonder if there was something the matter with her. The most that she seemed to be capable of doing was to sit vacantly regarding Tania in her playpen, or lift her up and carry her around in an aimless manner. The odd jobs for which she was responsible were done badly, or not at all. The washing was seldom brought in before it rained, as it did more often than not in the early afternoon. Of course my Malays could read the signs of the sky, but they did not trouble to. When a storm was approaching it always fell on me to rush round closing doors and windows in time, as they would not bother to stir themselves until the wind whirled into the rooms, blowing everything all over the place — papers, letters, or whatever happened to be lying about; it even sometimes blew pictures off the walls.

It was on such a day as this, when the rain had already started, that I found Mina sitting in the doorway of the kitchen looking at Tania's washing still hanging on the line. 'Go and get that washing in,' I said, 'you lazy, lazy girl,' not attempting to hide my annoyance. Mina rose slowly with an impudent and sullen air and went towards the garden to collect the washing. I was too angry to watch her and retired upstairs. But I could not stop myself thinking about her and became more and more indignant. By the time she finally brought the washing in my powers of endurance had broken down. I wanted a row. I called to her, and when she came I began to rate her all over again for her endless laziness. 'Never mind,' she said, interrupting me suddenly, 'I will go, I will go.' I did not know whether she was serious, or saying this for effect, and at that moment I did not care. But my mind quickly jumped from Mina to Suppiah. I did not want to say anything too definite that

might upset her as well, for during the ensuing months I could not do without her. 'Very well,' I said, 'but wait till Suppiah returns. I will talk to her.' Suppiah, Ahmad and Zeida had all gone out for the afternoon.

Mina hurried from the room, pouting. But I did not take the incident very seriously. Giving notice was a sort of game in our house, which they all enjoyed playing. Ahmad deliberately chose the most inconvenient time to indicate casually that he was thinking of leaving, as for example if one of the children were ill, or a guest had arrived unexpectedly, or some other event had occurred to upset the daily routine. There was nothing for it then but to reply equally casually that if he went it would be difficult, if not impossible, ever to find anyone to equal him. That was all he wanted to hear and there was no more talk of notice. Mina's trouble would blow over like the others, I thought, and returned to my work.

I was finishing, from memory, a head I had begun in the morning. It was of one of those chance models who turn up unexpectedly. Earlier in the week I had seen a Chinese peasant woman with a fine weather-beaten face at the back door selling fish and vegetables. Ahmad asked me to buy some tomatoes. 'She has eggs too,' he said. I glared at him. To ask me to buy eggs with those wretched hens all over the garden scratching up the plants was an insult. 'What is she asking for the tomatoes?' I enquired. 'A little more than the market price but they are better ones,' Ahmad replied. 'Very well. Tell her that when she has sat for me I will buy her vegetables,' I said, only half seriously. Ahmad thought this was very funny and went away chuckling to himself. I watched the Chinese peasant slowly disappear with her load of fresh vegetables in a large basket strapped on to the back of her bicycle. I thought no more about the incident.

But apparently Ahmad did not forget. One morning not long before lunch he suddenly appeared, very pleased with himself. 'Here's your model,' he said. I looked at the person standing behind him and at once recognized the Chinese peasant who had come to sell vegetables the week before. She was dressed in the high-necked cotton jacket worn by all Chinese working women, a style which was always the same, though the colour varied from black to many kinds of blue and, occasionally, light green. House amahs wore white ones, or perhaps a floral cotton for a trip into town. The peasant woman's jacket was Prussian blue, which looked very good over her black trousers. In one hand she

carried one of those tall pointed hats I mentioned earlier and, being shy, she played with it, pulling out the weave where it had broken. She could not understand more than a few words of Malay, but with signs I indicated to her that I wanted her to put it on, which she did with some embarrassment. I should have liked to have drawn her full face because she had those far-seeing eyes one finds in fishermen, shepherds or sailors, but I knew she would be much too self-conscious for me to attempt it. I had tried to draw Malays full face before now but found, until I knew them well, that they also were too self-conscious. When they sat for the first time they had to look down or away from me to control their nervousness. Only when I had drawn Supina and Mina several times did I attempt them full face. I sat my new model down in a place where others had posed before and where I knew how the light would fall, for I had no studio out here and there was no such thing as a north light. Light was a real problem; there is so much of it in the tropics, with doors and windows opening everywhere and white walls casting endless reflections. By experience I had learnt that if I closed some of the shutters on the veranda I had a certain amount of control over the light, though it was far from perfect.

I worked on as rapidly as I could because I felt that this might be one of those models who would not sit again. She kept looking up and saying something in Chinese which I did not understand. I gathered she wanted to go. She had her rounds to do and I suppose some of her regular customers would be expecting her. 'Only a little longer,' I said in Malay, which was a phrase she understood, and by repeating this at regular intervals I coaxed her to remain sitting until I had almost finished and had reached a stage where the rest could be done from memory. When she got up to go I thought she would hurry away but she seemed to have forgotten her previous impatience and stared curiously at the sketch on my drawing board. She appeared to be quite pleased with it and kept laughing and looking at it and laughing again. Finally I had to escort her down the stairs to get her to go so that I could finish the portrait while the details were still fresh in my mind.

It was strange how these models came to me. I have already mentioned the Cantonese lady in a red hat. I must now describe how she appeared when I least expected her and only after I had made several unsuccessful attempts to get one of these women, with their decorative red headdresses, to pose for me. The house we lived in had not been

done up since before the Japanese occupation. Funds and materials were short so there was no hope of having it repainted, but some of the woodwork was rotten and needed to be replaced, while the walls were overdue for a coat of distemper. The Public Works Department contractors visited the houses in turn to give what first aid was necessary; in ours they were to carry out some repairs, colour wash the walls and clean the paintwork. I came home one morning from a shopping expedition to find that they had already started and had turned every room upside down. Indoors on the ground floor there were buckets, ladders and workmen everywhere. Not very encouraged, I went upstairs and nearly fell over a large pair of steps jutting out from a doorway on the veranda. I peered through and a face turned round and grinned at me over the top of the door. Great was my surprise and delight, for it was the Cantonese lady I had been looking for, wearing her red hat. I could hardly believe my eyes. Trembling with excitement, I beckoned to her to come down, sat her in a chair and, before she had time to realize what was happening, started to draw her. I really think that the next few minutes were the most exciting of my life. She sat quite well and I worked feverishly, determined to take full advantage of the marvellous opportunity which had been given to me. After some forty minutes of intense effort, I had to get up to sharpen my charcoal. When I looked round, to my dismay, my model had vanished. She was up on the top of the steps again, cleaning the paint for dear life, her head bent over her work as intensely as I had been bent over mine a few minutes previously. She would not speak or even look round at me. Never mind, I thought, I would relax now and finish the portrait tomorrow.

But the next day she would not sit again. I was in despair. I only wanted another quarter of an hour, but I could not do without it. Fortunately our lodger could speak Cantonese. I told him about the plight I was in and he promised to have a talk with her. I waited eagerly to hear what he had to say. 'She is frightened of the Chinese foreman,' he told me. 'She thinks he will say she has not been doing her work properly. If you make it all right with him, she says she will sit again.' Next day, as soon as the foreman arrived, I cornered him. He smiled when I told him what I wanted and raised no objections. So she sat again in her red hat. When it was finished I showed her the result, which she seemed to think very amusing. She kept pointing to the outline of her high cheek bone and rocking with laughter. I gave her a tin of milk as a present and

she went back to her work perfectly happy. Later I finished the portrait from memory.

But we must go back to Mina. I had forgotten about her while I was working and only remembered when I heard Suppiah and Ahmad return. Then I called Suppiah upstairs. She listened carefully to all I had to say of the annoying event in the early afternoon. 'Never mind. Don't be angry. I teach her a little,' she replied. I knew that Mina had had more than enough time to be taught and would never learn, but I did not say so. 'Very well,' I said. 'Will you go and have a talk with her now?' I wanted to get the thing straight right away and start again in a happier atmosphere.

Memory drawing is important, I thought, forgetting Suppiah and the rest of them. It is essential to analyse the object to be remembered until one can pull it to pieces and put it together again like a jigsaw puzzle. Details will slip into their place easily if the construction has been correctly committed to memory. There is no better method for artists to use, if they think they have reached a standstill in their work and want to improve, than continual practice in memory drawing. Artists who have memorized an object and are able to reproduce it satisfactorily afterwards can be sure they have understood it. After practising figure drawing away from a model I found my confidence greatly increased. This morning's work, for what it was worth, was the result of rapid and intense concentration, which I could not have achieved without much previous practice in drawing from memory. In reality, all drawing is memory drawing, for it is impossible to look at a model or a landscape and draw at the same time.

Soon after Suppiah had departed I heard her calling loudly for Mina downstairs, using the abbreviated 'Mo,' which she affectionately employed in conversation with her. She repeated it again and again, her tone getting more and more desperate. I thought I had better go down and see what had happened. There was no one in the little room down-stairs where Mina and Zeida often sat, and no one in the back garden running between the house and the kitchen where the Malays usually congregated. The kitchen, too, was deserted. The door of Suppiah's room was ajar. I peeped inside and saw Supina fast asleep. Mina's room was the next. There I found Suppiah but no Mina. All Mina's belongings had gone, except for her big iron bedstead. Suppiah stood facing the bed in an attitude of despair, and I realized at once that Mina

must have run away. Suppiah did not seem aware of my presence. 'Where is Tania?' I asked. 'Asleep,' she said hoarsely. 'Where?' I repeated. 'On the veranda,' she said in the same husky voice. I went to satisfy myself that Tania was really there, and then returned to find Suppiah still looking vacantly at the empty bed. It was not her nature, as it was Ahmad's, to dramatize her feelings, and only her behaviour made me realize what Mina's sudden departure, without a word of farewell, must have meant to her. But she said little, either now or later.

At that moment Ahmad appeared. He did not take long to grasp what had taken place and seemed to derive a malicious pleasure from it. I already knew that he was insanely jealous of Suppiah's affection for Mina. Now he quickly took the opportunity to inform me that Mina owed him thirty dollars. At that time (as Ahmad knew well) I was too distressed about losing Mina to say anything except that I would pay up. But I have since doubted that it was a genuine debt. Ahmad was always cunning and clever at picking the right moment.

For me, Mina was part of the great joy I found in Singapore. She was there when I first arrived and, till now, had fitted into the pattern of our lives — a woven pattern in coloured threads, each one dependent on the other for perfect balance and harmony. A thread had been withdrawn; without it my pattern was incomplete and, being a dominant colour, the lack of it was all the more obvious. She had posed for me on countless occasions and was a superb model in spite of the fact that she seldom sat well.

It distressed me to see how upset Zeida became over Mina's elopement. On looking out of a top window, I sometimes saw her sitting on the steps, her head on her hand, thoughtful and melancholy. She was like a child without a playmate, a small girl without her elder sister. It was incredible that Mina should have left them all without one word. There must have been some reason for it. 'I am sure she will come back,' I said to Suppiah when the subject cropped up again. 'Not so,' she said. Mina would not come back. Mina was going to have a baby.

Supina had kept very quiet about the whole affair. Though I never got to the bottom of the matter, I did wonder whether she was harbouring some secret about it.

12
Life Without Mina and Supina

I wanted to find a replacement for Mina at once as Tania was at the most difficult age of learning to walk and falling down everywhere. Our house was surrounded by steep banks and the unprotected edge of the lower veranda was two or three feet higher than the cement path which ran all round it — very dangerous for a child at the toddling age. My thoughts turned towards Ka-Muna. She visited Suppiah regularly and was out of a job at present. As she frequently sat for me, I was pretty well acquainted with her and had heard her somewhat unusual life history. She was a Straits-born Chinese who had once been married to a Malay — a distant cousin of Suppiah's — but he had been dead for many years. She wore the Straits Chinese costume, which was much closer to the Malay than to the Chinese style of dress, though still quite distinct. Their jackets were longer and of a different cut, having long points in front and often scalloped edges, or trimmings all round. They dressed their hair in another mode, coiling it higher up the head and keeping it in place with one or more heavy gold pins. Ka-Muna had not much hair left, but what there was of it she brushed straight back and finished in the Straits Chinese style. The neatness of this fashion, compared to the loose, more untidy hairdressing of the Malays, always struck me as typical of the difference in the characteristics of the two peoples.

Ka-Muna had been thinking of marrying again, but one day, not long before Mina left, she confided in me that she had changed her mind. She felt she could not undertake the responsibility of the many grandchildren who were dependent on the man she was to have married. It was not perhaps a very promising introduction to my asking her so

soon afterwards if she would come and look after a child for me. However, after some hesitation she agreed to come. She had never worked in a European household before, and was already quite elderly.

But as she was a Chinese my hopes ran rather high. Nearly all my friends had Chinese amahs and seemed to think the world of them. After some training, perhaps, Ka-Muna would be equally efficient, and I could keep her without antagonizing my Malay staff, as she would be used to working with them and not rub them up the wrong way. It was too good to be true and, in the event, Ka-Muna did not stay for long. I think she was too old and set in her ways, and found the regular routine of bathing the children, taking them for walks and playing with them too irksome. The children exhausted her and she could not control them by mere charm of manner alone. One day she came to me in tears and said she had changed her mind again and would I let her go. Poor thing! I felt sorry for her, but I watched her leave with a heavy heart.

On the morning Ka-Muna went, without formal notice on either side, I suddenly remembered that I had promised to give Supina the afternoon off, having forgotten that Suppiah had previously asked if she might also go out that afternoon. As it would be difficult to look after Tania and do the cooking as well, I went into the kitchen to find Supina and see if tomorrow would suit her as well. She was stirring a pudding and did not look up when I came in. She was preoccupied as though she had something on her mind. Her husband was standing in the doorway.

It was not often I saw him about the house. He seemed rather put out and kept nervously twisting his hands and opening his mouth as though about to speak. I ordered the meals and explained to Supina that, as Ka-Muna had already departed, I hoped she would put off her afternoon out until tomorrow. She seemed a little upset, but agreed to the new arrangement, perhaps because she could not very well do otherwise without giving me a suitable reason why tomorrow was not as good as today. As I turned to go I was conscious of Supina's husband making a movement to follow me. She turned and glared at him. What was it all about? I wondered, but dismissed it as typical shyness. Perhaps he had a request to make to which Supina objected; perhaps a relative was sick and he wanted to borrow money, and Supina was ashamed of him on that account. He made a second effort, this time actually saying something, but I could not hear what it was. Turning to Supina, I asked: 'What is it your husband wishes to tell me?'

Hardly had I uttered these words when I saw Supina's face change and become like that of a wild animal. Her pupils dilated, her eyes seemed to stand out of her head. Her face was pale and set and passionately angry. In her expression there was a single-minded purpose, frightening and terrible. Before I realized what she was doing she had picked up the carving knife and was holding it high and purposefully, just like her ancestors must have used their daggers. She pointed it at her husband, while walking deliberately towards him, like a tigress measuring her distance before she pounces. Then I became frightened as I had never been frightened by a human before. The two of them struggled fiercely, Supina's husband being, fortunately, stronger than he appeared. What was I to do?

Ahmad had gone to market and had not yet returned; the gardener, Abbas, was nowhere in sight. The whole place seemed deserted as I ran out into the garden shouting for help. It was a terrible moment. Suppiah and Zeida ran to my assistance and somehow, between us, we managed to separate them, mainly thanks to Suppiah, who seized Supina's wrist and squeezed it so hard that she was forced to drop the knife she was carrying. She stood there, panting from exhaustion. 'Go to your room,' I said to her. 'And remain there until I call you.' The man I advised to go away at once. He did not have to be told twice and, as soon as he had gone, I walked up the garden trying to collect myself.

Margaret was at school and Tania was playing quietly in her playpen, out of sight of what had been going on. I asked Suppiah to keep an eye on her. By this time a kindly neighbour, who had heard me calling, was on the way over to see if there was anything she could do. 'You look very shaken,' she said. 'Won't you come over and have a cup of tea?' At that moment I badly needed to make contact with another European and to be with someone to whom I could talk, for I was still very frightened. So I accepted her offer with gratitude.

When I got back Ahmad had returned and Suppiah had Tania on her knee. They were all sitting round their door in a family party, having just finished their late breakfast, and were carrying on as though nothing had happened. Suppiah heard me coming and, looking up, said offhandedly: 'Supina has followed her husband. She did not take your knife though' — as if that were all that mattered — 'She took one of her own.' She spoke casually as of something that did not in the least concern her, which I suppose it did not, personally. I could not take

such an impersonal view and telephoned the police, who arrived shortly afterwards. Three of them came. One remained with me, as Supina's belongings were still in her room and it was thought she would return for them. Besides, it was the last day of the month and she was due to receive her wages at lunch time. The other two policemen went off in search of her, accompanied by Ahmad who would identify her. This increased his feeling of self-importance, besides which he enjoyed getting his own back on his sister-in-law for her treatment of his brother. He was quite cheerful, almost jubilant, as he stepped into the waiting car. 'You see,' he said, 'I find her. Give her to the police. Supina naughty woman.' I almost shared his disappointment when he came home empty-handed.

Supina's sudden departure brought Ahmad one material gain — the position of cook in our household, which he had always wanted. The change was quite easy, as we were losing our lodger and from now on might reasonably hope to have the house to ourselves. Nobody would describe Ahmad as a good cook, but out of consideration for his excessive sensitivity, we had to pretend that he was better than he was.

Ahmad was cook, so-called, but I was still without any help for Tania. Suppiah, who had been considering various possibilities, now came to me with the suggestion that, as her half-sister Asmah would be free for the next two months, I might like to take her on as washing ayah. She could also help with Tania, for the children already knew her and this would give us time to find someone more permanent.

So Asmah moved in, bringing her small girl and husband. Now we had another family at the back. How I hoped that they would all manage to live amicably together; possibly the fact that it was only a temporary arrangement would make it easier. Ahmad had his nose put slightly out of joint by Din, Asmah's husband, who, as a travelling barber, went from kampong to kampong on a bicycle, cutting people's hair. Now that there was a professional on the premises, the surrounding Malays flocked to the back of our house in the evenings to have their hair trimmed. Ahmad, of course, did not like this, and adopted a distant attitude towards the whole family.

These two months with Asmah about the house were the happiest and most peaceful I remember. She had a natural wisdom and, when there was any trouble, she always tried to smooth it over, instead of exaggerating it as the others did.

By this time, Salem and his attractive parents had gone elsewhere, for their employer had moved up-country and the father had found a well-paid job chauffeuring a wealthy Chinese, one of whose cars he was occasionally able to borrow so as to bring Salem back to play with Margaret. These changes were inevitable, and sorry though we were when they went, Salem's place as Margaret's playmate was soon taken by Asmah's attractive little daughter, Sitiawa. She was a most charming individual with a lively spirit, good will and perfect manners. She was thin and small and had no toys of her own, but was perfectly content and happy. Her large eyes were dark and glittering, and her hair would have been beautiful if her step-father had ever allowed it to grow. Din had been in the police previously and I think hairdressing was still a novelty, which had not worn off. Sitiawa never had anything but the closest of Eton crops.

As Asmah was expecting a baby in two months' time, it was understood that old Peah, her mother, should come along to keep an eye on her. I was a little nervous about this arrangement because Peah was strong-willed and would not go an inch out of her way to conciliate Ahmad, who was inclined to be jealous of her influence over Suppiah, even though it had, to date, been exercised on his behalf. As things turned out, the visit was a great success. Asmah had not been married to Din for very long and old Peah disliked and distrusted her son-in-law. Ahmad too was jealous of him for usurping his place as family hair-dresser. So he and Peah found a common bond from the beginning. I was often alone with Asmah when she was upstairs doing the house-work. She said more than she might have done had any of the others been present, and I gradually learnt something of her own life history.

Although still only twenty one, she had already lost one husband, who died during the Japanese occupation when Sitiawa was only three months old. She had loved him deeply and had never really recovered from his death. When she spoke, I became conscious of the difference between her life then and now, for our conversation found a bridge over which she crossed into the happier past for a few brief moments, taking me with her as a visitor to see their life together and to catch some fleeting impression of what it had meant to her. For her, they were familiar dreams in which she sadly strayed until some chance question of mine broke the charm and brought her back into the painful present. She felt no affection at all for her present husband, Din, who

had been attracted to her even before her husband had died, and since his death had constantly wooed her, taking her in the end, if not by force, with the threat of it. Asmah and her mother had been frightened into giving their consent. After her second marriage, Asmah settled down to a plain, hard life, devoid of every trimming. Din soon took all her treasured possessions, even the earrings her first husband had given her, and the bracelets and gold pins she had worn for her marriage. Of this, I learnt from her mother; Asmah herself accepted austerity as part of her present life with a self-discipline that astounded me.

This vague hairdressing business of Din's was a convenient cloak for any other diversions in which he might choose to indulge. Sometimes, after starting out on his bicycle first thing in the morning and not returning till sunset, he would bathe and change and go out again till the early hours of the morning. Where he went, or what he was doing, nobody seemed to know, but he got through all the money he earned shearing people's heads and neglected his wife disgracefully. Poor Peah used to talk to me about it sometimes, shaking her old head sadly.

One evening when I was standing in the garden listening to the old lady discoursing on the evils of the modern generation, particularly modern husbands, I caught sight of a man's figure coming slowly up the hill. It was gathering dusk and the hedge concealed him so it was only when he turned the corner at the top and started walking towards us that I recognized Supina's husband. He had grown very, very thin, looked ill and was more nervous than ever. I could see from his whole demeanour that he was greatly upset. He came to tell me that he had divorced Supina. Did he come through a desire to speak of the grief he nursed within him, or did he come to clear Supina's name? His reappearance was at least evidence that she had not killed him. She had, however, compelled him to divorce her for his own safety, which was what she had been trying to get him to do for some time. It was extraordinary that he still loved her and hoped to win her back. As I stood watching him go again, I felt some of the desolation and despair that his bent head and sunken eyes expressed. In this case, I thought to myself, not even Peah would have blamed the husband.

By a strange coincidence Supina arrived to claim her wages the very next morning. It was Ahmad who came upstairs to announce the fact; perhaps he hoped that there would be a scene. If so, he was disappointed, for I had no wish to see her and only asked Ahmad to tell her

that she might wait until my husband returned at lunch time. She was dressed in her best, he told me, after settling her wages, and so calm and collected that no one would ever have suspected the fire that had burst so furiously into sudden flame. She walked gracefully as usual, but something in her bearing made him feel that she was a little ashamed of herself. She spent the whole afternoon in Suppiah's room. They had not forgotten the incident, but regarded it, not very seriously, as an outburst of passion now subdued. It was the sort of thing that might happen to anybody. But I remained upstairs, remembering her white face, dilated pupils and mouth set in a hard line. I was relieved when at last I heard the party breaking up down below.

13

Drama in the Hospital

Din's manners were perfect, overpoweringly so, but they were quite artificial, as I was not long in discovering. One day I asked him if he would sit for me. 'Of course,' he replied. 'How could I refuse you? Whenever you wish. You have only to say when and I will be there.' 'Very well,' I replied. 'What about this afternoon?' 'This afternoon!' he exclaimed shaking his head. 'I am afraid that is impossible.' 'Then tomorrow morning?' But he shook his head again, regretting he would have left the house early. 'Any other time,' he said with a charming smile. When I finally got him to sit it was because he happened to be on the premises and had nothing better to do. He was handsome but short-sighted, so that he had to wear glasses. When he took these off his eyes did not focus properly, and this made him look introspective, which he was not really at all. He was merely completely self-centred and had few thoughts beyond the conquests he had made among the ladies of the town.

When the portrait was complete, I said to Asmah: 'You have a very handsome husband.' 'His face may be all right, but he has a bad heart,' she replied. 'What is the trouble?' I asked. 'He wants another wife,' she answered, raising her voice so that her usually soft Malay grew harsh. 'One wife is enough, I told him. And if he takes another wife, I don't want him.' 'Oh! What did he say to that?' I asked. 'He only laughed,' she replied.

I did not have the opportunity to discuss this conversation with Peah until the evening, when she and I walked round the garden together. Peah was very upset and naively asked me if I knew of some medicine to give Asmah to be rid of the baby — rather a tall order, as in a few weeks the little thing would be struggling into this world by itself. I did not feel there was really any evil intention behind the old lady's

remark, but just that she was searching about in her own mind for an escape for her daughter, whom she loved more dearly than anyone else on earth. 'Never mind,' I said, trying to comfort her, 'Asmah will love her baby when it is born.' It was all I could say, but she seemed a little reassured. 'Siti will love it too,' I said as an afterthought. To Sitiawa, Peah was a devoted grandmother. It was she whom Siti called mother, who provided her with food, and who had her to sleep in her room. Siti, in her childish wisdom, had a strong dislike for the man her mother had married and kept out of his way when he was at home. Peah loved and protected Siti in every way she could think of. And it was lucky she had this protection, for very soon her mother would be going into hospital.

One night soon after this, I had gone to bed and was dropping off to sleep, when I heard first the click of the lights being put on in the dining room downstairs, then footsteps on the stairs and Suppiah's voice softly calling, 'Asmah is sick.' We dressed hurriedly, but my husband was downstairs and had got the car out before I was ready. 'Are you coming? She will have the baby in the car if you are not quick,' he called from the garden. I threw a scarf over my head and ran down the stairs. The car raced round corners, shot through traffic lights and arrived at the hospital in record time.

Asmah was sent straight to the labour ward, while we went through the formalities of admitting her. As I returned to hand in her papers, I asked the nurse if I might have one last word with Asmah. Her face showed signs of great pain, but she smiled at me bravely. Now that she had reached hospital safely, she felt somewhat reassured. As we drove home, I thought that Peah too had been comforted by the sight of clean beds and ordered efficiency in the big hospital; having worked with Europeans for so long she appreciated such things, but even so I admired her calmness. At dawn next morning, the telephone rang. Asmah had given birth to a son. I dressed hurriedly and, at about seven o'clock, went downstairs. Din had just woken up and was stretching himself in the doorway of his room, wearing a crumpled black sarong. Knowing that Peah would not have communicated the news to him, I told him that his wife had given birth to a son. Hardly awake, he rubbed his eyes and stared. 'Hurry up and get dressed,' I said. 'Go quickly to see Asmah before the sister in charge of the ward comes on duty. If you don't get there before she does, you will have to wait till midday.'

All day long I felt glad, for Asmah had achieved what I longed for

myself — a son. I knew, because she had told me, that in the early days when she was first married to Din she had hoped for a son too. Perhaps now that she had one it would bring her some comfort and compensate for her husband's neglect. Then my thoughts went back to the birth of my own two daughters, and I began to look forward to my own future. Everything was turning out so well. I had often wondered what domestic arrangements I would be able to make when Asmah went into hospital. Then it all happened so easily. I had thought and thought about how to reorganize the household work when Asmah had gone, without finding any solution. All the time it had been under my eyes and I had failed to see it.

Machi, who stepped into Asmah's place, was a tall woman who moved with a lethargic grace and was imperturbably good natured. She was the wife of the driver next door — the successor to Salem's father — and quite soon after they settled in, she got into the habit of coming over to our house to sit on the patch of grass between Suppiah's room and the kitchen, where any fine evening you might find a group of Malays squatting in a semi-circle, occupied in endless discussions of the affairs of each other and of their innumerable relations. (World events had to be shaking indeed to penetrate our kampong.) Machi had never learnt anything beyond what she had picked up in her mother's home and later in her own. When Asmah left us earlier than expected, Suppiah asked her if she would be willing to take charge of Tania, under conditions Suppiah made easy for her. She was very willing. In fact I think she had been waiting to be asked.

Tania was then at a most attractive age and Suppiah was devoted to her. She cared for the child's development most sincerely. Looking after her was not a job to be idled through, as Mina had regarded it, but an opportunity to educate her carefully and intelligently in the ways of the world that was opening all around her. Suppiah was unique among the Malays in this respect. Watching her concentrate all her energy on teaching little Tania a new phrase or movement, reminded me of how impressed I had been, even at our first meeting, by the vigour of her character. Now she made Tania a part of her own life. Perhaps giving so much thought to this little girl brought some peace into her warring existence. I should have been glad if the care of Tania could have remained Suppiah's charge. But it could not be, for although she loved Tania dearly, her perpetual quarrels with Ahmad were dragging her

down and robbing her of her energy. She was never in bed early. I used to hear her prowling temperamentally round the garden in the moonlight, shouting at her husband. The next day her vitality would be lowered and she could not exert herself for Tania. Finally she asked me, when Asmah went into hospital, if Machi could take on Tania while she returned to the less exacting business of washing and ironing.

Copying Margaret, my husband and I had called her 'Machi' ever since she first came to live next door. We thought it was her real name. The Malays must have been amused at our ignorance, but they were far too polite to give the show away. It was some while before we discovered that the word meant 'Auntie', and by that time we had got so used to the name that we never called her anything else.

Since Machi already knew our family, she settled down quickly. In the afternoon I was able to take old Peah to see her beloved daughter. Her whole demeanour was restrained, but it was that admirable form of restraint which stems, not from lack of feeling, but from so much. When we arrived, Din was already there, as was Romala, Peah's daughter-in-law. Asmah was sitting up in bed, pale and thin, with the baby in her arms. She greeted me with the same kind of restraint her mother displayed, but I knew she was very glad to see me. She had that subdued, yet overwhelming, happiness some women feel with a new baby, and I recalled my conversation with her mother when we had walked in the wet grass just before the baby was born. Then there had been no joy in mother or daughter; only anxiety, which had blindly trampled every other emotion underfoot. Now a new joy had sprung up, causing all their former worries to recede into the background, where they would not remain for very long I feared. In the meantime, pride in her new baby enveloped the mother, protecting her from all other emotions and extending to those who stood around her bed, so that for the moment we were all linked together in one brief harmony.

In the bed next to Asmah on one side an Indian woman squatted, dull eyed and expressionless, her sari drawn close about her. Beside her lay her tiny baby almost covered by a little white blanket, and at the end of its cot a small red flag had been placed. A nurse told me that it was there to warn the young probationers not to bath the child, which was very ill. I turned to the bed on the other side where a Chinese woman lay, her face drained of all colour, still as death. There was no cot by her bed; the child, her fourth, had died as it was born. Two days later

when I returned, the mother herself had died and the bed next to Asmah was empty. There were sorrows as well as joys in this ward, and in my present condition I was particularly well attuned to observe them both.

On one visit, I saw a Chinese baby all alone in a cot in the middle of the ward, wriggling and screaming. Asmah told me that its mother had died and no one wanted it. Its father had come to see it and said he had enough girls already. What would become of it? I wondered. And where would it go? At the other end of the ward an Indian woman with happy dark eyes fed her baby at the breast; every movement she made was graceful and easy. Opposite Asmah, another mother lay childless after her labour, with a blanket wrapped about her, inarticulate like someone turned to stone. Others who had given birth some days earlier and just risen from their beds, walked the wards like large statues, for their still distended stomachs had not yet had time to contract again. A small Chinese girl with black, shiny bobbed hair, wearing a jade and blue print dress, stood by her mother's bed, a little bored with the new baby, chewing biscuits from a brown paper bag.

Sitiawa came with me and sat on the edge of Asmah's bed, her eyes growing larger and rounder and a little wet as she looked at her mother's new baby. His tiny hands were pink and perfect and his nails long and delicate and beautifully formed. I picked him up and held him against my shoulder, a tiny bit of life weighing five and a half pounds. Romala talked with Asmah, but Peah's eyes followed her son-in-law, and suddenly the new-found harmony snapped. There was hatred in the old lady's eyes, bitter and unforgiving. I put the baby back in its cot, while Din, quite unaware of the change of atmosphere, came round to talk to me. There was a half smoked packet of cigarettes lying near Asmah's pillow, and old Peah, having observed Din closely to make sure he was unlikely to look in her direction, stealthily picked up the packet, inserted a note, and replaced the packet under the pillow. I was touched beyond words, for only that morning she had come to me and asked, with evident embarrassment, if she might borrow five dollars. Glancing up, Peah was aware that I had watched her and the moment was rich with understanding between us. The tension created by her glance a few minutes previously had disappeared and we were an ordinary family party once again.

Further down the ward, a Chinese grandmother, wearing glasses, carried her daughter's newborn infant with pride and joy. Observing

her, I thought, East or West, black or white, when it comes to fundamental things in life we are all the same. We all give birth, we hate, we love, we laugh, we are hurt, we are kind; we are cruel, generous, mean, perceiving, unperceiving and, in the end, we all die. If there is any great difference between one race and another, I for one cannot see it.

Asmah was beginning to tire. Din had already left on his bicycle and it was easy for me to get rid of the other visitors by announcing that it was time for the car to take the rest of us home. Asmah lay back in her bed and sighed. 'Yes,' she said, looking at me, and from that one word I knew how she longed to be left alone.

14
A Shopping Excursion

My husband had left his office early and had walked to meet us. So, leaving the driver to take the rest of the party home, I walked with him, as we often did in the evenings, to a little row of shops a mile or two away from our house where we could make small purchases of odds and ends without the trouble and expense of going to town. These shops were a colourful sight, with each adjoining house painted differently, in yellow-ochre, grey and shades of green varying from turquoise to yellow. Without glass windows, as there are in Europe, all the interiors, not only of the shops but also of the family lodgings over them, were fully exposed to view, for on this warm evening they all had the double shutters of their front rooms wide open.

Standing well back one could see how every cell in this busy hive was occupied, except for one or two in which the overcrowding was so intense that a bed, with its mosquito curtain, had been placed level with the window so as to block out effectively any view into the interior of the room. The rest were all lit up, and in each one of them a separate scene was being enacted, as in a theatre, but with the difference that the actors here were unaware that one of the throng of humanity hurrying past below had become a spectator. Unlike the theatre, too, the acting was silent, for the sound of voices in the rooms was lost in the clamour of the street.

Here a man stood, shaving, glancing at his watch, as though pressed for time. In the next apartment a woman sat in a low chair with a navy-blue handkerchief tied round her mouth. What was she doing rocking backwards and forwards? Perhaps she was saying her prayers. Or she might have been gagged and robbed and left there bound in full view of the public street for all I knew. Further down the street, two children stood at a window, the little girl eating fruit from a bag the little boy

was holding for her and spitting the pips into the drain below with an accuracy of aim that her young companion applauded. A man who stepped unexpectedly out from a doorway and was nearly hit, looked up as he passed, but paid no heed to the little girl and boy, nor they to him.

There were various signs outside the shops; suits of clothes for a tailor, bleeding gums for a dentist; most of them with Chinese characters too, painted red on a yellow background or black on pale green, and a few with the name of the firm in English. Our favourite shop had three glass counters, which meant that there was no room for dried fish, so the shop was comparatively odourless. Whatever we wanted, a mousetrap or a cotton reel, we always tried here first. We passed between the counters into the shop, my husband stooping slightly to avoid some sarongs, bunches of green chillies and saucepans suspended from coat hangers fastened to pegs in the ceiling. There was not much free space on the floor, for rather more than a third of it was taken up by big earthenware pots, roughly glazed in dark green and with wooden tops. These held salt, flour or spices, and were quite convenient to sit on if one wished to try on one of the pairs of shoes at the back of the shop. There was not nearly enough space on the shelves of the counters or on the walls for the enormous variety of wares the shopkeeper found it necessary to stock, and a great many of the more bulky items were suspended, like the sarongs and saucepans, from the ceiling. Here were clusters of enamel mugs of all sizes and colours, bright blue, dark blue, green, yellow and streaky like children's plasticine carelessly rolled together. There, suspended from another hook, was a bundle of umbrellas with painted bamboo frames and oiled paper coverings, which conjured up memories of missionary bazaars at home.

Today we bought a torch battery, a ball of string and a packet of razor blades, resisting with difficulty some toy fishes that flapped their fins, as however well these worked in the shop, we knew from experience that in children's hands clockwork toys seldom survived a second winding. The shopkeeper jotted down the items in the margin of a Chinese newspaper for our benefit, not for his, because he always used an abacus and probably could not have done a simple addition sum on paper if he had tried. We haggled over the odd ten cents as a matter of form, knowing from previous occasions that if the total exceeded three dollars it would be reduced without any argument, if it was less we

should be told that we were being given the articles at cost price. Then the parcel was done up and the wrapping paper held in position by rubber bands — a colourful handful of which would also be presented to the children if they were with us.

People who did not mind the congestion or the smells walked along the pavement, and it was to them that the hawkers catered. There was always one selling coloured clogs. He brought these to his pitch in a large hand-woven basket, which he slung over one end of a pole balanced across his shoulders, with a shoe stand over the other. He set these down outside our favourite shop, arranging the shoes in different coloured rows on the stands. There was a red row, a green row, a black row and one in plain wood. An old Chinese woman put down her basket of vegetables, sat on a low stool on the pavement and started trying on the shoes. Other pedestrians had to decide whether to push past her, go out into the road or wait and watch until she had finished. The Chinese were not self-conscious about conducting their domestic life in public. A side street without much traffic served as a convenient sitting room, where they would set out their rattan chairs.

This was a favourite haunt for petition writers, with their stock in trade of old-fashioned typewriters, foolscap, carbons and well-worn phrases calculated to melt the adamantine hearts of government offi-cials. An Indian with a fawn coloured turban wearing glasses and a long beard, a grey cloth slung over his shoulder, stood about waiting to do business. A very down-at-heel and dirty Arab came along talking to himself. He stopped and stared at one of the writers as though he might want a letter written. His grey white turban slipped a little further over his eyes while he felt in his leather belt for his money, took it out, looked at it, thought better of spending it, and passed on.

'What sort of letters do they write?' I asked. My husband told me that anyone wishing to make a complaint or to apply for a licence or any-thing of that sort would go there to get a typed letter for a small sum. I thought it very strange to do this sort of business under the trees in the grounds of a local eating house. I paused to take a last glance and suddenly caught sight of Supina.

What a surprise it was to meet her after all this time, for many months had passed since the day she came for her belongings and the wages that were due to her. She had changed greatly, having grown much thinner, and her skin was so parched and yellow that I hardly recog-

nized her. She was wearing the same black jacket (which shone as it caught the light) that she had worn the first time I drew her, when she had come upstairs one morning to ask me a question and I, fearing she would spoil the natural position in which she stood, shouted at her not to move. She, not comprehending my words but understanding my gestures, had stood there, stock still and very patient while I completed the drawing, the first of many. She stood very still now and wide-eyed. 'Yes, I am working again,' she said. 'Over there,' and she indicated where 'there' was with a mere tilt of her head. 'But could I ...? I would like ...' she began, without ending her sentences. And, lest she should ask for something I would have to refuse, I said, taking my husband's arm, 'Come. We must be getting back before it is Tania's bedtime. Goodnight Supina.' So we smiled and parted. But on the way home I remarked to my husband how very ill Supina looked. Clearly she had not found the happiness she sought and her third marriage was, I guessed, as unsuccessful as the others had been.

15

A Tamil Wedding

The shadow, which began under the trees, spread beyond the grass and on to the side path in front of the church, where it changed from cool green to mauve, and became more intense. An over-laden black and battered car pulled up, and out stepped about eight Tamils, including Letchumy. It was she who had invited me to come to this Christian wedding. The invitation card was printed in Tamil — strange gilt lettering on shiny paper. As I was the only European present, the page at the end written in English, which dealt with the name of the church, the place and time, concerned me alone. I looked at my watch. The ceremony was already ten minutes late.

Except for Letchumy and her husband, to whom I had been introduced before, I knew no one in the party. Now, from among a host of friends and relations, I suddenly saw the bride emerging, her head demurely bowed. Like someone who had been brushing against heavily pollinated flowers, her forehead and forearms were dusted with gold. A black spot had been painted between her eyes and she wore a glittering diamond in one nostril. She jostled her way into the church with the rest of us and finally sat down in the front pew, where I too was subsequently guided by Letchumy. Here I had an opportunity to observe the details of her attire. A cap of tiny white flowers fitted over her head and continued down one of her two braids of hair, to well below her waist; the other braid was left uncovered except for an apple-green bow at the end of it. Following the Indian tradition, she wore a garland round her neck, but its flowers were rather incongruously cased in cellophane and entwined with strands of red and green. The garland came into a point at her waist with a bunch of red roses and small white flowers. In her right hand she carried a mace decorated with more of the same flowers and silver tinsel. Jewelled rings hung from her ears and her supple

wrists were adorned with bracelets as decorative as autumn berries on brown boughs. Her sari, which was of the green of crushed jade, was bordered with a formal pattern of gold thread. Beneath it she wore a purple satin blouse, deep in tone and with scarlet trimmings. The bridegroom on the other side also wore a garland of white and red flowers, which looked out of place with his European shirt and trousers.

In front of our pew stood a plain wooden table. One of the bridegroom's friends moved forward bearing a wide, flat bowl containing bottles of orangeade, bananas, apples and another garland of flowers, and set it on the table where the priest would see it and be moved, it was hoped, to conduct the service with a full heart and thankfulness of spirit. The girl who rose from her place to act as bridesmaid stood on the bride's left and carried a torch-shaped bouquet. Her hair was quite simply done up in two braids, pitch-black against her satin blouse. What function the older girl behind the bride fulfilled I could not be sure. Possibly in imitation of a European ceremony she was intended to be a second bridesmaid — a trainbearer — but in fact there was no train to bear. So, half-way through the ceremony, having nothing to do she sat down again.

A very tall Tamil girl stood clutching the end of our pew. Her wild eyes fixed on the ceremony with such intensity of emotion that I could hardly bear to watch her. I turned my gaze towards the bride again. The priest was blessing something wrapped in a piece of newspaper, but his words were almost drowned by the scream of a baby just behind me. Having blessed it, he undid the little parcel and the paper fluttered to the ground revealing a heavy gold necklace, which the bridegroom fastened round the bride's neck, disturbing the flowers that were already there and filling the church with their perfume. This must correspond to our wedding ring, I thought, and turned for confirmation to Letchumy. She nodded, and then, tilting her head towards bride and bridegroom, whispered in halting Malay: 'When he dies, she will take the necklace off.' Afterwards I learnt that, in such an event, the necklace would be carefully put away and, if there were any children, passed on to a daughter.

As the wedding ceremony drew to a close, the Tamil who had placed the fruit on the table picked up the garland of flowers and threw it over the priest's head. The congregation applauded heartily, like an appreciative audience at the end of a good play. The service then ended in as

disorderly a manner as it had started. Those nearest the door went first, and everybody else followed. The bride, lost in the crush, was one of the last to get out.

When we got outside, I found Letchumy's husband waiting courteously to escort me to my car. I offered him and Letchumy a lift to where the wedding reception was to be held. It was a large car, not very new or smart, but the best of any that were there, so not only Letchumy and her husband, and the bride and bridegroom, but the best man and both bridesmaids squeezed into it. Even more might have tried to get in, but I was quite apprehensive already about springs and tyres, so I told the driver to go very slowly.

We went cautiously, and as we left the streets behind us, the road began to wind among palms and banana trees and little houses, from the small verandas of which the Malays, enjoying their leisure, idly stared at us as we passed them by. Finally, Letchumy asked the driver to turn off the road on to an unmade track, but after a few yards of this he brought the car to a stop. He asked Letchumy how much further we would have to go. 'Not far,' she said, and quickly got out of the car when he said we would have to walk the rest of the way. The other guests remained in their places until, after much explanation of the state of the track and the condition of the car, they too began to get out with a not very good grace. The best man pushed the bride out of the way rather than open the door on his own side — to walk to the house which was, in fact, less than a hundred yards away. A goat looked at me enquiringly as I followed the others along the track. Baby pigs ran under the banana trees. What were they doing here, I wondered? I did not know that Indians kept them. But Letchumy, turning round, explained that the home to which we were going was in a settlement in which, from necessity rather than choice, Indians, Malays and Chinese all lived side by side. Both the Indians and Chinese reared pigs. How the Malays must have disliked it, I thought, knowing with what abhorrence they regarded these animals.

The dwelling places were not like the attractive small houses on stilts we had seen through the coconut palms by the side of the main road, but drab little huts resting on the bare earth which would turn to slime when the heavy rains came. Near the end of the lane, we stopped before one of these small huts surrounded by banana trees. It contained one room only, but was extended in front by a rather dilapidated awning

made of palm thatch and supported by thin bamboo poles. Only the very crudest attempt had been made at decoration, by means of paper flowers and small grass crosses hanging in rows from the ceiling. On a kitchen table, which had not been scrubbed or even dusted for the occasion, were various musical instruments, including a drum and a battered accordion. An Indian sat cross-legged on the table beating the drum in time to a squeaky gramophone being played by the master of ceremonies — a young man who was very conscious of his smooth hair, navy-blue suit and bright red buttonhole. The records he chose were of Eastern music and their monotonous rhythms, with periodical harsh discordant clashes, were quite meaningless to me. I was interested to observe that the Eastern audience gave it as little attention as the majority of Westerners give to their background music on similar social occasions at home. Letchumy's husband brought me a chair, which he politely placed in the middle of the room but which I removed to one side so as not to interrupt any further ceremonies that might be planned, for it was clear that what we had seen in the church did not conclude the ritual.

Through the darkness of the doorway a figure came into the hut waving a burning censer in front of the bride and groom. Then it was my turn to be garlanded and to be given a bouquet of flowers, similar to the bride's, and to be applauded as the priest had been applauded in church by the congregation. By the time I had recovered from this surprise, the bride and groom were no longer to be seen and the guests were thronging round the doorway of the hut, peeping in through the one small window in the wall. Joining the inquisitive crowd, for I was determined to miss nothing, I pressed forward till I too had reached the window. Then Letchumy's husband appeared and cleared the way to the door blocked with people so that I could go inside.

Here nothing had been done to disguise the squalor. How incongruous, I thought, to dress like a king and queen and live in a dwelling place worse than a London slum. My undisciplined eye rested on a bundle of old clothes hanging over a line of string above the bride and groom's heads. I caught the expression on the mother's face (the old hag whose home this was) and at once realized my mistake. She clearly resented my curiosity, that of an outsider intruding, and I knew that nothing I subsequently said would restore her confidence. However, I stumbled on in my bad Malay, making an effort to be pleasant.

Letchumy and her husband were constantly at hand, now clearing a space on the low table for me to sit on, now bringing me orangeade in a clean glass. The room was dark and stank of dirty clothes and stale food, but I tried to forget these things, which the others did not notice, and to concentrate on the gorgeous saris, the artistically woven garlands, the jewellery and the features of the bride and groom, now seated cross-legged and with bowed heads on a grass mat in the middle of the floor, submitting to the critical inspection of their newly acquired in-laws.

When I left them the party was still very sedate and would probably have remained so for as long as I was there. Letchumy's husband escorted me to the car. I said goodbye on the best of terms to Selverani's grandfather who had railed at me in Tamil in my garden the last time we had met. Now he gave me a low bow as I passed, and his son-in-law gave me a smile, if not a wink. I was still wearing the garland round my neck and carrying the bouquet of flowers, and did not take them off until the car was safely round the corner.

16
More Family Rows

W hen Asmah came out of hospital I gave her and Peah per-
mission to live on our premises until she was strong enough
to return to the family kampong. Everybody looked forward
to her arrival from hospital with the baby. My children regarded it as a
new toy produced primarily for their benefit. Zeida sewed for the child
three little yellow pillow-cases of the size I had once made at Christmas
for Margaret, for one of her big dolls. Unlike European newly-born
children, a Malay baby always lies with a tiny pillow under its head.

Zeida, who did everyone else's work besides her own, and looked
desperately tired and unhappy, got a new lease of life about this time
when the news of Abbas the gardener's engagement to be married was
announced, freeing her from the horrid, haunting fear that she might be
his intended bride. Now it happened that his bride-to-be lived on the
quarantine island, where there was a small Malay village. The wedding
involved long preparation and, as usual, was to be extended over sev-
eral days. But just before it was due to take place a ship delivered some
smallpox subjects to the island and, consequently, no visitors were
allowed from the mainland until the period of quarantine was over.
Abbas had already been given leave when the whole arrangement had
to be cancelled. This was just the sort of thing that would happen to
him. He had a clumsiness of manner which somehow seemed to influ-
ence everything with which he became associated.

Some time later on he tried to get married again. We did not see the
earlier part of the ceremony, which took place at the bride's father's
house. But we were present when he brought the little bride and a few
of her young relatives to his room at the back of the house, and what a
funereal procession it was. I have never seen such an unhappy bride.
The pale yellow-gold sky was fading into pearl grey as she walked

slowly towards her husband's room, but there was still enough light to see her rose-coloured jacket and blue sarong. Her head drooped and she hung back, unwilling to commit herself to the fate her parents had chosen but only the last few hours had revealed. A bride was expected to be demure, but there was no mistaking for this the heaviness of heart that found expression in her attitude and communicated itself to the two or three little child relatives who had followed to support and comfort her. (I wondered where they were going to spend the night.) I watched her reach the threshold of Abbas's door and, as she turned to wait for her companions, I saw tears glittering on her cheeks.

The following morning she sat in the doorway of their room, her head supported by her hands, her arms resting on her knees, staring at nothing. Suppiah, who was tender to most people except Ahmad, did her best to comfort her. She was charmed by the young girl's prettiness, and calling to me, said: 'See, she is beautiful,' so that all could hear. But the bride paid no heed. She could not bear this man her parents had chosen for her, and two or three days later ran back to the island, praying, I feel sure, for a lasting epidemic of smallpox.

Not long after this, it was about a week before Princess Elizabeth's wedding, I remember, Suppiah's quarrel with Ahmad came to a head. I was sitting sewing on our upstairs veranda, the pretty airy room with a view over the tops of the trees in the garden and beyond. Ahmad came into the room, swiftly and noisily, with his hands shaking and his face pale and contorted. I had never seen him in such a state before, and he allowed me no time to question him. 'I divorce Suppiah,' he said, his voice rising with emotion. 'I must divorce Suppiah. She say very bad things. I proud. I cannot allow her. I go. Suppiah can stay here but I, I must go.' It would be an ideal arrangement, I thought, if he did go, but I knew he wouldn't. I spoke to him softly, reminding him of his past services and praising them, and saying how difficult it would be to do without him. I could say this with some truth, for it would be most awkward at this stage to reorganize my household entirely. Ahmad must not go. Ahmad was splendid. Slowly his eyes calmed and lightened and his features returned to normal. Once more a crisis had been averted.

The day of the royal wedding dawned appropriately gold and red, but it was not to remain fine for long. We had promised to take Ahmad, Suppiah, Zeida, Machi and her son, Wandi, in relays to see the various

shows. Wandi was a very well-mannered child of about 12 years. At lunch-time it started to rain heavily, flags and bunting drooped dismally from every window and lamp-post, and cardboard hearts and crowns were turned to pulp.

In the evening, as darkness fell the rain ceased. Ahmad sat in front of the car with my husband, who was driving, and I climbed in the back between Suppiah and Wandi. Suppiah was in a happy mood, determined to see everything and enjoy it all. Ahmad was the very opposite. He eyed Suppiah jealously and seemed to be determined to spoil her evening with his sulkiness if he possibly could. But Suppiah was invulnerable that night and merely ignored him. There was to be a torch-light procession. The people who had grown despondent lining either side of the road three of four rows deep became lively again and a tide of faces turned in one direction. I saw a blaze of light in the distance and heard a blare, which swelled in intensity as the head of the procession drew near and its different components could be distinguished.

Drums beat and trumpets brayed as, one by one, decorated floats and vehicles in fancy dress came slowly past, often having to halt while some obstruction ahead was cleared out of the way. The cacophony was matched by the garishness of the electric bulbs strung over the tops and down the sides of the covered wagons, precariously supplied with current from a motor mounted on a trailer attached to the rear. Sometimes a band of musicians, a dozen drummers whacking their drums, or a score of cymbalists clashing their cymbals, as though their lives depended on it, would be plunged into sudden darkness by a break in the connection, and the nerve-shattering music would abruptly cease. Then mechanics leapt down, groping and grappling with wires in the darkness, working feverishly so as not to lose their place in the procession, till the fault was found, the lights blazed anew and the band resumed its unvarying rhythm. Suppiah appeared to be enjoying the show as much as anyone, not merely as a spectacle, but falling in with the mood of the performers. The floats were elaborately decorated, representing flower gardens, ships, houses or palaces, according to the taste and resources of the society or guild that had created them. In honour of the day, they all bore giant cardboard pictures or photographs of the royal couple, which matched the other decorations in crudity.

A large dragon came dancing down the road. We were used to dragons — they appear constantly in Chinese crafts, sprawling across hand-

made chests, embroidered down the backs of dressing gowns, painted on plates and teapots and engraved round pewter mugs. In front of the dragon a small figure wearing a very large mask danced lightly, periodically bowing to the crowd after a particularly narrow escape from the dragon's jaws. The crowd applauded with delight at his antics, and I watched as eagerly as any of them, wondering what the reaction would be if he allowed himself to be caught for a change, so ending once and for all a pursuit that had lasted for generations. The dragon itself was a hundred feet long and gaily coloured; it writhed and twisted as its 'legs' ran hither and thither, pausing occasionally while one of their hard worked occupants removed his head from its stuffy canopy to mop his brow and recover his breath. Then there were more floats, decked with coloured lanterns, artificial trees and paper flowers; more crowns and more royal couples, and finally the procession ended with a police motor bicycle and a small flock of Malay and Chinese boys following in its wake. Suppiah said she thought it had been beautiful, but Ahmad maintained a dogged silence. He was too entrapped in jealousy to enjoy anything but his own misery.

Before going home we drove to the top of a hill overlooking the harbour, from where we would get a good view of the fireworks display if the day's storm had not made everything too damp. We stopped the car and all got out. Now the night, after the day's heavy rain, was cool and beautiful, and up on the hill it was quiet and very still. Down in the harbour the mooring lights of the boats shone like cats' eyes in the darkness and lights from the islands in the distance glittered like tiny diamonds. Many of the fireworks had suffered from the rain and would not go off, but every now and then we were rewarded with a brilliant cascade of coloured jewels, of yellow stars which momentarily hung in the sky, illuminating the still water as vividly as lightning. Wandi clapped his hands and even Ahmad forgot himself to marvel. By the time we got home he had quite forgotten his bad temper.

I was hardly through with one row when I found myself in the thick of another. This time it involved old Peah, Din, his wife Asmah, and the new baby. The trouble started one evening at bedtime when the baby started wailing so pathetically that I felt I must go and see what was the matter with it. To my astonishment I found Romala trying to feed it with a bottle. Romala, who had come to live at the back to help Asmah until she was stronger, was, as I have mentioned, a daughter-in-

law of Peah's. I had observed that relations between Din and Asmah had become more difficult than ever since her arrival, and it crossed my mind that perhaps Romala, who was so wretchedly unhappy herself, might be getting some of her own back, as it were, by fostering the quarrel between them. Under normal circumstances Asmah might have held her own, but she was still weak from childbirth and did not have the physical strength to combat Romala's intrigues. Romala always seemed to be hiding in some dark corner, ready with Din's meal when he arrived home in the evening, ready with his clothes carefully ironed and neatly folded and, above all, ready to listen to whatever Asmah said to her old mother while Din was out. Like a witch stirring the cauldron, she mixed and spiced her tales till they were done. Din believed every word she told him and Asmah never had a chance.

Now Romala had removed the baby to Supina's old room, where I found her attempting to feed it on condensed milk and water, without regard for quantities or the correct temperature. There were no spoons or other means of measuring the milk, the bottle was too small and the directions on the tin were in English. Din, standing in a corner as far away from me as possible, was avoiding my eyes like a schoolboy who had been found out. I demonstrated how to feed the baby with the bottle and went next door to see Asmah who, for the time being, occupied Mina's old room.

She was lying down, while old Peah sat on guard beside her and Sitiawa slept in the corner. What was it all about, I wondered, looking from one face to another, trying to read the signs. Was Din intending to wean the baby from its mother so that he could make off with Romala and his newborn son? He was undoubtedly proud of the boy, and if he could persuade Romala to bring it up, he would be free to live his own life away from the inquisitive eyes of old Peah, who watched all his goings out and comings in and missed nothing. 'Well, Asmah,' I said, 'Can't you feed your baby?' But Asmah had no time to answer me because her mother chimed in quickly asking me to persuade Din to give the baby back to Asmah so that she could feed it herself. I told her I would do what I could and left them, not feeling very optimistic. It would not be easy or pleasant to do what she asked and I was not at all anxious to take part in a Malay family quarrel.

As I was returning to the other room wondering what I would say to Din, it suddenly occurred to me to begin the conversation in a way that

he would not expect. So I approached Din a little less fearfully. 'Couldn't you persuade your wife to feed your baby?' I asked, looking at him, but his eyes shifted and the colour rose slowly in his cheeks. 'Do you know,' I went on, 'that if your wife does not feed her baby now, in a few days she will not be able to?' 'Yes,' he said, 'it doesn't matter.' 'Do you know,' I said again, 'that if the baby is not correctly fed by the bottle it will get ill?' 'Yes,' he replied, 'it doesn't matter.' Then, after a pause, he added carelessly: 'If it dies, it dies.'

I felt defeated. Without another word I left them and for two or three days did not go round to the back. But Ahmad, who was interested in the whole affair, told me that one night of the baby's squealing had been enough for Romala and that she had returned to her kampong.

Asmah had not picked up after her return from hospital and seemed not to care for her baby. Din's utter disregard for her health when she came out of hospital probably intensified her dislike of him, and this in turn might have affected her attitude towards the baby. Peah did not seem to want it either. She complained bitterly of her son-in-law's treatment of her daughter and, in one outburst of protective feeling, said it would be better if Din went away and took the baby with him. I could not believe my ears. My mind ran back to the day I took the old lady to the hospital when the baby was newly born. When it had cried, Peah had poured some hot water into a little bowl, dipped her finger into it, and then, with the utmost gentleness, had let it drop into the baby's mouth. Now she was talking of getting rid of it. I gave up trying to understand the situation.

Then suddenly the mystery was solved. One afternoon I went to town and when I returned Margaret came running to meet me, calling out: 'Asmah is awfully funny, she is shaking all over.' She in fact had a temperature of 107° — I wrapped her in a blanket and took her straight back to hospital.

I later learnt that all the Malays had known for some days that Asmah was ill and they were hiding it from me. When previously in hospital, Asmah had been given an injection and, because it had frightened her, she now pretended that she was not ill. Had it not been for Margaret, Asmah might have died before I discovered the truth. Of course she did not want her baby. She was too ill to want anything, and Peah, who was due shortly to go back to work when her employers returned from their leave, could not undertake to care for the child. Now there was no

question about what would have to be done with it. It must go to Din's relatives in the kampong.

17

Preparing for Christmas

There was a great deal of discussion before Christmas over what to do about a tree. To Margaret, who vividly remembered the celebrations in England, it would not have been a real Christmas without one. Children find nothing incongruous about December in the tropics, whereas to me, a Christmas tree in such surroundings seemed like a paragraph from a book without its context. Of course nothing faintly resembling a Christmas tree grew in our garden and the dealers stocked something about two feet high for which they asked a fabulous price. 'Never mind,' said Ahmad, 'my Chinese friend has big trees in his garden. You leave it to me. I get Christmas tree.' It was some time since I had heard anything of the friend with the big, big garden and I was glad to hear he still existed. I let Ahmad off, telling him not to come back without a Christmas tree. When he reappeared it was close to nightfall. My husband and I, going out for our usual evening stroll, saw the tree coming up the road. Ahmad was completely hidden from view in his seat and it was not until he came quite close that we could even distinguish the trishaw driver, who bent low over his pedals, not only on account of the weight of his load, but also so as to avoid its overhanging branches.

Trishaws were quite different from the old rickshaws, which were still operating when we first came to Singapore. Rickshaw pullers run between shafts, while the passenger sits perched on an elevated seat slung on the axle between two giant wheels, and shaded by an awning. I think most people were glad when the authorities in the city decided not to license these vehicles any longer and to repatriate the pullers to their homes, for it was a hard life to have to run in all weathers, up hill or down, tired and hungry. Although only the stronger men undertook it, they did not keep their health for long. They became lean and

shrunken, with their copper skin stretched taut across their ribs and shoulder bones.

Trishaw pedalling is tiring too, but the work is not nearly as hard. Though perhaps better able to see from a rickshaw, the passenger feels more secure nearer the ground, seated in a comfortable sidecar painted red or green and picked out with flowers. Also, trishaws look neat and clean, with their newly washed white covers on the cushions. The driver and passenger sit at the same level, albeit with one pedalling and the other resting, but the passenger can at least speak to the driver without having to shout directions as though to a harnessed animal.

Not that Ahmad and his driver could have had much conversation on this occasion, for Ahmad was fully occupied with looking after the tree, which was positively enormous, I thought, gauging its height with my eye and wondering whether it would ever get inside a room. What a Chinese friend! Or was that merely a tale? Would we later discover a horrid stump in the botanical gardens? At least 18 inches had to be cut off the trunk before it would fit in the room, and even then we had to haul it over the edge of the veranda, as the stairs were too narrow. Abbas helped to do this, though he was quite uninterested in the proceedings — as befitted a devout Muslim. Not so the rest of our Malay household, who were being invited to help decorate the tree and had been looking forward to it for weeks. They threw themselves into the task as enthusiastically as children.

Margaret had other reasons for being excited. She was taking part in the Nativity pageant at the garrison church on Christmas Eve. For weeks now she had been practising 'Away in a Manger'; we had heard it flat, sharp and with every possible variation, till at last the day had come when she would stand with about 20 other little 'angels' and sing it in public. Suppiah and Zeida, like everyone else in the house, knew the song by heart and were as anxious as we were to see her this evening. When I first invited them to accompany us, Suppiah was a little nervous about entering a Christian church, but I assured her that no objections would be raised and they accepted with enthusiasm. She had made a new blue jacket for Zeida, who now, with a small scarf over her head, looked more like a beautiful Indian girl than ever. Suppiah also had made a special effort on our behalf, being liberally perfumed with a cheap scent, which I suspect she had found in Mina's room after she had run away, for it reminded me strongly of Mina. Mina may even

have given it to her, for she had come back last night, after we were in bed, with Christmas presents for both children — a small blue suit for Tania and a pair of red shoes for Margaret.

This was not the only occasion Mina had returned to visit us since she had left. The first time was only a month or two after her sudden departure and there had been no sign of any baby. Suppiah had given me a warning glance, so I did not pass any remarks, but merely asked whether she had succeeded in getting another job, which she said she had. She had the same remote, untroubled look on her face, and whatever had happened to her had left no visible trace. She smiled easily, always a sign that she was fundamentally happy. Suppiah whispered to me later that Mina had got rid of her baby but nobody knew. I do not think she ever told Ahmad.

We drove to the church in a party. Suppiah was extremely nervous about going in and I whispered to her not to be frightened but to do what everybody else did. While we were waiting we caught sight of Margaret peeping from behind the vestry door, not a bit abashed. She was already wearing a halo perched on the back of her head, and a long white gown with a pair of wings at the back, half folded. She waved, her eyes shining with delight as she smiled at me. Soon afterwards, all the lights in the church were dimmed, while through the open doors the perfume from the garden flowers outside came in, filling the church with natural incense. We relived the story of Jesus's birth, told countless times in different countries by people of all ages. The children acted so well and the production was so beautiful that the congregation seemed to be at prayer. I felt that the two Muslim women sitting quietly beside me were very impressed. In spite of all the open doors and windows, nothing stirred outside to spoil the peace and beauty of the children earnestly acting those holy lives with such absorption that they forgot themselves. Suddenly a small noise was heard, the pattering of children's feet, and the carol we had so often heard at home was borne aloft by 20 children's voices, a choir of angels with haloes glittering like 20 golden moons. I leaned forward in my seat and strained my eyes to find where Margaret stood among the others. 'There!' said Suppiah with emotion, grasping me with one hand and pointing with the other. All our heads, mine, Zeida's and my husband's, followed Suppiah's direction. I swallowed hard. The Christmas carol ended, the lights went up, we said prayers and departed.

That evening I had arranged that we should have a cold supper so that Ahmad could get on with the business of decorating the tree, which would make him feel important and not hurt at having been left behind. This was the first time Margaret had been up for supper. Flushed by her new experience, she still clutched a box of chocolates Father Christmas had given her in the vestry. She was so excited that she ate very little and I had some difficulty getting her to bed. The children's room unfortunately led off the veranda, where the tree stood, and the little half-doors were an inadequate bar to the light and to the exciting noises of stifled whispers, occasional laughter and the rustling of paper and wrappings. All the presents had been wrapped in coloured paper and tied with lots of string, as the more difficult they were to undo, the more exciting they would be. At last the constant tossing and turning next door ceased. I tiptoed into the room and found the stocking hanging at the end of Margaret's bed had slipped and fallen. I picked it up and went to see if both children were asleep, or only pretending. Tania sprawled, spread-eagled in the deepest slumber. Margaret clutched a pillow and I could not see her face, but knew from her steady breathing that she too had gone off to sleep at last.

Ahmad and Suppiah produced surprises for the Christmas tree — streamers, large paper balls (like schoolboys' caps which were quartered in alternate colours and had to be blown up like balloons), and garlands they had made themselves. Ahmad had dressed some slender sticks with frills of coloured paper, like the sleeves chefs use to decorate legs of cold ham at home, only smaller. He stuck these in the wooden tub in which the tree stood so that they pointed out all round, dainty as fairy wands. These were the most Christmas-like in appearance of all the home-made decorations. We had seen them before at Malay weddings arranged in bunches at the tops of bamboo poles and later distributed among the children, as one might hand round balloons at a child's birthday party in England.

Some days before, Ahmad had puzzled out the English lettering for Happy Christmas, and now, in silver capitals of his own spelling, it greeted us from the top of the tree. All had come to join in this grown-up's game of decorating, like happy children. The fat sister arrived with her little swinging baskets of paper flowers, so light that they could be hung on the ends of the branches, branch above branch in glowing colours, brilliant red and orange, grass-green, violet and blue. Had they

been made for a Malay wedding, these baskets would have been stuffed with cooked rice and a hard-boiled egg, dyed a deep purple, to be given to the guests. Peah sat on the floor tying up parcels. When Asmah came out of the hospital for the second time, she had returned to her kampong and was unable to come this evening as the distance was too far for her to walk. Instead, Peah had brought with her the daughter with the wandering mind. She sat by her mother and, in her own way, seemed to find contentment watching the others hanging the pretty coloured balls on the tree, but although her lips were parted and the lights, catching her teeth, made them glitter, there was no smile on her face and no spark lit her dull witless eyes.

For weeks we had been collecting silver paper, which Zeida and Suppiah sat over in the evenings making into flowers and posies. As we hung them on the tree the tiny lizards appeared on the ceiling making noises like old men laughing. Clammy little creatures though they were, I was glad to have them about, not only because they eat flies and mosquitoes, but also for the Malay superstition that any house where lizards abound is a happy one. The lizards laughed and the bullfrogs croaked antiphonically, the residents along one side of the road boasting that there was more water in their ditch than their neighbours had in the other, and all the while the Malays and we sewed and chattered and wrapped up and tied on until the waving branches of our big bare tree were all festooned with gold and silver and scarlet, and I was irresistibly reminded of the scene in the *Tailor of Gloucester*, in which ten little mice work busily all through Christmas night on the coat the mayor must have ready for his marriage in the morning.

Now it was time to start tying on the presents, which of course was Ahmad's privilege, standing commandingly on a borrowed stepladder giving directions on which parcel was to be handed to him next. They had all bought presents — clockwork bears that turned somersaults, celluloid dolls in red and green siren suits that opened and shut their eyes, a dancer that turned round and round, chocolate for me and shaving soap for my husband. Suppiah had made a small Malay costume for Margaret.

Of all the presents Margaret was ever given, she loved this the best. In that it had long sleeves, reached down to her ankles and was made of heavy linen, which looked as if it might last for ever, it was far too hot for almost any weather we were likely to get in Singapore. But Marga-

ret adored her sarong and wore it on every possible occasion. I frequently tried to hide it, but somehow she always managed to find it. Much later, when we returned from leave, she found it again amongst things we had packed away. She put it on, even though by now she had grown far too big for it — the buttons would not fasten and the sleeves were too tight and too short. Suppiah had made it beautifully and, while it still fitted her, Margaret walked round the house as gracefully as any Malay. She had unconsciously observed their gait and no sooner was the costume on her than she became one of them. It was in a beautiful shade of lavender, with a pattern of small white sailing boats and golden flowers.

I was relieved that Suppiah and Ahmad had given Tania something more practical, a short floral skirt and small blouse of which she also became very fond when she grew old enough to wear it. We had already wrapped our presents to the Malays in coloured paper and, as we gave them to Ahmad, he weighed the parcels in his hands, joking and guessing what they might contain before tying them onto the tree. But we were getting tired. The Malays would have sat up all night decorating every corner of the room and I found it difficult to bring the evening to a close. Zeida was still busy arranging some palm leaves on the other side of the veranda; Ahmad wanted to put the last touches to a lower branch and the fat sister was not quite content with the positions of some of her little baskets. I would drop sweets in them tomorrow, I told her, for the ants would only get at them tonight. My husband closed the shutters while the Malays picked up odd bits of paper scattered upon the floor, balls of string, fallen petals and broken boughs. Zeida was still sweeping up what remained as the last of them made their way downstairs.

Early in the morning shutters were opened wide and the scent of hundreds of little white flowers on the tree outside the window came into the room. The morning light caught the spangles dangling on the Christmas tree, the silver paper blooms and Ahmad's decorated wands. Two excited little faces peeped from the bedroom door, and rushed onto the veranda.

18
Isnain and Mun

S hortly after Christmas, my husband came to tell me that Hassan, our driver, had asked to leave. He had been with us for some while, and Ia, his wife, had endeared herself to all of us and was as much a member of the household as anyone. Hassan was a small man, a Boianese with great waves of black hair. When he was off duty he wore attractive sarongs in bright colours and there was a light of good humour, if not of very deep intelligence, in his dark brown face. He was an erratic driver, liable to panic if anything went wrong or even if someone spoke to him when he was not expecting it. When he came to us he had only just got married. It was as pleasant to have a happy family at the back as it had become disturbing to have Ahmad and Suppiah, always bickering with one another.

Ia was a slim girl of fifteen who reminded me of Mina, possibly because she had that same far away look and the seeming understanding of things remote from the scope of her own experience. At first she was so shy that she could not bear to come out of her room when there was anybody looking. Sometimes, early in the morning, I could observe her walking gracefully down our road and descending the steps into the wasteland which lay on the other side.

Before the war this had probably formed part of our garden — it contained the ruins of a potting shed and traces of a tennis court. But it would have been too expensive to keep in order, even if restored to good condition by levelling the furrows where food had been planted during the Japanese occupation and cutting down the various trees that had grown up there. Most of these were mere weeds, having no beauty of shape or foliage, but they provided shade, and kindling for anyone

who bothered to collect it, and from time to time several of them pro-
duced a kind of mango of which the Malays were quite fond. There
were no fences, so people came and went across it as they felt inclined,
and the veranda of our bungalow was an excellent place from which to
watch them do so. Most of them were strangers, or too far off to
recognize. I could watch them as one watches a play, or other people's
lives, or, more rarely, one's own.

A fold of the bank hid Ia from view and I did not see her again until I
caught sight of her returning, carrying a load of dry twigs neatly
bundled and stacked across her shoulders, turning to gaze at a passing
kingfisher, her head poised elegantly on her shoulders. Her beauty was
unconscious and her charm enhanced by simplicity. She was thrifty,
and if she could gather firewood, she would not buy charcoal or kero-
sene. Suppiah spoke of her shyness with approval; genuine modesty
was becoming in a bride. It amused Suppiah to bring her out little by
little, and this she did with sympathy and understanding until Ia's barri-
cade was broken down. After that she was often in the house and I too
became acquainted with her.

Margaret unconsciously drew the truth from these people because she
accepted their actions uncritically. She scattered the jewels of her
knowledge carelessly before me as she chattered on regardless of what
she said, or of the deep interest it held for me. I would watch the
diamonds fall and gather them up one by one. It was never any good to
ask her questions. If I did her conversation ceased to be natural and she
would invent something she thought was expected of her. So, when
Margaret had nothing to say about Hassan's impending departure, I
went in search of Suppiah. Perhaps she would tell me. I found her in the
ironing room but as soon as I pushed open the door I knew that I was
unlikely to learn very much, for Ia was also there. Suppiah worked
busily over the daily washing, the white sheets becoming smooth under
her brown fingers. 'Why are you leaving?' I asked Ia, but she only
smiled shyly and, when I pressed her, said that it was her husband's
decision. Suppiah did not look up when I put the same question to her
and I felt sure she was hiding something.

So Hassan and Ia left without ever telling us the real reason for their
going. My husband thought that he had had an offer of a job with a
higher salary elsewhere, but Ahmad made me even more suspicious by
putting forward a theory, which I did not believe for one moment but

felt certain had been invented to conceal the truth, which he knew. He said that Hassan was temperamentally incapable of remaining in one job for more than a short time at a stretch and, to avoid any questions I might put to him, then launched into a long monologue about drivers in general. He would not give Zeida in marriage to a man of this occupation, he said. As a class, he would have nothing to do with them, or policemen either, for however high the moral integrity of the individual the opportunities for erring from the path of marital devotion were far too numerous. They could be out all day, and very often all night too, pretending that it was in the course of duty, when it was really nothing of the kind. What he looked for, he said, was someone in a steady job, such as a clerk in government or a mercantile firm, with fixed hours and settled prospects. (I was to remember this conversation about Zeida later on, when I heard him use the same arguments to justify a choice made on quite different grounds.) But for the moment he was leading my thoughts to this subject and away from the cause of Hassan's departure. I was aware that this was being done deliberately and felt certain that, in some way, Hassan's and Ia's departure concerned Suppiah or Ahmad, but could not guess what the connection was.

We had already had a succession of drivers. Of these, the first, who was with us a long time was 'Ahmad the Bald' as we called him, to distinguish him from Ahmad our cook. He was what is known as a *Jawi pekan*, that is Malay speaking but more Indian than Malay by ancestry. He had two distinct styles of driving; one reserved for my husband; and the other, whenever I was in the car, steady, cautious and never too fast. I always felt completely safe being driven by Ahmad and it was a pleasure to go shopping with him.

We went on some interesting trips together. I remember one particularly clearly because I was on my way into the centre of the town for an appointment to draw a portrait. It had been raining heavily all night and all morning and many of the roads were flooded. I had heard people talk about the floods, but had never seen one myself until now. And what an extraordinary sight it was! We were about a mile from home, having just passed the little row of shops we knew so well, when the car in front of us slowed down. I looked out and saw that the main road ahead, usually so crowded and busy, was submerged in water as far as my eye could follow it. It was not completely deserted; some of the bigger lorries were still able to get through, hugging the crown of the

invisible road, and a few cars had tried to follow in their wake, but had been abandoned by their owners after failing to get through.

It was not this that amazed me, however, but the utter lack of concern with which everyone seemed to regard this dislocation of their normal routine. Shoppers on their way to market paused for no more than a moment, to roll up their trousers or sarongs, before going into the flood. The shopkeepers waiting to receive them sat with their legs tucked up beneath them, behind counters that were even more crowded than usual now that the goods had been taken off the lower shelves. The only people who seemed to find the situation in the least unusual were the children, who were either penned gloomily upstairs or splashing about up to their waists on the pavements. I thought of the damp houses, the undried clothes and the misery of it all, of which no one seemed to be in the least aware. In fact I became so engrossed in my thoughts that for a moment I even forgot my anxiety about either having to turn back and miss the appointment or carry on and get stranded in the middle of the lake. But I need not have worried. Ahmad was used to floods; he had known them all his life; in fact he probably knew through observing the rainfall and tide when they were likely to occur. He turned off the main road and, taking a route that followed the higher ground, brought me only five minutes late to my destination.

My appointment was to draw a Sikh who worked in the city as a doorkeeper. He had a splendid head, swathed in a pale mauve turban of a very fine gauze-like material. It had been cleverly twisted so that the folds of material radiated from the centre of his head, spreading out to one side. One end of the material emerged on top of the turban and gave a most impressive finish to the structure, with the light shining through it so that it looked like a plume. One wondered how it got there and I wished I could have seen him put it on. It was wound round his head as mysteriously as Indian saris are wound round the bodies of their wearers. He had a small grey beard and a large moustache (which in forming a mask concealed the line of his mouth so I was unable to draw the character hidden beneath it), but his rich brown eyes were intelligent and far seeing. He was so lost in his own thoughts as he sat for me, that I had the feeling that he was not in the room with me at all.

Soon after this, 'Ahmad the Bald' disappeared. We did not like his substitute, Ismail, at all. He was a dressy man who always wore a fez, and had an impertinent manner, which may not have been intended but

was nevertheless unpleasant. We got rid of him as soon as we could replace him and then had a distant relative of Suppiah's — a nice man called Sarip who had gold teeth. But he was a rolling stone and did not stay with us any longer than his predecessor had done. Then, until their departure, there was a long and peaceful period with Hassan and Ia.

Hassan's place was taken by Isnain, a very merry and handsome young man, with charming manners and a wasp-like waist. He wore smartly tailored clothes and grew his hair rather long and all to the same length, brushing it straight back into an even line just below the nape of his neck. We thought he would make a very smart chauffeur, but unfortunately he had not passed his driving test. I felt very dubious about taking on a learner, but my husband, who was tired of engaging what seemed a succession of drivers without end, was prepared to give him a trial. Things actually turned out much better than I had expected. My husband gave him driving lessons on the way to and from his office and he passed his test without difficulty. He was undoubtedly grateful for having been given this chance and after this we had no more change of drivers. Much later, after I had written to him from leave in Australia asking if I might borrow his wife when stopping in the city for a few days on my way up-country at the beginning of a new tour, I found them both on the quayside as the ship came in, for he was most willing to do all he could to help us.

When Isnain came to work for us, my husband drove him and Margaret to fetch Mun, as his wife was called, from the kampong where they had temporary lodgings. I met her for the first time when they arrived back at teatime. Margaret was already talking to her as if she had known her all her life, while Isnain unloaded the car of all they had brought with them. Mun was a rather plain woman, much older than her husband, and I liked her as soon as I saw her. There was nothing hard in her character. She was gentle and friendly and wore an expression of quiet sympathy for the troubles of others, born of a wise acceptance of her own life, which she found difficult but could not alter. Her clothes, which were very clean, billowed around her in an older fashion than that adopted by most of the Malays we knew, who liked to cut their bodices to show the line of their bosom, waist and hips. Mun was content to be fresh and neat, while her husband's eyes wandered to other girls' curves.

At first I wondered why such a lively young spark as Isnain had

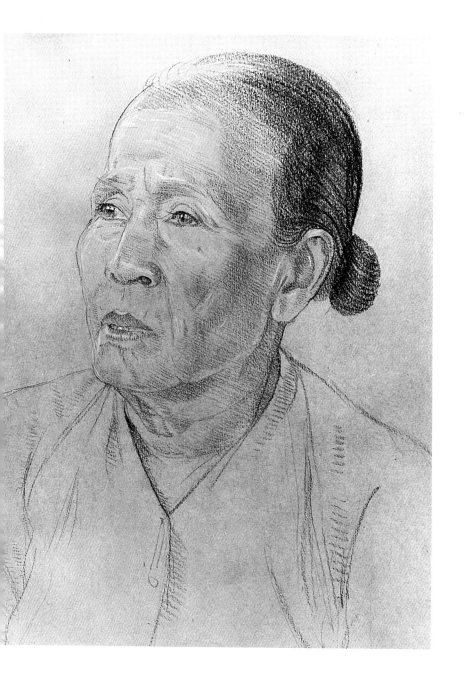

9. Peah.

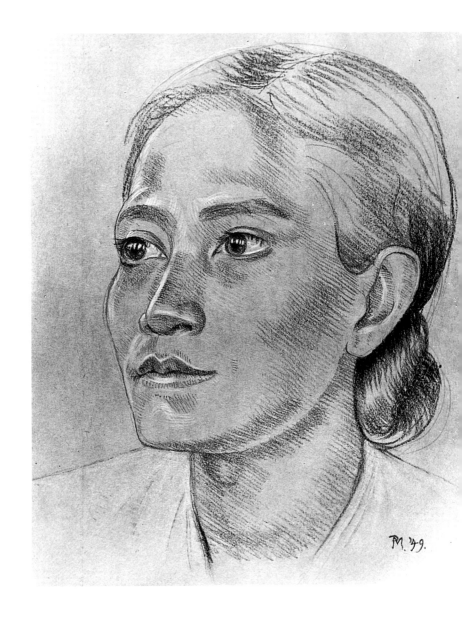

10. Asmah.

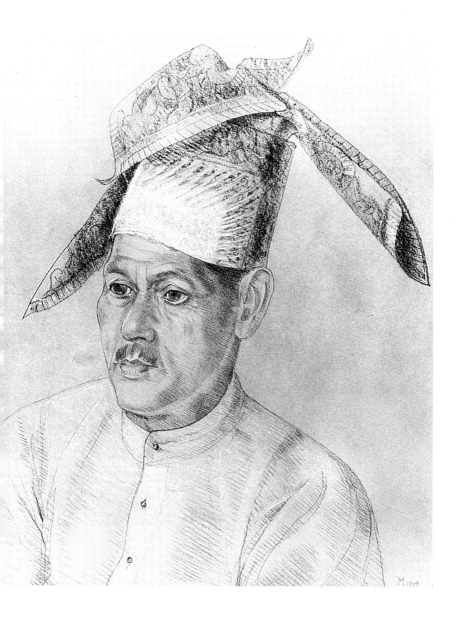

11. Yussuf.

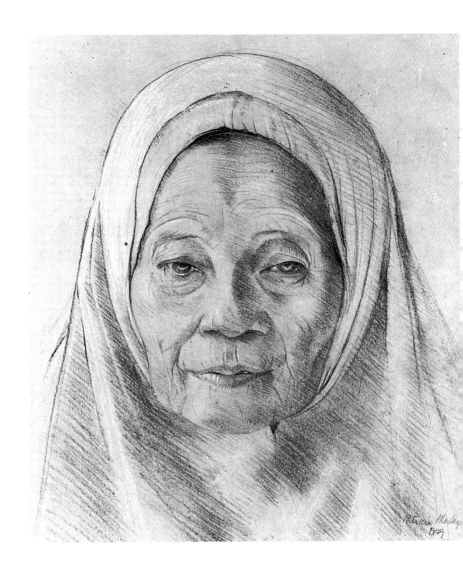

12. Old Malay in her prayer costume.

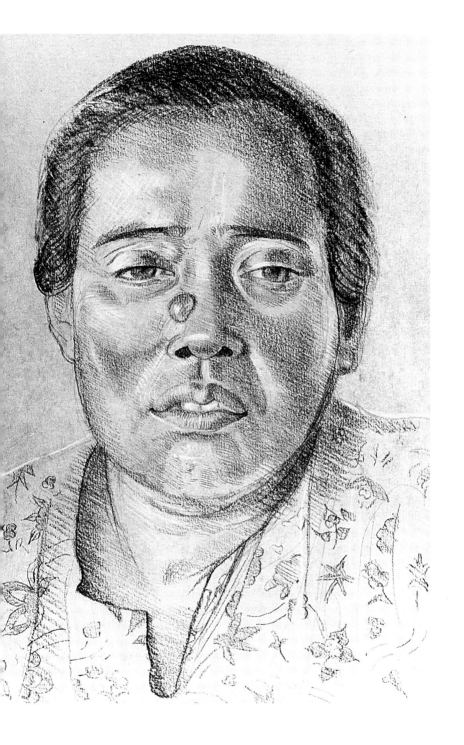

13. Ahmad's mother.

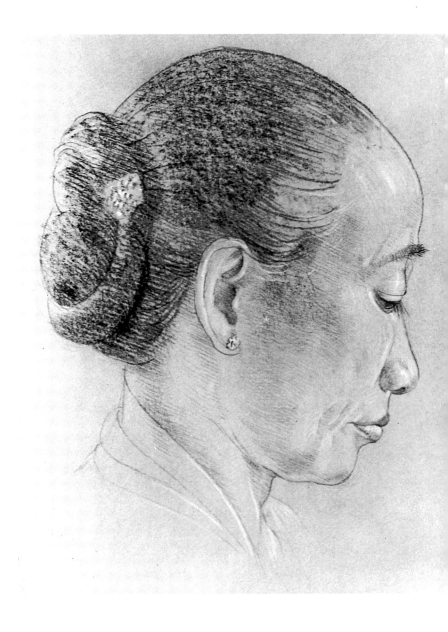

14. Ka-Muna.

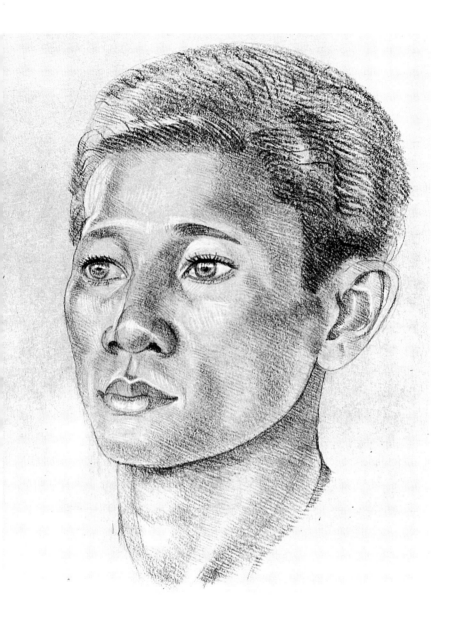

15. Din.

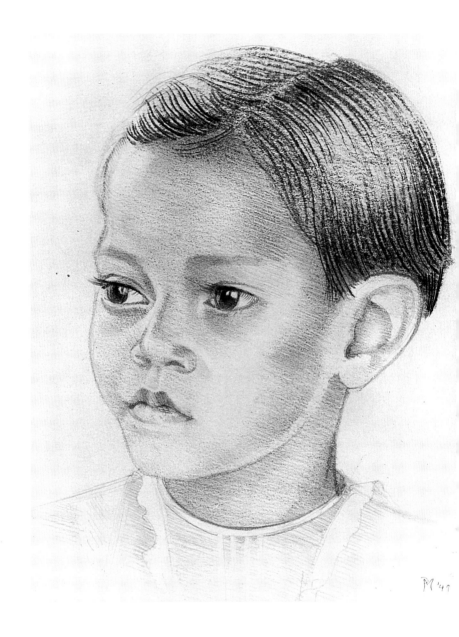

16. Sitiawa.

married Mun. But it did not take me long to find out. She was spot-
lessly clean and to enter her room was a pleasure. From a practical
point of view he had done well, as she could clean and cook and sew
beyond the qualifications of most Malay women, whose tender charms
often flourished to the neglect of more useful attainments. Isnain liked
to be well looked after and was sensible enough to appreciate his wife's
qualities.

But in spite of this, I fear he treated her abominably. The time of the
birth of our third child had now drawn very close and Mun was brought
upstairs to sit with me during the long hot mornings and to help me
mend and sew. She had never sewed for Europeans before, or indeed
done any work in a European household, but her nimble fingers, which
had worked so diligently on her own and her husband's clothes, took
quickly to the work she was given, and soon she was able to hem the
children's frocks far more neatly than I. So, while I cut out and tacked,
she trimmed and finished. Side by side we sat, working on different
parts of the same garment in perfect harmony. Sometimes we talked
and it was thus that I learnt more about her.

This was her second marriage. Her first husband had died during the
Japanese occupation soon after the birth of their first child. Isnain
refused to have this daughter live with them, so the little girl was
growing up motherless in the care of her first mother-in-law. Mun had
no other children. She was unhappy and fretted for the child she had
not seen since her marriage to Isnain two years ago. He kept her very
short of money. These sewing sessions with me in the mornings were
her only means of independence. She discussed with me freely the
possibility of leaving her husband and coming to Australia with us in
six months' time. The only thing that prevented her taking such an
irrevocable step was that she had no one except her husband on whom
to depend. She was wise enough to realize that, while I could take her
to Australia and bring her back again, I would not remain in the country
for ever. Being alone in the world was a serious matter for a Malay
woman, who had few possibilities of a career open to her outside
marriage. So it was really not to be wondered at when, after all, she
decided to lie upon the bed she had made for herself, in spite of all its
discomforts. She knew that since this was a second marriage in which
she had some freedom of choice regarding a husband, she could not
expect a great deal of the world's sympathy if it turned out badly.

Isnain, so delightfully courteous with us, was obviously not kind to her. Many a morning she arrived with her eyes so swollen that she was unfit for work, though she liked to remain in the sewing room where we could talk. One day she came with the whole of one side of her face swollen and her eyelid standing out like a ping-pong ball. It appeared that Isnain had been beating her the night before. 'Why do you allow this sort of behaviour to go on?' I asked. 'I'm alone in the world. Where should I go?' she answered. She knew that Isnain, who had lost interest in her as a wife, still valued her as a housekeeper, and though by now she was resigned to expecting very little from him, she clung desperately to what she had.

In the meanwhile he had learned to drive very well, apart from outbursts of speeding now and then which reflected his high spirits. That would not have mattered had there not been so many other drivers on the road with equally high spirits but far less competence. The main roads were terrifying for pedestrians. One that led to our little shops and to the house of a friend whom I often used to visit in the evenings in the later days of my pregnancy had no pavement on either side of it. On the way back, as it grew dark, I crept as close to the hedge as possible, seeking the cover of the big trees which stood at regular intervals down the side of the road, looming out of the darkness like large policemen in whose protective custody I might find safety. I hoped that if I stood close enough to them, the drivers of the enormous lorries that thundered past might respect my humble self. They were my only salvation, for my small torch had no useful effect at all. As I crept along I became aware of fellow sufferers engaged in the same attempt to escape the horrors of the highway. Black, white or brown, we were of no account at all as pedestrians. Smiling at each other wanly as we passed, caught in the uncertain gleam of pocket torches, we longed for the safe turnings to our own homes, where we could walk bravely again without needing to skulk along hedges and ditches.

Even in the daytime the traffic was terrifying, especially in the centre of town. Trishaws were far more formidable to pedestrians than the slow old-fashioned rickshaws. Unless they saw a possible fare, their drivers had no eyes to spare for the shopper optimistically waiting to cross the road. They formed eddies down the side of the streets, quite as fearful as the main currents of traffic in the centre. I did not enjoy being a pedestrian and felt much safer inside a car with Isnain at the wheel.

He seemed to understand my feelings perfectly, applying the brake when I made the mildest protest from the back seat and, when I had left the car and gone shopping, he appeared from nowhere, offering to carry my parcels and to escort me across the crowded street. Sometimes I wondered if this were all part of the Arabian nights.

19

The Newcomer

In the late autumn of that year disease came to our populous city, visiting impartially the crowded tenement houses at its centre and the mansions of the wealthy lying back from private roads, half hidden by trees and massive walls surmounted by railings. It was infectious but nobody could how, and, though it was believed to be passed by human contact, the cases, which were reported daily, came from all parts of the city and there seemed no connection between them. The shadow fell on rich and poor and on all races, but more particularly, it seemed, the disease claimed its victims from among the European community. Perhaps they had less immunity than the others but this, like most theories, was guesswork. We knew many who suffered, or our friends knew them, and this gave me the feeling that the shadow was drawing closer daily, quenching all gaiety. I know that few mothers escaped this feeling and some of them experienced it acutely. I could recognize its presence in their halting speech and even more clearly in their expressions. It was no use trying to console oneself with statistics, or with the knowledge that people died every day and with as little chance of protecting themselves in road or other accidents.

There were certain rules which had to be observed. I forbade the Malays to bring any children to or near the house. Suppiah obeyed through common sense, but Machi was too naïve to understand. She probably did not know what poliomyelitis was, as none of her friends had had it and, should they have got it, would have expected all their friends and relations to go and visit them, and Machi would have gone with the others as a matter of course. Having a line of reasoning of her own, she could not imagine that there was any other, and, in spite of my

frequent warnings, saw no cause to tell friends who might visit her with their children to stay away.

So, one day, when a family party appeared in the road, I had the unpleasant task of ordering them to leave. It was a very hot afternoon. The children flocked along the road behind their mother, who had covered her head with a veil of pink material to shade herself and the small child she carried from the sun. Beside her walked a friend who had draped her head in green net, which was more decorative than practical for a hot afternoon. I was sorry my mission was such an unpleasant one, because I knew that as soon as I spoke she would lose her smile. How disappointed the children would be too, I thought, for they were all dressed up in their best, the small girl in white, with black hair shining like silk, and her elder brother in his suit of grey.

I talked to the mother and tried to explain why I did not want them to visit Machi's house. But I could see that she did not understand. She only turned and said something to the old woman behind her. I did not catch her reply because at that moment Machi, who had been playing with Tania in the garden, came over to see her friends. When I told her that they must return home, she was most indignant and for some time tried to avoid speaking to me.

Soon afterwards Ahmad came to me and said: 'I think the child next door is sick. Leman have cloth over his head. I told his mother take it off. She will not.' I thought at once of the shadow that had been hanging over us for so many weeks and believed it must be our turn now. Why should it not be? By what right did we deserve to escape? I could see no reason for surviving or escaping. And who could say that, while others were destined to suffer, we were not? I saw the shadow and felt ourselves already caught in its great darkness.

So I went sorrowfully to my neighbour's house, passing the hibiscus hedge with its scarlet lanterns, now hanging like the tawdry decorations of a ball that is over and done with. I wanted to inform them, should they not know, that their gardener's child, Leman, was ill. But their cook told me that both of them had gone to the coast for a holiday in the government bungalow I described earlier. However, he said that the husband returned for his midday meal on weekdays. Fortunately, it was still only Friday and, when I called again later, I found him in. We telephoned the health department immediately and instructed Leman's father to watch for the doctor's arrival that afternoon.

121

Unfortunately this Malay family was uneducated and superstitious and would have nothing to do with health departments or medical authorities. So when the health inspector arrived and got no response from the locked door he sought in vain to open, he came over to see me. He was an old Malay with grey curls and spectacles, whose earnest eyes were in keeping with his gentle manner. He was very sorry to disturb me, he said, speaking English slowly and softly, but he could not get into the quarters next door where he believed the child reported sick must be. There was nobody about in the garden either, he added by way of explanation for having disturbed me. I was charmed by his quiet manners and gentle tones.

We went together to the gardener's room and on my way I looked all round to see if Leman's father had returned. But the garden was deserted. The flowers and fallen leaves lay in the unswept grass and a garage door, moved by a puff of wind, creaked wearily on its hinges. Only the birds fluttered in and out of the trees, merry and cheerful as usual. The door was still locked. We knocked again. In the silence, the repeated knocking gave me that same sense of desolation as the garden. Then Leman recognized the voice of Margaret's mother and was persuaded to open the door. He was bewildered and frightened, for, before going off with their two younger children, his father and mother had told him some strange tale of what would happen to him if he disobeyed their instructions to remain locked inside their room until he was called for later on.

'Chicken-pox,' the doctor said, turning to me after examining Leman. I sighed with relief. Once again we had escaped this disastrous illness with which some of our friends were already smitten. I thanked God and returned home. That night no moon lit the sky and in the morning the infected room was deserted. A few days later Tania developed spots. Knowing I should soon have to go into hospital there was nothing I could do but instruct Suppiah in home nursing so that she would be able to look after her when the time came.

Then 'my day' came, at last. Something stirred within me like a bird beating its impatient wings against the bars that held it prisoner. It was a fine day, beautiful and still, with sunlight making the green leaves gold and the flowers glow. This was the day for which I had been waiting and I was glad, as only a woman who has the end of her pilgrimage in sight can be glad. For a while I did not tell Suppiah or

those who worked around me. But in her nervous concern, busying herself close by me, and Margaret picking up her toys unasked, in these little things, I felt they knew. The coming on of a birth, with its mixture of pain and joy, is an experience like nothing else on earth.

But Suppiah only saw my pain. She knew nothing of the joy and I could not tell her about it. So, until I decided the time had come for me to leave them, I spoke of what had to be done, of Tania, and household matters. My bag had been packed for days, so neither the preparations nor the leave takings were long. As the car turned the corner I saw Suppiah and Ahmad waving, and even Abbas paused in his grass cutting to stare after me. For we are all caught up in birth and death, and in this knowledge mankind has sympathy one with another.

The son Ahmad predicted was born. It was his one and only fortune-telling success. I spent 12 gorgeous days in hospital enjoying the kindness of both East and West. I had been allotted one of the very few private wards, in case I developed chicken-pox, and occupied the last of three small rooms at the end of a balcony, which looked out onto the garden below. What peace! Then after five days I was moved into the large ward. As I was passing the other two little rooms I saw, for the first time, the patients who had been my neighbours. One was too ill to be interested in who passed her door and in the other room there was no cot, so I turned my head quickly in the other direction, but I had seen her, surrounded by flowers, and knew that nothing could make up for her very personal loss. I felt almost ashamed of my own good fortune and longed to send some message of comfort to her.

So I moved into the large ward, where I spent another week. I wondered how the little Chinese night nurses managed to keep so good-tempered through the long trying nights. It was very hot and they had a lot of work to do, both for the mothers and for their babies in the adjoining nursery. There they all lay in rows, their small cots covered with white mosquito netting, sometimes asleep and quiet but always waking early for their first morning feed and resenting the long wait with high pitched screams. In the morning the cots were brought in and placed one by one at the end of the mothers' beds. If the babies cried continually, the nurses took them out and put them in the nursery again,

which they seemed to prefer for they usually fell asleep there, lying stretched out like dolls on a shelf in a toy shop. Sometimes there were a few premature infants, more expensive looking toys, clad warmly as Eskimo babies with great hoods and many layers of covering.

The ward was large and airy. Birds flew into it, as though they too had come 'out of the everywhere into here' and built their nests in the ventilators in the ceiling just like the tree tops. Hygienic or not, this made us patients feel ourselves in the very heart of spring. As each new mother arrived in the ward fresh baskets of flowers were carried in and ranged down the centre, like tributes to a prima ballerina from her friends and admirers, brought from the stage to her dressing room. Chinese and Eurasian nurses hurried backwards and forwards doing all that had to be done with a cheerful kindness and gentle hands. The ward maids, Malays and Indians, who pushed the luncheon trolleys up and down, wore white jackets and scarlet sarongs.

Opposite me, Asian mothers sat in their beds like Gauguinesque madonnas. They and their babies were clad in brilliant colours, unlike the polite pastel shades the Europeans wore. The women in the ward fed their babies with great tenderness, all except one, a Chinese mother whose mind was anywhere but on her child. Her eyes ran round the ward from one end to another seeking some diversion. It was the unfortunate sex of the child that gave rise to this boredom. It was a girl and she had not wanted a girl. I wondered under what bare conditions the child would grow up. Her troubles had already begun, for while she was trying hard to take her meal her mother was not making things very easy for her.

So my days passed in lazy enchantment. I watched all that went on until at last the time came to make the effort to go home and start again with another new life. Giving birth was like crossing a familiar bridge for the last time. Having once reached the other side there is no going back. Everything is new, but the old view is there to be seen from the new side, on which there is so much to be learnt and discovered, for no one child is like another.

My bag was packed again and the car came. I sat in front hugging my son — a bundle in a white shawl. I was going home, and with the thought came many desires and fears, so filling my mind that I hardly noticed until we turned the corner that we were nearly there. Now I could see Margaret clapping her hands and jumping up and down,

dressed in her best frock, with a ribbon in her hair. Tania was trying to jump too, and all my Malay family were there smiling and waving, 'Mummy, Mummy, Mummy' rang in my ears as the car rolled under the porch. As I got out my eyes fell on a large placard, WELCOME HOME, in Ahmad's ungainly capitals, and round it were garlands of flowers. They all ran forward to get a first glimpse of the crumpled little thing that lay in my arms while I, speechless with emotion, hurried as best I could to my room.

20
Mina Reappears

When I got back to my daily round I found myself with a great deal more to do and much less energy to do it. I had no nurse for David, who slept badly — we never knew the joy of unbroken sleep, however tired we were. And when David slept we were often wakened by Tania who was still teething and very restless at nights. If she woke up before our bedtime, I sometimes called Suppiah to come and croon her to sleep again, but once their door was closed I did not care to rouse her from a sleep that was, she said, so heavy that she never heard a sound, whatever went on in the house at night. One evening Tania was so feverish we had to take her to hospital, fearing she was really ill. But even then we did not ask Suppiah and Machi to share our trials, because by the end of the day they seemed even more exhausted than we were. Suppiah ought properly to have been fresh for her work by the morning, but her quarrels with her husband became even more frequent and I found that her work, which had at first been so good, began to fall off. We were, however, due for long leave shortly and I had no wish to make a change now.

Ahmad complained of headaches until I sent him to the hospital to have his eyes tested. He came back with a note saying he suffered slightly from long sight and should wear glasses for reading. Now the amount of reading Ahmad did was negligible, but he had been much impressed with the appearance of the Malay doctor who had visited me when Leman was sick. He saw himself in the role of a professional man and suggested that we might like to give him some spectacles. But I told him that he could well afford to pay 20 dollars out of his wages if he really wanted them. For some days he sulked like a spoilt child

whose parents had refused him a coveted toy. The more he thought of them the more attractive they seemed, until he could resist the temptation no longer, and appeared one day in a pair of horn-rimmed spectacles. He looked most impressive. But evidently Suppiah did not think so, and after a few days she laughed him out of wearing them.

Early one morning, not long after Ahmad's day off to visit the hospital, Suppiah came running into my room in tears. Picking up my hand she kissed it several times, whether from an excess of emotion or to make it more difficult for me to refuse her, I do not know. At the time I thought it was emotion, but now I am not so sure. 'My sister, my fat sister very ill,' she said, 'My other sister come. Please may I go?' 'Yes, you must go,' I said and she fell to kissing my hands and arms again and then ran quickly away. Poor fat sister, that was her second baby to have been stillborn in two years. She recovered fairly quickly, but when she came to see me I saw that her smile was a little forced and her saddened eyes looked weary.

These extra excursions could not be refused, but they were very inconvenient. They always took their half-day just the same, and this too was made as awkward as it could be by Ahmad and Suppiah always going out together. I had no doubt that Suppiah would have infinitely preferred to have gone off by herself on a different day from Ahmad, but this did not suit his book at all. So they went together, accompanied by Zeida, since it would have been considered improper for her to have been allowed out alone. This was difficult now that my time was so taken up with the new baby, for it left me with only Machi to fall back on — lackadaisical Machi — who for all her good nature remained careless and vague.

However, on the days when the others went out she seemed to pull herself together and became much more useful. I think they rather overpowered her and made her pretend to be less intelligent than she really was. Ahmad certainly used to tease her. It gave him pleasure to bully a person who was weaker than himself, to give Machi some of what he got from Suppiah. When the others were out she showed energy and initiative which quite surprised us. She also had an unexpected streak of courage.

One evening when Suppiah and Ahmad were out, Machi was at the back carrying things backwards and forwards between the kitchen and dining room. As I have already explained, the kitchen was unconnected

to the rest of the house except for a covered way. My husband and I were sitting upstairs when we heard an extraordinary sound of beating, loud and reverberating. It continued for so long that I went downstairs to find out what had happened. I found Machi battering a black snake to death. Abbas was shown the corpse in the morning and said it was deadly poisonous. Machi had seen it on the concrete slide outside the back door just about to enter the house, where I suppose it might eventually have found its way into the bedroom downstairs or into the dining room, as there were no doors to stop it. I congratulated Machi on her courage, but she dismissed the killing of a snake as almost an everyday occurrence, turning her face away in what was a typical mannerism of hers when she was embarrassed. Many women would have run away or called for help and I admired her not only for dealing with the situation so confidently but also for the absence of any boastfulness about it.

Abbas told us all to look out for its mate, and the following evening Ahmad, who was extremely jealous of the attention given to Machi, dramatically called us into the garden. He said he too had seen a snake — a much larger one than Machi's. It had crossed his path just where he was about to tread, but fortunately he had a torch with him and had seen it in time. Now with a long pole he was prodding the bushes where it was alleged to have disappeared, making dramatic jabs at something which, in the darkness, we were quite unable to see. Eventually it became so dark that we gave up looking, but were quite convinced that the snake was there. What an excellent actor he was, we thought later.

So Machi was still without a rival in the esteem for which she had not asked, and Ahmad had to pocket his pride. About this time Machi gave me another pleasant surprise. One day she arrived in a very beautiful sarong. It was patterned with broad bands of colour and bordered like a seashore on which each receding wave has left behind its burden of shells — rose and mauve, white and yellow-ochre. I happened to remark on it and say how pretty it was. The next day she gave me a small parcel. When I opened it I found the sarong, washed and ironed and neatly folded.

Only once do I remember her really overcome by emotion. Usually she hid her feelings under the cloak of pride, going about her work silently when anything had upset her. But one day she received a letter

from Java to say that her father had 'returned to the mercy of God,' as a Malay saying describes it. She was beside herself with grief. Seeing that she would be incapable of working I gave her leave to rest till the following day. I had observed before how devoted Malay women were to their fathers.

The next day was spent in preparation for the funeral feast ordained by custom. With all the bustle and activity it had more the atmosphere of a wedding. But custom has its usefulness and while Machi was so busy she would have no time to think of her own sorrow. A large table was brought into the shade of the trees at the back, and all afternoon Malays squatted there pounding and mixing and cutting, while others bent over large flat trays of rice picking out the husks and withered grains. One dish after another was made ready. Margaret and Tania moved among them watching all that was going on. I never allowed the children to take (or the Malays to give them) food between meals but in spite of this they had no appetite for supper on this occasion. Ahmad sat apart, his deft fingers weaving long bands of fresh-cut grass still green and easily worked into small baskets. These, he explained, were not for tonight's entertainment but for his 'little' brother's wedding party which would be taking place shortly, and for which, on a suitable occasion, he would no doubt approach me for a loan.

Mina was invited and arrived that evening. She was to stay the night and be fetched the next day by her husband. We had heard before that she had married a connection of Machi's, and I wondered whether she had got a ruling that her first marriage to the young man who had sailed away and never come back was no longer valid, or whether, being Mina, she had never bothered. We were greatly relieved that Mina seemed to have settled down at last, for after her flight from us we had worried about what would become of her.

Her new husband was a very smart young man with smooth hair, small waist and purple shirt, all of which would no doubt appeal to Mina. She seemed contented at last and had lost the look in her eyes that had sometimes made me nervous for her future. I was glad for the sake of Suppiah, who had given up so much time to look after her, and wondered what might have become of her without that steadying influence. Even now her husband would have to be very good at sweeping and cooking and sewing, unless Mina had changed considerably, which I doubted. Now she came upstairs for her first sight of David. I

observed her closely while she looked at him and saw that her eyes no longer strained after some distant horizon, but were turned in on herself with a level of contentment that could have only one meaning.

We sat in the room at the back that evening for the first time since David's birth. It was like stepping into the past and everyone was in excellent humour. While we older ones sat together, Mina and Zeida remained apart in another corner of the room, though now that Mina was married she was really entitled to sit with us. She and Zeida had much to talk about, and from the frequent laughter it sounded as though they were enjoying themselves.

During a pause in the conversation Ahmad dramatically announced that Zeida would soon be getting married, raising his voice so that she too would hear what he said and savouring the full delight of his moment of power. I wondered what fate Ahmad had planned for Zeida and, watching her bowed head as she listened to her foster-father's words, imagined how much she must dread having a marriage chosen for her. I was glad when the subject was dropped and I saw her happiness reassert itself, for when she listened to Mina's chatter she forgot to worry about her own fate.

Soon they were laughing again together as of old. As I watched them I remembered all the fun they had had in each other's company: Mina wearing my husband's cast-off trousers, Mina cross, Mina cheerful, Mina learning to ride a bicycle (the only woman I saw doing so in our city at that time, though up-country it was a common sight), Mina asleep with her long black tresses falling all round her, or Mina sitting for me with flowers in her beautiful hair — always Mina in the foreground and Zeida effacing herself. And now too Zeida was far too good-natured to envy Mina her present happiness. It was only later, after a great struggle, that Zeida was even allowed to earn a recognized wage for herself in our household, instead of doing all her foster-parents' work unpaid. This happened when my sister-in-law came to live with us and, after endless discussions about how the extra work was to be done, they eventually, to my surprise, agreed to let Zeida undertake it. But afterwards I often wondered how much of her wage went into her own pocket.

I tried to persuade Mina to have her baby in the hospital at which mine had been born. She would be attended by the same doctors and nurses and it would cost her very little. She responded readily, more

readily than I had expected. But of course it would all depend on her husband, she explained, and I feared that despite his sophisticated appearance he would have the usual prejudices against European medicine so prevalent among uneducated Malays. (Those who had been educated held quite different views.) He would probably insist on the birth of Mina's child taking place in some back room of their kampong. But I need not have worried, for even if he had agreed, Mina would not have been able to reach the hospital in time, for she lived a fair distance from it, and her child, a little girl, was born prematurely. Machi visited her a few days after the birth and told me that it was a very delicate baby. What a pity I thought. With expert handling it would have a far better chance of survival. That was the last I heard of it, but later when Mina failed to come and say goodbye to us before we went on leave, as she had promised so faithfully to do, I wondered.

21
The Christening

T he preparations for and then the arrival of the new baby had left me with less time to give to Margaret and Tania and, as a compensation, I promised them both something rather special in the way of new frocks for their brother's christening. So they both looked forward to this event with great excitement — Margaret because she was already interested in clothes and Tania because she wanted in every way to be as much like Margaret as possible. I had ordered them pink dresses with pale blue smocking. The smocking was exquisite, both in design and finish. Even in modern times fine needlework is common among the Chinese, so common in fact that it is less highly valued than it should be. Much of the beautiful work done in crowded back rooms at a heavy cost to eyesight is stitched on inferior material which, after a little wear, begins to disintegrate. Knowing how beautiful the work would be, I chose the best material I could find and the children's dresses continued to look charming until they grew out of them.

The Malays too were looking forward to the christening, as they had already been told that they would all be going to it. Machi was to look after Tania as usual, Suppiah would hold the baby, and Zeida would go because it was unthinkable that she should be left behind. She had such a loving nature that without ever using a harsh or unkind word she could always command Margaret's perfect obedience. If Zeida went Margaret was sure to be good.

Zeida wore a new pair of earrings, little swinging silver moons, bought with her own money. I was slightly disappointed to see that Machi was not wearing a set of silver buttons I had given her as a small present in exchange for the sarong. Like all the other women who

visited our Malay family at the back, she wore a jacket that was care-
fully cut and neatly sewn, but fastened up the front with a line of safety
pins. It cannot have been that button holes were too difficult for them to
stitch and I could hardly believe that laziness prevented them from
putting the finishing touches on garments to which they had already
devoted so much time and care. Peah once told me that if women wore
buttons they would be accused of dressing up like men. I do not know
whether that was the real reason, but felt sure that if one of them had set
the fashion they would all have followed it. I felt a little concerned to
note that Machi was wearing her husband's sarong and supposed that,
now she had parted with her own, it had become the family's best. It
was quite usual for them to borrow each other's sarongs. Husbands
wore their wives' ones, provided they were not too flowery, and wives
wore their husbands'. Even Ahmad wore Suppiah's on occasions, and
old Peah borrowed her daughter's. How useful I thought it would have
been when clothes were rationed to have had a common pool of best
clothes, which could have been passed round the family for use on
special occasions.

With such a large crowd of people it was necessary to hire an extra
car. As usual, we had the greatest difficulty getting everyone ready and,
after going back once to collect the baby's water bottle with which
Machi had been entrusted and which she had left behind, arrived only
just in time. Our friends were already assembled and the ceremony
began without delay, the rain driving through the great porch of the
cathedral in sheets. Machi and Zeida, who were too bashful to join the
semicircle round the font, sat awkwardly in the pews. But Suppiah, who
was getting used to churches by now, was today at the centre of atten-
tion, for she held the baby in her arms. Even if she did not understand
the words that were used, she fully grasped the reason for the ceremony
and possibly something of its symbolism also. She stood there with
perfect poise and I saw her glance comprehendingly as the child was
named and admitted into the fellowship of his religion.

Before it started I explained to her what was going to take place, for
in her custom there was no parallel. In some parts of Malaya, I had
been told, a baby is named at a ceremony held at its parents' house, at
which the baby's head is shaved and a piece of gold, sprinkled with salt
and a fragment of date or something sweet, is passed across its mouth.
But these symbolic acts were no longer performed over most of the

country. The shaving of the head had mainly been replaced by the snipping of a strand of hair, but the reason for it had been forgotten. Suppiah was familiar with this practice, but had not even heard of the others. A baby's name, she explained, was chosen through consultation. It could be named after a favourite relative or ancestor, according to its horoscope, or simply because its father liked a particular name. It was a first name and there was nothing to correspond to our set surnames going from father to son and from generation to generation.

Afterwards Machi and Zeida joined us to go to the christening party, which one of the godfathers most generously provided at his house. This was a greater relief to me than he could have known, for I could never have risked going to the ceremony and leaving Ahmad behind in charge of the preparations, for he was far too absent-minded and would probably have made it the occasion for a 'scene'. Our host had a lovely house situated among sloping lawns and large trees, all in view of the room where the guests were gathered. The room had been decorated in white and green — white orchids, wax-like frangipani (sometimes called temple flowers), spider lilies with their torn petals and, round the cake, gardenias like carved and polished ivory mounted in leaves of shiny green. The sprays of bamboo in the background were perhaps the most beautiful of all the decorations. I thought how the subtle tracery of its fronds, springing so naturally from graceful strong and slender stalks, would have appealed to the Gothic craftsmen of our own land. It had certainly delighted countless generations of Eastern artists who, over the centuries, had explored its endless combinations of form and intricacy of texture. For many of us, bamboo lives mainly in their paintings and drawings, for in England one rarely sees bamboo growing to perfection. It usually exists miserably in half starved clumps, missing the warmth and wetness of its proper home. The afternoon sun lit a corner of the veranda where a vase was standing — shining through the stems and foliage it traced patterns on the floor that were almost as lovely as the bamboo sprays themselves. Zeida looked all around her, taking in the details of the decoration, and I could see from her face that she was entranced.

It was a lovely party, with the cake, and champagne, and our friends, and the photographer, and three children, all my own. How proud and possessive I felt! David behaved perfectly and as soon as their tea was over the children disappeared from view, scampering through the

rooms and passages at the back of the house. Tania was out of action early; she was still unsteady on her legs and had fallen over. My husband picked her up and handed her over to Machi, while Zeida went off to join in the children's games and Suppiah, still holding David, stayed with us, proud of the compliments the guests were passing about the baby. At last we had to leave and, saying goodbye to our hostess, we set about collecting cars, Malays and children.

Machi was still carrying Tania, who had fallen asleep, she said. Getting into the car I told her that I would take Tania. But when she put her in my arms I knew at once that something was wrong. She lay limply across my knee like a rag doll that has lost its stuffing, her legs dangling uselessly, her body cold, and all colour faded from her face. I felt sick, as one does with shocks that come when one is totally unprepared for them, and could not even look at our little group of friends standing anxiously on the steps as I told Isnain to drive straight to the hospital. He drove as fast as he dared through the crowded streets to the admission room where my husband borrowed a blanket in which to wrap her. I could not stay there, with David to feed, but left him with my sister-in-law (for whose practical help and comfort in this as in many difficulties I shall always be grateful) standing there, waiting for the doctor to come, carrying the lifeless Tania in his arms.

At home everything was in confusion. Margaret was near to tears, Suppiah was walking up and down distractedly wringing her hands, and Machi was being scolded by her husband for not watching Tania more carefully. She often deserved blame but on this occasion it was certainly not her fault; any child of two may slip and fall even though several eyes are watching to prevent it. Just then my sister-in-law arrived back with the news that Tania was coming round from her concussion and, as far as they could tell, there was nothing worse than that, though she would have to spend a night in hospital under observation. The news was a relief to me, but it seemed to make Suppiah even more upset than ever. 'She will miss me. I know she will miss me,' she said over and over again, thinking of her nightly routine of putting Tania to sleep. But in fact by the time I got back to the hospital — leaving Suppiah to put David down — Tania was already halfway off to sleep. I stayed there until I was sure she was all right and, after helping my husband arrange the bed where he would spend the night beside her (she was almost as used to him as she was to Suppiah), went

home with a thankful heart to look after the rest of my family. Early the next day Suppiah and I went to fetch them.

Tania seemed a little dazed. Her large eyes were full of wonder as though she had been visiting some far-off country and was still dreaming about it. Most of the day she slept and when she was not asleep Suppiah carried her about (like a Malay baby) supported in a hammock of cloth slung from her shoulder. In a few days she was running about again quite normally, though I continued for some time to watch her nervously, recovering only slowly from the shock of the experience — an incident such as can be expected to occur once if not more often in the life of most mothers with young children, but no less alarming for that.

Suppiah was so good on occasions like this, understanding exactly what the children needed, that I felt I must do all I could to smooth out the difficulties which constantly arose between her and Ahmad, and somehow keep the peace until it was time for us to go to Australia. There would be a great deal to do and it would often be necessary to leave the children in Suppiah's care; to replace her would be very difficult. Children like familiar faces and an accustomed routine and do not readily accept a change of either. A big uprooting would soon have to take place anyway when our leave fell due, and that would be time enough to cut the present roots before transplanting to new soil. I thus tried very hard to forestall or divert their quarrels, though the effort of doing so taxed my powers to the utmost.

I was already overtired from the continual short and broken nights caused by the baby. Ahmad seemed to have lost all pride in his work. His cooking was atrocious and the kitchen, which he used to keep so clean, was filthy. The stove was rusty, the sink was stained and hens perched everywhere, under the table or on an old wicker chair in the corner, laying their occasional eggs in a basket hung below the kitchen window where Ahmad could conveniently retrieve them and identify them as Suppiah's. In the end I had to tell him that I could tolerate his poultry farm no longer, pointing to the birds sitting about miserably, looking diseased and unsightly. But when I complained Ahmad said that they were mine. 'My hens!' I retorted, 'but we haven't had an egg for months. The hens are no use in their present condition. You had better kill them. At least we can eat them.' Ahmad looked very angry but made no reply and there the conversation ended.

At lunch that day the food seemed to take abnormally long to arrive. Zeida brought in the dishes apologetically and then went out again. It was obvious that something was going on at the back that I was expected to see. Ahmad, with his gift for stage management, had this time really excelled himself. I found a number of corpses of hens already laid out in a row, and Ahmad in the process of beheading the last, an act he had clearly postponed until I put in an appearance. It was quite clear from his behaviour that he had wilfully misinterpreted my instructions out of spite — a silly triumph for him and one about which he already felt a little ashamed. He knew that we denied ourselves the luxury of expensive chicken from the market and would have enjoyed eating our own poultry on Sundays or on other special occasions. Now we were compelled to eat chicken for breakfast, lunch and supper and even then the last bird had to be flung into the rubbish bin uneaten because our appetites could not keep pace with Ahmad's slaughter.

In addition to all her other duties, Zeida had begun to wait at table. She could not get through all the work Ahmad and Suppiah now allotted her. I could not understand why Ahmad had become so idle. Perhaps, as with Suppiah, it was because the constant quarrelling affected his vitality. I noticed that Suppiah had reached a stage of no longer caring how her work was done unless she was handling the children. Only a few more months, I said to myself, wondering how I should ever get through the packing when the time came. I really relied on Suppiah and cast about endlessly in my mind for some way of patching up their quarrels for a few months longer. Ahmad was clever enough to realize this and, though he did less and less work, he became increasingly sensitive to any suggestion of a criticism. One day I put a lot of clothes out on the veranda to air. When I put them back in the cupboard I noticed that where they had rested against the shutters they looked grey as though they had brushed against powdered charcoal. I mentioned this to Ahmad and asked if he or Suppiah would clean that particular section of paintwork.

A little later on I found Zeida in tears. At first she was too upset to tell me what the matter was, but eventually it came out that Ahmad had scolded her for laziness and would no longer allow her to work in the house. I went to find Ahmad, but did not have to look far, for he had placed himself in a most conspicuous and unusual position. He was on a stepladder washing down the outside walls of the house in the full

heat of the sun. As soon as he became aware that I was looking, he mopped his brow and fanned himself before carrying on, with ostentatious fervour, his self imposed task. This dramatic self justification was ridiculous, but had become such a habit with him that it amounted to a mania. When I called him, he affected at first not to hear and then came down, descending gingerly to draw attention to the danger of his occupation. I admired his handiwork and said, with an irony I knew would be lost on him, that we could safely leave the rains to complete the work he had begun.

I asked him about Zeida, whom he scolded for the faults that were rightly his, just as Suppiah had done over the ironing board. Poor Ahmad, he was his own worst enemy. If only he could have been honest with himself and admitted to his own mistakes and accepted facts as they were. But he could not. He had practised self-deception for so long that what had at first been a pleasant evasion of responsibility had now become a permanent refuge from reality. As long as Zeida remained under his roof he would be able to blame her for everything that went wrong. Zeida submitted to his behaviour with the meekness derived from strength rather than weakness. In a day of two she was back at work again and for the time being nothing more was said.

22
The Storm Breaks

'**M**ay I go to my *leetle* brother's wedding?' Ahmad asked in English one morning. He and Suppiah used to mix the two languages when speaking to us, sometimes using one and sometimes the other. 'When is the wedding?' I asked. 'Tomorrow. But I make all ready before I go.' 'Very well,' I said, 'you may go.'

This was Saturday morning. In the afternoon the house seemed unnaturally quiet. It was past the hour when the Malays usually stayed in their room for their afternoon siesta. Ahmad was not in the kitchen where he was normally to be found about this time. 'Machi!' I called. 'Will you tell Ahmad we are ready for tea?' 'Ahmad has gone,' said Machi. 'Gone, gone where?' 'To his brother's wedding,' she replied. 'But I understood they were going tomorrow,' I said in surprise. 'Ahmad said you had given them permission,' said Machi, sounding a little peeved, as well she might be, since one afternoon's holiday a week was the rule and when one went it left more for the others to do.

I was flabbergasted. 'When are they coming back?' I asked. 'Ahmad said he would return tomorrow night with some curry for your dinner. Suppiah and Zeida are staying there till Monday morning,' she said. I felt very angry. Ahmad had deliberately left things vague. I had made no plans to do all the cooking over the weekend, nor could I find anything left ready. Besides I had the baby to attend to, who was not himself today and would require a great deal of looking after. This made Ahmad's behaviour all the more infuriating. He and Suppiah and Zeida had never all been allowed to go off together for a long period like this, and he knew that I would not have given them permission to do so on this occasion.

So my husband and I set about doing our own work and, as we did so, talked things over. We decided that Ahmad should not be allowed to get away with such behaviour again. During the afternoon of the following day we took the children for a drive and left Machi at home to prepare for the evening. When we got back Ahmad had still not returned. It was not until the children were in bed and the light had all but gone that we heard a taxi draw up and saw Ahmad emerge from it, weighed down by a large pail he carried in one hand. He dragged himself, rather than walked, as he came towards me. I saw that his eyes were bloodshot and his face pale and haggard. 'Well!' I said, 'You might have told me that you were all taking the weekend off.' 'You said I could go,' he replied curtly. I tried to explain exactly what I had said, but with an impatient gesture he interrupted me. 'Never mind. I go now. I give notice.' It was an awkward moment.

I had come to the end of my reserves. Upstairs packing cases lay empty on their sides waiting to be filled and it was clear that baby David was far from well. How should I ever manage? Going on leave was like moving house. Everything we possessed would have to be packed up and sent off somewhere, either to go with us or to await our return. The last thing I wanted was to be deserted in this fashion, but I had no words to say so.

However, my husband who was standing near had already weighed up the situation and said, 'Well Ahmad, was it a successful wedding? Oh yes, it must have been with Ahmad in charge of the arrangements. What was Ahmad carrying in that pot? What a good smell. It must be one of Ahmad's curries.' Ahmad grinned sheepishly and opened the lid. 'Just look at the way that rice was cooked! No-one could cook curries like Ahmad, and it would taste as good as it looked and smelt.' Despite his tiredness, Ahmad was beguiled. He could never resist this sort of flattery. Yes, it had been a successful wedding. 'The guests all say my curry very good. This curry I bring back to you.' And he started to disclose the contents of the other dishes before he paused, remembering that he had just announced his departure. But we affected further interest in the curry, saying how lucky it was that we had not yet eaten, until Ahmad, with the sort of coaxing one would use on a tired child, was brought into the kitchen, and after more in the same strain, the temperamental outburst of a few minutes before was smoothed over and forgotten.

Soon we were sitting over one of Ahmad's really excellent curries. 'But this is positively the last time,' said my husband, and we there and then resolved that, however great the inconvenience, we could not and would not let Ahmad get away with this sort of behaviour again. The next morning Suppiah and Zeida came back. They were tired after their festivities and worked badly. Suppiah knew that she had deceived me and for the time being hated me for the shame she had brought upon herself.

But for the next few days I was aware of neither her moods nor Ahmad's. The baby's health took a turn for the worse and developed into a serious illness. All my time was taken up watching him. My husband and I took it in turns to nurse him during the nights. After two of three days of feeding him on glucose and water, we spent a night when there was nothing that would send him off to sleep. Finally we brought his pram upstairs. But we had to keep it covered with a mosquito net and, as we pushed it in turns, the net got tangled in the wheels and this was more aggravating than anything. As the hours went by he got worse and eventually, in the early hours of the morning when it was still dark, we decided to take him to hospital.

Isnain was called and had the car at the door almost before we were ready. We drove quickly and silently down the dark empty roads, I hugging my little son with a mixture of agitation, love and utter exhaustion. When we reached the hospital it was just dawn. A little Chinese nurse took David from me and, looking at him, assured me that he would be all right. How I blessed her for those comforting words! We stayed at the hospital until the doctor came on his morning rounds.

When we got back Ahmad was waiting with hot coffee, but I could see from the look on his face (and on Suppiah's) that there had been trouble again between them. Ahmad clearly wanted to tell me about it, but I was too tired to listen or to care. 'Later, Ahmad,' I said, without even feeling resentful that he should be so blindly selfish as to choose this moment to try to inflict on me the history of his sordid quarrels. Exhaustion had dulled all my senses to a partial numbness.

All morning Ahmad and Suppiah were sulky and bad-tempered. But we got through it somehow until it was time for the children's lunch, which they had to have earlier than we did because they found the long morning very tiring, especially Tania. After lunch she had to have a rest and it was Machi's job to take her upstairs and settle her down, but it

was Machi's day off, so the duty fell on Suppiah. I was aware that Tania had not gone up and, hearing her whimpering at the back, went out to see what was going on. Suppiah was sitting cross-legged, arms folded, watching her. 'Suppiah' I said, 'I think it is time for Tania to go upstairs for her rest. She is overtired.' But Suppiah took no notice and sat on as though she had not heard me. 'That child ought to be asleep,' I said again emphatically.

Although Suppiah made less of it than Ahmad would have done, I found myself in another drama put on especially for my benefit. She did not raise her head, or look at me, but said casually, 'I don't want to work here any more.' I suppose she had a grievance against Ahmad which she wanted to unburden on me, and was asking to be petted, sympathized with and praised until she felt herself again. Having no other way of compelling my attention, she thus idly seized on the words she knew I could not ignore. But she had chosen her moment badly. I was far too tired to make an effort to calm or conciliate anyone. 'Go then,' I said, and picking up Tania myself I took her upstairs.

I did not know what would happen next, but I assumed that she would go and that I should not only lose a friend but have all the trouble and toil of finding and training other people for the few weeks we had left, at the end of which everything had to be packed up and we would be saying goodbye to the house for ever. What an effort! But if they had to go, it was better that they should go now, while the baby was in hospital and I had some chance of reorganizing my household.

For the rest of the day I did not see Suppiah. And Zeida hid herself away. Ahmad came to me and said that of course I must understand that it was only Suppiah who did not wish to work any more. He himself would continue. Poor Ahmad! I was grateful to him but he did not realize that without Suppiah he would be no more than the setting that remained, uselessly reminding me of the loss of a jewel. 'No Ahmad,' I said. 'I'm sorry, but if Suppiah goes you all go.' And with that he saw it was no use pleading and walked dejectedly away. The next few hours felt strange indeed. Ahmad busied himself here and there and whenever he came near me his manner was gentle and sympathetic.

'Excuse me, I must take Suppiah's machine,' he said. It had been in my room for some time now. My own German machine was being repaired by Ahmad and, as these repairs were never quite completed, it stayed with me permanently. She would 'borrow' it when she had some

sewing of her own to do. It had been very generous of her, as she said that she had had the machine for twenty years, having even managed to keep it through the Japanese occupation. She must have greatly treasured it. I had been very busy making the children the clothes they would require on leave, and I should miss Suppiah's machine. Mun would have even more hand sewing to do. The removal of the sewing machine was the first practical reminder of what I would miss when she went and I experienced a strange hollow feeling, which started a train of old scenes and associations running through my mind.

My mind went back to the very first time Suppiah came to see me and to how readily we took to one another. I recalled Suppiah tying Tania's fine wisp of hair with my ribbon, Suppiah teaching her to throw corn to the chickens, Suppiah sitting for me, rather nervous on these occasions, Suppiah's brown hands, the smell of her cheap scent, her common sense and above all her affection for the children and for me. People who work day after day in one's house inevitably enter more and more into one's life. I felt this most acutely, for in two years I had spent little time outside my house and garden. My home was my workroom and these Malays had not only made it possible for me to do my work, but had themselves become an essential part of it. In losing them I thus also lost marvellous material, which had given me many hours of pleasure and provided much of the inspiration I found in this wonderful city. Anyone wishing to draw or paint Malay people or to make a study of them will understand why I put up with so much and why, when they left me, I felt as if I had lost something that money could not replace.

In the meanwhile, preparations went forward in the room at the back. A lorry arrived and the household goods were brought out to load upon it — their one mattress, several pillows, the old gramophone, the cracked mirror, Ahmad's guitar, the cooking bowls and many other of their household things, with which I had become as familiar as though they were my own. When I saw that the moment of departure was near, I told Mun, who was holding Tania, to take her away so that she should not see the family leaving or their empty room. A few minutes later they were gone.

That same evening I saw Margaret's large doll sitting on the sofa where I had not noticed it before. It must have been one of Ahmad's last jobs. For days it had lain in the kitchen with its head off waiting to be mended. Ahmad had not had time, but in the interval between

packing and going he had somehow managed to do it and had brought the mended doll upstairs without saying anything about it. Now, as it sat there on the sofa, its face seemed to mock me, reminding me of all that had been good about them and nothing that was bad.

23
Reconciliation

Next day the children woke and sang and played as usual. Tania seemed not to notice the absence of the other family, whom she had known since she was a few months old, but Margaret was naughty and uncontrolled for many weeks to come. We were astonished at Tania's apparent calm, for she had seemed so fond of Suppiah, and Suppiah in her turn had played with Tania and loved and looked after her as though she were a child of her own.

Over this period Mun and Machi were pillars of strength. Machi, who was normally so lazy, rose to the occasion, while Mun took it in her stride, and together they did all they could to lighten for me the blow of Suppiah's departure. One cannot lose friends after two years of intimate contact without feeling it very deeply, especially since she and Zeida had grown into our household and become part and parcel of it. That they had not come to say goodbye made me think that they on their part had also felt the separation more than they cared to show. But, even while commiserating with myself, I had to confess that I was glad to be rid of Ahmad. His perpetual play-acting had been a constant strain on my nerves. Having to respond to his moods, however little I felt inclined to do so, had compelled me to act a part myself. Although it is not unusual for Malays to wish to elicit an emotional response to their behaviour, none of the others demanded it as excessively as he did. There were other things that helped reconcile me to my loss. The chief of these was that David was better and that in a few days I would be able to bring him back from hospital.

Machi, who had always been frightened of Ahmad, now spoke more freely than she had dared to before, and it was from her that I eventu-

ally learnt the reason for Hassan and Ia's hasty departure. When Ia was expecting her baby, she saw Ahmad throw a fit one night and was so frightened that she had made Hassan take her away at once. So Ahmad was an epileptic after all. Machi told me a lot more. Latterly Ahmad had been having fits regularly about once a month, which was why Zeida had begun waiting at table. Many other things now became clear to me, such as Ahmad's unhealthy pallor and occasional strange appearance, his journeys back from the market in a taxi, and his quarrels with Suppiah. Suppiah felt she had been deceived when he married her, for he had not told her of his tragic disease, which Malays view with such abhorrence. She must have taunted him with it night after night, trying to rid herself of the shame she felt.

Knowing what they had to endure, one could hardly help but feel sorry for them both. 'To know all is to forgive all,' it is said, but that surely is a counsel of perfection. Most of us do not really know ourselves, and therefore cannot expect to know much about others, even when they have been our daily companions for years. Language is naturally an important aid to understanding, but never more than an aid. A person understands those people best whose way of looking at life is nearest to his or her own. Through community of language I made only slight progress in understanding these Malay people; through community of feeling I advanced, I believe, quite a bit further.

I also heard from Machi about Zeida's betrothal to one of Ahmad's brothers. This was of course Ahmad's work. Knowing Suppiah's affection for Zeida, he planned, by marrying her into his own family, to tighten his hold over Suppiah. But why did Suppiah consent to it? What custom compelled her? Or was it because in the bottom of her heart she knew she was too old and too tired and too bowed with life ever to resist and try to alter things? Zeida had resolved to run away to Mina before her wedding, Machi continued. But I wondered whether she would have the courage to carry out her plans or whether she would find the weight of convention too strong for her.

In the meanwhile my husband interviewed one Chinese amah after another, as I was too busy in the house. He selected a middle-aged woman with good references and she promised to find someone to work with her. A couple of days later they arrived. As I showed them round they grinned at one another, shaking their heads and exchanging glances which clearly indicated what they thought of the condition of

my house. They wanted a much higher wage than the Malays and free bread and tea. Only a few weeks, I said to myself, nodding to them that I agreed, for they spoke very Chinese Malay and I found myself having to resort to signs. My knowledge of Malay was nothing to boast about, but the Malays had a remarkable capacity to jump to the right conclusion when I started a sentence and did not know how to finish it. Somehow we understood each other far better than we should have considering my very rudimentary knowledge of their language. Having ascertained their requirements of bread and tea it was some time before I understood what else they expected — camp beds to sleep on. Fortunately we had two. Later, when I went downstairs I found with some horror that they had turned the garden hose on them. Seeing my expression they said that they were so dirty they could not possibly sleep on them. But nobody has used them except my husband and me, I explained. They went into peals of laughter, but what that signalled was more than I could follow.

Of the two amahs I preferred the little one. The big one with grey hair disappeared the next day and I was not sorry. She was so efficient and so managerial that I no longer felt that my house was my own. So much bustle and noise was strange to me. She talked loudly and seemed unaware of it. The little one was charming, working efficiently and moving lightly in the kitchen. I liked her more and more, though she always remained distant and I never had any idea what she was thinking. However, there was too much work for one amah so we asked her to go and find a friend to help her.

While she was gone Ahmad arrived unexpectedly. It was just one week since their dramatic departure. He sat on the steps by the front door taking up a characteristic attitude of despair, coiling his arms one about the other like affectionate snakes. We asked how Suppiah and Zeida were. Zeida was well, he said, but Suppiah could not stop thinking about Tania. I wondered about Zeida too, in spite of Ahmad's good report of her. She had been happy with us. I was sure Ahmad would never give up the idea of her marriage and allow her to follow her ambition to become a nurse. Hers would be one more of the many lives spoilt by jealous and selfish adults who will not allow children to follow their natural bent. She would have made an excellent nurse. Her gay, happy spirit would have healed many a sick heart and her hands would have been quick to learn a gentle efficiency. She was one of

those rare people who understand at quite an early age that true happiness is found only in the service of others.

We never quite discovered the reason for Ahmad's visit, but I think he may have hoped we could not do without him. In the meanwhile the little Chinese amah had returned with her friend. They looked suspicious of this man idling about obviously touting for work. If Ahmad did not go soon I thought, we shall lose both the Chinese before we have even started. So excusing myself I departed and left my husband to get rid of him.

The second Chinese amah spoke no Malay at all. She was strong and buxom, an attractive country girl, but she was as strange to me as a book in a foreign language. We seemed to have no points of contact. My house became unfamiliar to me; I understood it no longer. Before, sympathy had been like a ball caught and thrown from hand to hand, but now there seemed nothing but bare walls and no warmth anywhere. My kitchen was frequently filled with the black trousers and white jackets of visiting friends, but to me they were always strangers. I thought of Peah with her old eyes still twinkling (a couple of diamonds she would carry to her grave), of her favourite daughter Asmah, and of the fat sister with her swinging baskets. I thought of Salem and his laughter, of Mina and her many moods, and above all of Suppiah and Zeida.

I had retained Machi to look after Tania, but she was bewildered these days like a lost child. She had never helped much with looking after Margaret, who obeyed people either because she loved them or occasionally because she feared them — there were no half measures — and unless it happened to coincide with her own inclinations, an order to Margaret from Machi merely resulted in her doing the exact opposite, just for the fun of disobeying a grown up. Suppiah would not have allowed behaviour of this sort to pass unchecked, but now that Suppiah had gone Margaret could do as she liked and Machi, with her lazy good nature and soft heartedness, contented herself with useless rebukes. Mun had more depth of character and Margaret behaved well with her. Her husband Isnain still drove the car and so Mun remained at the back to help me. We had finished the sewing we had begun many weeks ago, but sometimes she came to sit upstairs to do her own, and the two of us exchanged opinions about our new surroundings while we worked together.

Then Ahmad returned again, alone and looking ill. Could he and Suppiah and Zeida have letters of reference? His was a difficult one to write but there was plenty of praise for his womenfolk. They both had fevers, he told us. He then described how they and a host of other relatives were crammed into one little house, which was unbearably hot in the daytime and so crowded at night that Ahmad had to sleep out in the open on a corner of the veranda. Afterwards I learnt that on this visit he had been to see Machi too. He had told her a fine tale. He was cooking for 80 people and earning a salary of 200 dollars a month, she said. I held my tongue. Poor Ahmad, full of pride to the last.

I made one of two attempts to draw again but found it very difficult. The Chinese were suspicious about sitting. The little one refused point blank, and though the attractive country girl sat once, she would never consent again. So I found myself in a desert, with only a bare horizon.

About three weeks later Ahmad put in a third appearance, looking very much better. He had followed the example of his brothers at last and was in business, but on the lowest rung of the ladder, I fear, for his job was to carry round the firm's letters. His life in the open air had given him a healthy tan (no pleasure for him, for city-bred Malays look down on and avoid the sunburn Europeans go to such pains to acquire) and his salary was barely enough to keep them all. Suppiah was better and had begun to sew jackets, which she sold for a small sum in the kampong.

When Ahmad had gone, I cast my mind about to think of some way of helping Zeida. Suddenly an idea came to me. Why should she not come to Australia with us to help me with the children, as Mun would not be able to? The more I thought about it, the better the idea seemed. It would cost quite a lot of money, but for me it would make all the difference between drudgery and a pleasant holiday, while for her it would be a wonderful chance to travel and to learn English, which she had always wanted to do. Also, in this way she would escape the bad influences of her foster-parents, with their laziness, jealousy and interminable quarrels, and enjoy several months at least of freedom. A few days later I decided to visit them and put my idea before Ahmad.

I did not know where they lived, but Machi's boy Wandi did. So one evening Isnain drove Machi and Wandi and me to the kampong. We had to stop the car some way off and walk in single file along a narrow lane. There the small Malay dwellings stood in a row on stilts, all grey

and a bit drab, their roofs thatched with woven palm leaves. At about the third house, I suddenly came upon them all, except for Zeida who must have been inside, sitting about on the steps. Suppiah ran forward and fell on my neck weeping. Zeida, hearing her, ran down to find out what had happened and, seeing me, gave a little gasp and took my hand. For some time I was incapable of speaking. The fat sister and her husband laughed and asked many questions.

'Now Ahmad,' I started at length. 'I've come to ask you if I may borrow Zeida for six months to take to Australia with me?' I saw a look of excitement dawn on Zeida's face, but quickly cloud over as Ahmad said: 'She has to be married in three months' time. I must ask her future [and he spelt the letters out for dramatic effect] H–U–S–B–A–N–D. I will come on Thursday and tell you what he says.'

He called on Thursday, but I knew before I saw him what he would say. He also brought a veiled message from Zeida. I understood what she meant, but it would have been impossible to have taken her without his consent. Now we turned to Mun again, and my husband asked Isnain point-blank if he could spare her for six months. At first he seemed to think he could, but later changed his mind again. At least the request had one good result. Isnain now appreciated that we were in earnest and from that time onwards began to treat Mun much better. She kept him to it by saying that if he gave her cause for dissatisfaction, she would leave him and go with us to Australia. If only a few more Malay wives had been in a position to speak to their husbands in that way, much unhappiness could have been avoided. As it was, the men had everything their own way, including the divorce laws, which made it easy for them to obtain separations from their wives but difficult if not almost impossible for wives to obtain a similar remedy. Few of them bore in mind the precept of their religion that 'divorce is the most detestable of permitted things' and some of them behaved in their matrimonial affairs most irresponsibly.

Having failed with Mun we asked our little Chinese amah, who was eager — almost suspiciously eager — to come. The cause of this was soon apparent when she was taken to the doctor to get the necessary certificate of health. She turned out to be suffering from tuberculosis, not badly, but badly enough to prevent her being given a visa. In fact it was risky even to let her stay on with us, but another upheaval in the last few weeks was impossible, so we took all the precautions we could

and allowed her to remain. The Ahmad family deduced from my visit to their home that they were no longer in disgrace, and returned my call by coming not once but two or three times.

On the first occasion Tania, who had never mentioned Suppiah's name since the day she left us, refused even to look at her, and ran away from her when she tried to go near her. There seemed to be a mature depth in the child, as though she thought Suppiah had deserted her. But the first visit over, the next time Suppiah was more successful and Tania allowed herself to be picked up. The last time they came Suppiah fell into her old jobs again for one happy afternoon, bathing and feeding Tania and putting her to bed. It was embarrassing for me with the Chinese in the house, for I could see they very much resented this familiar intrusion. But I felt powerless against the old ties and old affections and for an hour or two drifted back into the happy past, at the risk of finding myself on my own again with all the arrangements mounting up as our leave drew nearer. Lovely as it was I heaved a sigh of relief when we were alone once more and the neat Chinese amahs resumed their normal routine.

On our very last Sunday afternoon we paid a farewell visit to the lovely botanical gardens, where many varieties of tropical plants grow in their natural surroundings. Here all nationalities from this great city in which we lived sought relaxation and pleasure. Indians, Chinese, Malays, Europeans and many others strolled in pairs or groups across the lawns, or made their way towards the inviting shade of vast trees, growing in profusion like a well-selected jungle from which all undergrowth had been cleared away, enabling one to walk with ease between them. There was also a lake upon the surface of which the water lilies grew like saucers, with here and there a handsome cup among them. There were endless surprises of plants and flowers. One went to the gardens never knowing what would be in bloom, for in a land without seasons even quite short spells of dry weather, at any time of the year, are enough to bring out the flowers. How bewildering it must be to be a plant in Singapore, I thought.

The people in these gardens were as varied as the flowers. There were Chinese amahs wheeling flaxen-haired children, Indian merchants

deep in conversation making jottings in their notebooks as they talked, Europeans with their dogs and Chinese students with cameras taking photographs of the exquisite girls with whom they strolled from one shade to another. All of them seemed to be enjoying themselves in their own way, and though in most of their minds some other thought was probably uppermost, none could have failed to have been affected, at least to some degree, by the beauty of the natural scene around them.

Above all, the gardens were a resort for family parties, and the happy voices of children in many languages echoed there. After the babies came the toddlers, who were decanted from prams and pushchairs onto a level space of grass for their early lessons in walking, while their elder brothers and sisters climbed steps or rolled down banks not too far away. Bigger children found swings for themselves on the lower branches of the large trees, or played hide-and-seek behind the natural screens of bamboo. Others caught butterflies, read books, or walked about in passionate companionships. Mothers rested while fathers joined in the fun, and grandparents regarded the most ordinary looking grandchildren with a pride they made no effort to conceal. All around me I was conscious of this family spirit, gay and almost festive, and as I moved with my children among the various groups I felt myself carried on the wave of a real community of feeling, which flowed in and out among us all. Margaret knew no difference between Malay, Chinese and English children in her play, and I enjoyed as frank an interest in all these other families, their problems, their griefs and their joys, as they had shown in mine. For this bond of common interest is very strong and there are few who do not share it, few people who, even though uncommunicative or unwilling to speak on almost any other subject, will not readily discuss their children. It is natural that this should be so, for all except the very unfortunate are most at home in some sort of family life, and can speak of it without shyness or affectation.

We strolled across the lawn behind the children, who had run on ahead. Suddenly I heard voices calling, and turning round saw Suppiah and Ahmad, Zeida, the fat sister and her husband. Like ourselves, they were on their way to see the monkeys and, spotting us in the distance, had hurried to catch up with us. Suppiah had on her brown and white costume, the same one she had worn on the feast day after the fast, and her gold bracelets and earrings. Ahmad looked well and neat in his

black cap, and Zeida was very much the bride-to-be in a new jacket made by Suppiah and with her head draped in a blue silk scarf. The fat sister was as fat and flabby and more patiently resigned than ever. Her husband was looking forward to rejoining the Malay navy. They were all glad to see us and walked with us towards the avenue of trees where the monkeys frolicked and jumped from branch to branch. Margaret and Tania had their own little packets of nuts and as they chatted in Malay to each other, several other Malays joined us and stood around watching the scene and listening to their talk. It was difficult not to feel a little proud that our children could so readily enter into the lives of these friendly people and that they, in turn, should enjoy it so much.

As we were walking back along the edge of the lovely lake stretched out before us with its purple and pink water lilies, I listened to Suppiah's sad talk beside me. She was still quarrelling and still unhappy. Yet I felt that when we returned in five or six months' time, it would be just the same. But what would have become of Zeida? Would she have been married off to an unknown husband? Or, would she have found a way to escape? I hoped so.